WITNESSES TO THE STRUGGLE

*The Great Betrayal: The Evacuation of the
Japanese-Americans during World War II*
(WITH AUDRIE GIRDNER)

California, Where the Twain Did Meet

*A Long Time Coming: The Struggle to
Unionize America's Farm Workers*
(WITH DICK MEISTER)

WITNESSES TO THE STRUGGLE

IMAGING THE 1930s CALIFORNIA LABOR MOVEMENT

Anne Loftis

▲▲ UNIVERSITY OF NEVADA PRESS / RENO LAS VEGAS

University of Nevada Press, Reno, Nevada 89557 USA

Copyright © 1998 by University of Nevada Press

All rights reserved

Manufactured in the United States of America

Design by Carrie Nelson House

Library of Congress Cataloging-in-Publication Data

Loftis, Anne, 1922–

Witnesses to the struggle : imaging the 1930s California labor
movement / Anne Loftis.

 p. cm.

 Includes bibliographical references and index.

 ISBN 0-87417-305-1 (alk. paper)

1. Strikes and lockouts—Agricultural laborers—California—
History—20th century—Historiography. 2. Strikes and
lockouts—Agricultural laborers—Press coverage—United States.
3. Strikes and lockouts in literature. 4. Performing arts—United
States—Plots, themes, etc. 5. Agricultural laborers—California—
Public opinion. 6. Public opinion—United States. I. Title.

HD5325.A29L64 1997 97-22379

331.892'83'0979409043—dc21 CIP

The paper used in this book meets the requirements of American
National Standard for Information Sciences—Permanence of
Paper for Printed Library Materials, ANSI Z39.48-1984. Binding
materials were selected for strength and durability.

First Printing

07 06 05 04 03 02 01 00 99 98 5 4 3 2 1

FOR SOME VALIANT WOMEN IN MY FAMILY WHO INSPIRED ME:

Mary Loftis, Laura Craven, and Lucy Benaouda

Meredith Mayer, Jane Mayer, and Cynthia Mayer

Mary Ann Radzinowicz

Jane Hufft, Amy Hufft, and Patricia Sciarrotta

Mary Richardson Davis

and Betty Freund

CONTENTS

ILLUSTRATIONS

PREFACE

This book was conceived more than two decades ago when I began interviewing Californians who were involved in some of the controversial events that took place in the state during the 1930s. They included union leaders who had been farm labor organizers, men and women who had worked in the Farm Security Administration's camps for migrants, and photographers who had recorded scenes of the Great Depression for New Deal agencies. In the early 1980s the momentum of the project increased when I worked as a research assistant to Emeritus Professor Paul Taylor at University of California, Berkeley. More interviews followed, although a good deal of information about the activities of Taylor and his wife, Dorothea Lange, comes from transcripts of interviews with them done by Malca Chall and Suzanne B. Reiss of the Regional Oral History Office of the Bancroft Library and from Lange's field notes, edited by Zoe Brown and located in the Art Department of the Oakland Museum.

My work on John Steinbeck was spurred by the opportunities offered to me by his biographer Jackson Benson and by Susan Shillinglaw, head of the Steinbeck Research Center at San Jose State University. These activities led to contacts with individuals in Los Gatos, Salinas, Carmel, Fresno, and Bakersfield who had taken part in (or had a connection with people who had taken part in) the events of the 1930s that I was studying. Moving south of the Tehachapis, I explored the early career of Carey McWilliams through his papers in the Special Collections archives of the Research Library at UCLA.

I would like to thank a number of other individuals who helped me during the project's evolution from research to writing. Alice Bernard Thomsen of Houston, Texas, sent me the letters her father-in-law, Eric Thomsen, wrote to Steinbeck. Margaret Kimball, head of the Special Collections Department at the Stanford University Libraries, assisted me in reviewing Steinbeck's letters to his literary agents. I am grateful to Kathleen Sullivan for guiding me through the Farm Security Administration files at the National Archives in San Bruno, and to Jack and Sharon Goldsmith, who steered me to the transcripts of interviews with former dust bowl migrants commissioned through the California Odyssey Project of 1980–1983 at the State University in Bakersfield.

Susan Parker Sherwood of the Labor Archives and Research Center at San Francisco State offered assistance with illustrations, as did Joy Tahan of the Oakland Museum and William Roberts of the Bancroft Library. Jennifer Watts, the curator of photo archives at the Huntington Library in San Marino, helped me locate pictures in the Huntington collections as well as at other institutions. For the loan of their precious family pictures I thank Helen Dixon of Berkeley, Charles Garbett of Los Altos Hills, Roy Hamett of Madera, and Bob Taylor of Portola Valley.

In the long process of assembling many separate elements into a book, I was encouraged by Margo McBane and other members of the Bay Area Labor History Workshop and by members of the California studies group at UC Berkeley. Professors Jackson Benson, James Gregory, Jeff Lustig, Sally Miller, and Susan Shillinglaw gave me opportunites to present papers on topics related to the project at academic conferences. I am grateful to Professors Susan Shillinglaw and Charles Wollenberg for reading drafts of the manuscript. At various times three close associates, John Loftis, Rachelle Marshall, and Jean Simpson, read or listened to parts of the work in progress. I thank Jean and Michael Sherrell for publishing excerpts from my work-in-progress in their innovative magazine, *The Californians*. In the final stages of the preparation for publication, Margaret Paulekas of Walnut Creek painstakingly checked quotations in the Art Department library at the Oakland Museum, and Jyllian and Mary Ann Halliburton of Stanford conducted a successful search for illustrations at the San Francisco Bay Area institutions.

Finally, I want to thank my first editor, Trudy McMurrin, for her buoyant faith in the enterprise and for her role as intermediary with my later and insightful editors, Sara Vélez Mallea and Cam Sutherland, and with my copy editor, Gerry Anders, who have all been creative participants in the production of the book.

WITNESSES TO THE STRUGGLE

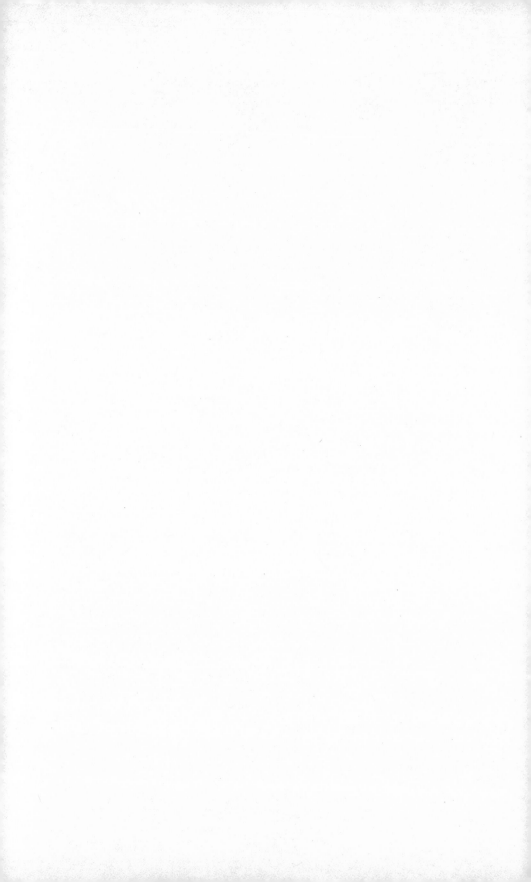

1

SHADOWS IN THE LAND OF SUNSHINE

If the Great Depression of the 1930s was a time of trial for millions of Americans, it was also an intensely creative period for the artists and social scientists who recorded it. Focusing on one state, California, this book explores the correlation between the economic and political upheavals that transformed the lives of ordinary citizens and the efforts of professional observers to put those changes into a historical—and occasionally an ideological—context.

"There has never been a time," Malcolm Cowley wrote, referring to the country at large, "when literary events followed so closely on the flying coattails of social events."[1] The term *literary* has to be expanded, however, for in addition to novelists, poets, and critics there were economists, painters, photographers, film makers, and musicians interpreting what was happening, following the journalists, radio announcers, and newsreel cameramen who dispatched the first reports from the scene.

To a surprising degree, this heterogeneous group of observers found a connection through social values that they shared. The realism and documentary

expression that characterized the art of the depression decade grew out of a sense of personal involvement in the problems of society. The message conveyed by those who recorded what was taking place was: "We are here. We are witnesses"—and, by implication, "We care." Looking back on that era from the vantage point of a quarter century, the journalist-historian Carey McWilliams quoted a letter that his contemporary John Steinbeck sent to a student magazine at the University of California, Berkeley, in 1936. In it, Steinbeck said of young writers: "The ones capable of using their eyes and ears, capable of feeling the beat of the time, are frantic with material."[2]

Among the social upheavals that gripped California during the depression decade, problems related to farm workers attracted particular attention. In addressing the subject, Steinbeck and McWilliams shared common ground with the economist Paul Taylor, the photographer Dorothea Lange, and a number of other interpreters who were less well known. Although (except for Taylor and Lange) they worked independently, they traveled along parallel lines—literally and figuratively.[3] Their work was so closely tied to current events that they seemed to be scarcely conscious of what had come before.

Farm workers in California had been overlooked in earlier decades. This was a consequence of their mobility—their work on short-term jobs, their frequent travel from place to place—and their anomalous status. Farm work in the past had been a fallback occupation of the resident unemployed as well as an entry-level opportunity for new arrivals. It was in this second category, as the 1930s commentators noted, that the workers played a significant role in the history of the state by revealing the disparities in its social structure. The waves of people coming from Europe, Asia, Latin America, and from other parts of the United States to make a fresh start in one of the richest agricultural regions of the world encountered barriers that seemed to deny the egalitarian promises of the frontier.

Small farming and homesteading had figured in the settlement of Washington and Oregon, where rainfall was more abundant. In California, which had an annual six-months' drought, a very different pattern of land-labor relationships had evolved. It dated from the Hispanic era when a small population was engaged in cattle raising on large tracts of land. Most of the physical labor was performed by descendants of the Indians who had been pressed into servitude by missionaries and soldiers establishing settlements along the coast in the late

eighteenth century. The pattern of large landholdings continued after the American acquisition of California, although the use of the land changed. Cattle ranches and *vaqueros* gave way to bonanza wheat-growing enterprises that provided employment during the brief harvest season for some among the thousands of newcomers from all over the world who arrived during the gold rush.

In agriculture, as in the gold camps, ethnic identity was a factor in individual progress. Whereas the white ex-miners who became wheat harvesters were free agents who could—and did—quit their jobs at will, the Chinese laborers who left railroad construction to build levees in the Sacramento Delta were indentured to fellow countrymen who had subsidized their travel to the New World. There were later well-publicized instances in which European immigrants who arrived penniless became leaders in fruit growing and viticulture, but among the so-called racial minorities such success was less common. A few East Indians and Chinese became growers, but only the Japanese as a group made the transition from hired labor to entrepreneurship despite formidable legislative barriers raised against them. Their success was confirmed by the naming of a Japanese "potato king" in the tradition of the Caucasian "grain king" associated with the international wheat trade. The promotion of successful growers to the status of royalty was an indication of the attitude in the state toward large-scale enterprise.

Human relationships on the land had been recorded by English-speaking observers in California from the time that Richard Henry Dana described life in the Hispanic settlements in *Two Years Before the Mast* (1840). Although Dana's account was in part critical, its chief effect on readers in his native Massachusetts and other parts of the eastern seaboard was to arouse their curiosity about a little-known place on the other side of the continent. The gold rush stories of Bret Harte and Mark Twain had a similar impact on armchair travelers. Avid for reports from Eldorado, they ignored the authors' social criticism.

An extraordinary instance of misinterpretation involved the Indian-rights advocate Helen Hunt Jackson and her 1884 novel *Ramona*. She had turned to fiction to dramatize the campaign—set forth in her 1881 tract *A Century of Dishonor*—to win retribution for native tribes from the U.S. government. She succeeded to some degree in her cause, but the unanticipated impact of

Ramona, which describes the relationship of Indians, Mexican landowners, and rapacious Anglos in Southern California, was to stimulate the cult of the romantic Hispanic tradition that appealed to tourists. For many years after Jackson's death, her best-selling novel was exploited by local-color propagandists.

In its ultimate commercial expression, the semifictional California of the "Land of Sunshine" and the "Italy of America" posed a challenge for serious critics. In one instance, a 1923 history called *California the Wonderful,* the instincts of a social reformer warred with the booster's impulse. The author was Edwin Markham, a teacher and poet (best remembered for his poem "The Man with the Hoe") who had worked in his youth on ranches in the interior valleys. He condemned the monolithic enterprises of the "wheat barons" and empathized with their "labor vassals." As a replacement for corporate agriculture, he proposed a "co-operative commonwealth," an expansion of the small, sporadic, and relatively short-lived communal-farming experiments in California in the nineteenth and early twentieth centuries.[4]

Markham looked forward to a time when government-subsidized irrigation projects would lead to the cultivation of a variety of fruits and vegetables on moderate-sized tracts of land. His blueprint was accurate in one respect. The importation of cheap water brought about a shift from extensive to intensive agriculture, leading to the production of over two hundred different farm commodities in the state. But high capital costs and the need to connect with distant markets discouraged individual farming on a small scale. The historical reality was closer to the vision of the popular novelist Harold Bell Wright, who publicized the impact of the Colorado River irrigation project in his 1911 best-seller *The Winning of Barbara Worth,* set in the Imperial Valley.[5]

Edwin Markham followed in the tradition of several earlier dissenting writers. The significance of land use in human history was the passionate concern of Henry George, a former reporter and editor of *Californian* magazine. He devoted years of labor and sacrifice to writing his book *Progress and Poverty* (1879), in which he examined the paradox that as civilization advances, "want increases with abundance." His frame of reference was far-reaching in its scope, global in its scale, but his personal observations in California contributed to his thesis that an increase in wealth was accompanied by a commensurate inequality in its distribution.[6] His solution to the problem, a single tax

on land, was too controversial to win strong support, but the book, which became a best-seller, won him a reputation as a reformer and champion of workingmen and ethnic minorities.

Henry George's views on land monopoly and human relations in California were shared by Josiah Royce, a Harvard philosophy professor who was born in Grass Valley in the Sierra foothills in 1855. In 1886 he published a critical study of interpersonal conflicts in his native state beginning with the American conquest and continuing through the gold rush that had brought his parents and thousands of other new settlers to the West Coast. As a member of a younger generation, Royce cut through the pieties and the legends that surrounded these events to examine the motives and actions of the participants. The fact that the book is opinionated adds to its authenticity. In a burst of emotion Royce condemned "the fearful blindness of the early behavior of the Americans in California toward foreigners" as "something almost unintelligible"—and then proceeded to analyze and explain it.[7]

Both Henry George and Josiah Royce attacked the railroad monopoly that exerted disproportionate power over the state legislature. The most effective writing on this subject, however, was done by the novelist Frank Norris, who was, like Royce, a graduate of the University of California. In *The Octopus* (1901), Norris described the warfare between wheat farmers and the Southern Pacific in the San Joaquin Valley. In *McTeague* (1899), he evoked the materialistic, chaotic atmosphere of post–gold rush San Francisco. In his subjects and in his style of romantic realism, he was influenced by Emile Zola.

Norris's work made an impact on Jack London (1876–1916), who combined an enthusiasm for socialism with a passion for red-blooded adventure. An inveterate traveler and foreign correspondent, he found material for his writing in his trips to the Alaska Klondike and the Orient and his experiences sailing in the Pacific and tramping around the United States and Canada. When he was still in his twenties, he went to England and disguised himself as a derelict to gather material for a study of the indigent, published in 1903 as *The People of the Abyss.*

In going abroad, London overlooked a similar situation in his own backyard. A survey taken just before the turn of the century reported 40,000 single men holed up in the ten- and fifteen-cent lodging houses and cheap hotels south of Market Street near the San Francisco waterfront, which had been the

locale of some of London's early activities and writings.[8] Many of these men were miners, woodcutters, and fruit pickers who had come to the city during the winter layoff.

In the decade before the First World War, workers in these occupations made up the membership of the Industrial Workers of the World (IWW), the unorthodox union of the unskilled which challenged the craft-oriented American Federation of Labor (AFL) and called strikes and work stoppages in mines, lumber camps, and ranches throughout the West. Most of the actions of the IWW were condemned by government representatives and the press, but one dramatic incident, the 1913 Wheatland hop-field riot in the Sacramento Valley, was credited with opening up "a narrow window of public and academic interest in the problems of migratory labor."[9] The interest was stimulated by the reforms of the Progressive Republican governor, Hiram Johnson. It proved to be ephemeral, however, and all but disappeared after the IWW, which opposed the U.S. entry into the war, was suppressed through federal espionage and sedition acts and the criminal-syndicalism laws enacted in twenty-one states, including California.

The revival of interest in farm workers during the Great Depression was part of a national focus on "the common man hero, the forgotten American."[10] It was encouraged directly by the insurrectionist ideology of the left and indirectly by the reformist philosophy of the center. On a political level, the new Democratic administration in Washington brought benefits to workers as well as relief to the unemployed. Labor legislation led to an unprecedented increase in organizing, which challenged the dominance of the craft unions that excluded unskilled workers. The time was ripe for protest, even for farm workers, who were not covered by the laws.

In 1933, strikes against the state's agricultural industry were led by a new generation of radical organizers and were supported by a coalition of Marxist intellectuals and nonaligned liberals. This alliance was cemented several years later during the controversy over the newly arriving dust bowl migrants, who for a brief time transformed the agricultural landscape of the state. Year by year the battles between workers and growers and their partisans intensified until at the end of the decade the furor on the West Coast reached a crescendo that reverberated in the halls of Congress and the White House.

California led the nation in the number of farm strikes in the 1930s. At least 140 were recorded, involving over 127,000 people.[11]

The interpreters who brought this story to the attention of the public did not at the time think of themselves as a group. Yet they gave a collective strength to the voice of dissent that in the past had been raised by lone individuals within the state. They had, furthermore, a common perspective. They looked from a nontraditional viewpoint at a situation that had been ignored. In the process they exploded the image of California as a second Eden.

Fired by a spirit of urgency, Steinbeck in 1938 told his literary agent, Elizabeth Otis, "I'm trying to write history while it is happening and I don't want to be wrong."[12] But he and the other interpreters were also trying to *affect* history. They believed that reporting would stimulate action, that revelation would lead to reform. From the perspective of sixty years, this is a premise that raises a number of questions. Some are about the outcome: Did exposure of abuses bring about reform? There are also questions about methods, about the techniques by which these artists and investigators forged a common ground. Did they tell the truth, or did they create propaganda? Would their art have been better if it had been less polemical, or was their vision inseparable from their involvement in the events?

This book is written in the hope that an examination of the record may supply answers that are relevant for later interpreters in our time.

2

THE STRIKES, THE PARTISANS, AND THE PRESS

During the 1920s the California farm labor scene changed. Workers began to travel from harvest to harvest by automobile, bringing their families. The number of white "fruit tramps," who had been the mainstay of the iww, declined. More of the single men in the fields were recently arrived immigrants.

A small number of Sikhs from the Punjab region of India worked in irrigated agriculture in the Imperial Valley. Some of their countrymen were drawn to the Marysville–Yuba City area of the Sacramento Valley. Working in the asparagus fields in the Sacramento Delta or in the lettuce industry in the Salinas Valley were a larger number of young men from the Philippines, who were among the more than 31,000 of their fellow islanders who arrived in California between 1920 and 1930.

The introduction of cotton as a major crop, first in the Imperial Valley and later in the San Joaquin Valley, attracted a few black as well as white pickers from the South, some of whom came in answer to advertisements from growers who were themselves originally southerners. In the beginning, many of

these pickers returned to their home states at the end of the season. Later, more of them began to stay year-round on the West Coast, mainly in the cotton-growing counties. Like the East Indians and the Filipinos, they were a small minority among California farm workers.

The Mexicans, who outnumbered all the other groups, were not defini-tively associated with any particular crop or region. They traveled the length of the state from one job to another. In the winter months, if they were not working in the Imperial Valley or the Coachella Valley, they gravitated to Los Angeles or other urban areas or they returned home; in the first two decades of the twentieth century it was relatively easy to cross the border in either direction. The Mexican workers engaged in very little strike activity in Cali-fornia until 1927, when they formed the Confederación de Uniones Obreras Mexicanas, which had twenty locals. The following year, when cantaloupe pickers walked out of the fields in the Imperial Valley, the employers used the threat of deportation as a tactic to break their strike.

The activities of the Mexican unions attracted organizers from the Trade Union Unity League of the Communist Party. The TUUL, created in 1929 by leaders of the American Communist Party after an international conference in Moscow, aimed to bring unskilled workers into organizations that cut across racial, ethnic, and class lines and were dedicated to Marxist principles. The strikes joined by the TUUL in the Imperial Valley were forcefully suppressed. Eight of the Communist organizers were tried, convicted, and handed prison sentences under California's Criminal Syndicalism Act, enacted in 1919, which forbade advocating or promulgating violence as a means of "accomplishing a change in industrial ownership or control or effecting any political changes."[1] In 1932 the TUUL created the Cannery and Agricultural Workers Industrial Union, based in San Jose, near the orchards and canneries of the Santa Clara Valley. In its first year the CAWIU made little impact. Although farm wages in California had dropped to about half the 1929 level, the workers were not in a mood to protest. In the nadir of the Great Depression, when prices for farm commodities were at rock bottom, their position seemed hopeless.

The following year the apathy disappeared under the stimulus of a slight upturn in the economy (although at the beginning of the season this upswing was more of an expectation than a reality). Great changes were under way in Washington. In the emergency legislation passed by Congress in the first one hundred days of the Roosevelt administration—measures to stabilize the

10

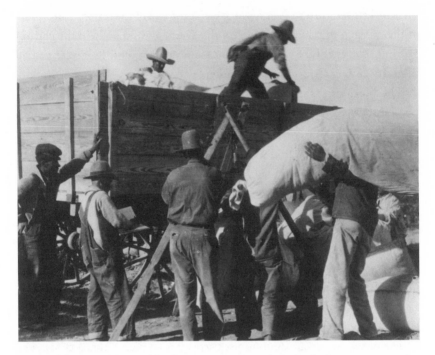

Mexican laborers weighing and loading cotton. Courtesy, The Bancroft Library, University of California, Berkeley.

banks, relieve the unemployed, and rescue farmers with a crop reduction and subsidy program—a labor reform was embedded in a relief bill. Section 7 (a) of the National Industrial Recovery Act gave workers in industry "the right to organize and bargain collectively through representatives of their own choosing."[2]

The passage of this landmark legislation touched off an explosion of strikes throughout the country. From a present-day perspective, the California crop pickers' revolt of 1933, which involved some 47,500 workers,[3] appears to have been part of this chain reaction. That was not, however, the view of the Communist Party, which in this period condemned the initiatives of the federal government across the board. Farm workers had in fact been left out of the New Deal reforms. They were excluded—through a separately enacted statute—from the rights guaranteed to other workers under Section 7 (a). They did not share the benefits of the Triple-A farm relief program designed to raise commodity prices.[4] In 1933, farm prices rose in California as in other states.

The cost of living also rose. Farm wages, however, were at the same level as the previous year, as low as fifteen cents an hour, occasionally even twelve cents. The impetus for the more than thirty strikes that took place that season came from frustration and anger. To California farm workers living in a period of rising expectations, the low wages they were offered signified that they were being ignored.

The CAWIU organizers who channeled this resentment into action were for the most part city-bred young people who had more enthusiasm than experience. Some of them were former college students, some had been blue-collar workers—there was no hierarchy of background or class in the Communist Party. Like novices in a religious order, they were instructed in service and sacrifice. They were also cut off from their past lives, harnessed to the daily demands of the present. They hitchhiked from place to place and stretched any money that came their way, using much of it to pay for stamps and paper to get out calls to action. Their survival wages put them on a par with the workers they represented.[5]

The organizers generally took the pragmatic position of focusing on the concerns of the workers in spite of the stress on ideology that was put forward by Party officials in evaluation sessions. "Our unions are rank-and-file controlled and must be kept so," the CAWIU executive secretary, Caroline Decker, told the Party purists. "In our unions are workers of all beliefs and theories. Our own theories cannot be forced down their throats by burocratic [*sic*] blustering and mouthing of revolutionary words and fist-waving, but by honest, patient and day-to-day work side by side with these workers."[6] That this view was adopted is suggested by the statement of a representative of mainstream labor who, after observing the CAWIU in action, said: "The Communists talked strike and not revolution."[7] The strike demands were in general few and simple: an increase in wages, a decrease in work hours, abolition of oppressive middlemen and labor contractors, and no reprisals against the workers who went out on strike. There was also a call for union recognition, although one of the chief organizers who led successful strikes said later that this demand was "utopian" in that era.[8]

The early strikes were met with violence. Picket lines were attacked by opponents wielding clubs and other weapons. Strikers were arrested and sent to jail. A strike of pea pickers in April in Alameda and Santa Clara Counties was quashed by opponents and law-enforcement officials. Then the tide be-

gan to turn. A Santa Clara County cherry pickers' strike in June held the line against a reduction in wages in spite of incidents of brutal vigilantism. A pear pickers' strike in the same county in August raised the wage from twenty cents to as much as twenty-seven cents an hour. Also in August, a strike in the peach orchards of the 4,000-acre Tagus Ranch near Tulare resulted in a wage increase for peach pickers in other areas mediated by the California Department of Industrial Relations. The chief organizer was Pat Chambers, a thirty-one-year-old former construction "boomer" who sneaked onto the ranch at night past the guards to talk to the workers.[9] A grape pickers' strike near Lodi in September was not successful, but the momentum of the earlier victories continued to build to the October cotton pickers' strike, a walkout that broke all records.

Considering that the CAWIU was a minuscule, improvised, hand-to-mouth outfit, its success in challenging the largest industry in the state was remarkable. Timing was essential. The strikes broke out so fast that the opposition

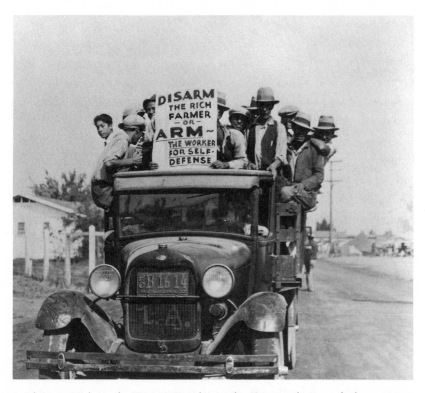

A picket caravan during the 1933 cotton pickers' strike. Courtesy, The Bancroft Library, University of California, Berkeley.

was taken by surprise. Another key factor was the backing of supporters, not only small farmers, townspeople, and merchants in the area of the strikes, but also financial donors and spokespeople on the outside who brought the cause of the farm workers to the attention of the public. This effort, which had an urban and suburban base, was promoted by professional people, intellectuals, and students who had no connection with agriculture.

13

In this period the Communist Party USA exerted an influence that extended well beyond its membership, which was estimated to be 14,000 in 1932 and 70,000 six years later.[10] In addition to the "fellow travelers" who endorsed but did not officially join the Party, there were moderates and liberals who rejected the Communists' goal of revolution but supported some, if not all, of their highly visible public activities.

One reason the 1930s were called the "Red decade" by some observers was that Communists were active all over the country—championing the destitute and powerless, exposing instances of injustice and inequality, and (as noted in a recent history of the period) "helping to nurture rebellion industriously when and where" they could.[11] Were the causes less important because the individuals who pursued them had an ulterior motive? Communists defended victims of white supremacy in the South, mobilized the urban poor through hunger marches and "unemployed councils," organized textile workers in the Northeast, coal miners in Kentucky and Pennsylvania, and sharecroppers in Alabama, as well as farm workers in California. Some of their campaigns were brought to the attention of famous people outside the Party's sphere of influence. H.G. Wells and Albert Einstein, for example, signed a petition supporting the defense of the "Scottsboro boys," five young black men falsely accused of rape in a highly publicized case in Alabama. Another group of intellectuals—less famous, although their names were well known to the reading public—supported Communist causes through personal witness and individual actions on a regular basis. Prominent in this category were the California-based journalists Lincoln Steffens and Ella Winter, who were tireless intermediaries in behalf of the CAWIU.

They were an unusual couple, very different from one another in appearance, temperament and age. Steffens, more than thirty years older than Winter, had been a renowned muckraker in the Progressive era in California and New York before he became a roving foreign correspondent in Europe, one of the first outsiders to report the Russian Revolution. In 1919 he met the viva-

cious, dark-haired student Ella Winter at the Versailles Peace Conference and in courting her converted her to his enthusiasm for the new government of Lenin. In 1927 he brought her and their young son back to his native California to live in the artists' colony at Carmel-by-the-Sea.

14

Four years later Steffens won new celebrity following the publication of his *Autobiography,* in which he described his transformation from liberal reformer to proselytizer for the Soviet Union.[12] When the book appeared in 1931, it became a bible for political theorists who were predicting the imminent collapse of capitalism.[13] With the passage of years it has become a minor classic as the story of man who was immersed in important historical events on two continents.

Steffens was sixty-five when the book came out. During the long years of its composition, he and Ella Winter experienced some strain in their May-December marriage. From the beginning of their relationship, they had decided it should be flexible.[14] When she became restless in the hedonistic atmosphere of the artists' colony, he persuaded her to file for a secret divorce. This step would give her sexual and artistic freedom and bring him peace of mind, after which they would continue to live together as before. Or almost as before, because when their legal action was discovered by the press, their private life was exposed to painful scrutiny.[15]

Ella Winter had been frustrated in some attempts to write fiction. Her gifts were critical and reportorial rather than imaginative. Steffens urged her to begin a writing project that would take advantage of her cosmopolitan background, a legacy from her German-Jewish family, who had lived in Australia and England, and her training at the London School of Economics. She went to Europe to conduct an investigation of recent events and produced a topical, if ephemeral, account of her travels to the Soviet Union and to Germany on the eve of Hitler's rise to power.[16]

When the book appeared in the spring of 1933, Winter found herself in the vanguard of the left-turning literary establishment. While she was addressing forums in New York and being interviewed by the press, she joined Joseph Freeman, the editor of the *New Masses,* in founding the League Against War and Fascism, the first anti-Nazi organization in the United States. She and Steffens were among the fifty-two American intellectuals who announced their support for William Z. Foster, the Communist candidate for president in 1932,

Lincoln Steffens, Ella Winter, Charles Erskine Scott Wood, and Sara Bard Field in Fiesole, Italy, soon after the Steffenses' marriage in 1924. Charles Erskine Scott Wood Collection, The Huntington Library, San Marino, California. Reproduced with permission.

when he won 103,000 votes (as compared with 900,000 for the Socialist, Norman Thomas, and almost 23 million for Roosevelt).[17]

In California, Steffens and Winter were in close touch with the young, able director of Region 13 of the Communist Party USA, Samuel Adams Darcy, who despite his American name had been born in the Ukraine and trained in Moscow. Steffens was not himself a member of the Party. He might have made the excuse that he was unsuited to its discipline, that he would not, even if he could, drop his lifelong habits of candor, cajolery, and humor. His qualities balanced the militancy, energy, and single-mindedness of Ella Winter. The

16

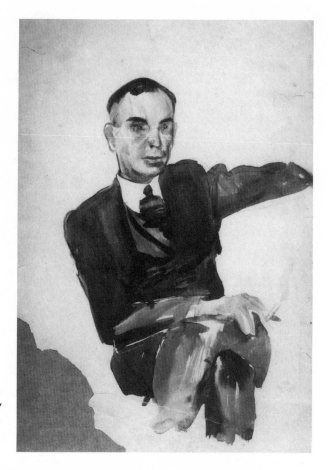

George West, from a watercolor portrait by Cornelia Barns. Courtesy of Charles R. Garbett.

critic Max Eastman, who had a different leftist perspective, had a harsher view: he characterized her as "a zealot" who converted Steffens "from a sentimental rebel . . . to a hard-cut propagandist for the party line."[18]

In their activity in behalf of the CAWIU, Steffens and Winter called on their intimate circle of friends, some of whom lived outside Carmel. Colonel Charles Erskine Scott Wood, a West Point graduate and former Portland, Oregon, lawyer, had become a poet and philosopher in his retirement years, which he spent with the poet Sara Bard Field on an estate near Los Gatos.[19] Another friend and potential supporter was George West, the editorial page editor of the *San Francisco News,* who also lived in Los Gatos with his second wife, the poet Marie de L. Welch. In the 1920s West had been an iconoclast in the H. L. Mencken tradition.[20] In the 1930s he became an advocate of farm

workers, although the *News,* a Scripps-Howard paper dedicated to a reader-ship of workingmen in a city that was pro-labor, did not formally endorse the strikes of a union that was outside its sphere of interest.

George West and Colonel Wood were among the prominent residents of Santa Clara County who condemned the vigilante tactics used against cherry pickers and union leaders in the June 1933 strike that took place not far from where they lived and in which one of the CAWIU organizers was clubbed. The protest led to a change in strategy in the pear pickers' strike two months later, where Louis Block of the California Bureau of Labor Statistics was called in to arbitrate a settlement. The CAWIU organizer Caroline Decker said that this intervention "saved our lives. Instead of sending out vigilantes to break heads, the growers treated the union as a legitimate entity."[21]

Ella Winter became involved in direct action in behalf of the CAWIU at this time. Her book promotion had ended with a tour of ten California cities under the auspices of the "Friends of the Soviet Union."[22] Soon afterward, back home in Carmel, she was contacted by strike supporters on the Monterey Peninsula. By the end of June she was driving to courthouses in Santa Cruz and Santa Clara Counties to post bail money, which she solicited from friends, to free organizers who had been arrested. With her flashing black eyes, inci-sive manner, and British-accented speech, she was a figure of authority in her encounters with judges and representatives of the law.[23]

Winter could also be persuasive. She helped to devise a scenario to coun-teract the opposition's tactic of drawing a subversive image of the union in order to divert attention from the strike issues. At gatherings where commu-nity leaders—teachers, clergymen, and social workers—were told about the grievances of the strikers, she shared the platform with the organizers Caroline Decker and Jack Warnick, a bright, personable young couple who were ideal publicists for the CAWIU. Decker, a small, blonde twenty-one-year-old, spoke with the assurance of a college girl who had received an early start in radical politics through her family. She was still in her teens when she took part in the 1931 coal miners' strike in Harlan County, Kentucky.[24] Shortly after she came to California with a delegation of labor activists, she met and married Warnick, an arrestingly handsome graduate student at Berkeley. While she became the executive secretary of the CAWIU, he concentrated on fundraising for the union. He had considerable success among Hollywood actors, produc-ers, and screenwriters who felt guilty to be earning weekly salaries in four fig-

Caroline Decker meeting with Mexican strikers in Tulare during the 1933 cotton pickers' strike. Courtesy, The Bancroft Library, University of California, Berkeley.

Pat Chambers (left) and aides during the 1933 cotton pickers' strike. Courtesy, The Bancroft Library, University of California, Berkeley.

ures while farm workers were paid fifteen cents an hour. The Steffenses had a connection with the film colony through James Cagney, who was a frequent visitor at their home even after he acquired his own weekend retreat in Carmel. He could be counted on to contribute to the CAWIU and to other causes they espoused.[25]

Winter found another ready donor on the local scene. Noel Sullivan, a singer and patron of the arts, a member of a wealthy Catholic family (he was a nephew of the reformer-politician James Phelan), responded generously to requests for help. During the cotton pickers' strike when Caroline Decker sent an SOS for funds to pay for gas for the vehicles used on the mobile picket line, Winter took up a collection among her friends. There was a second alert when Decker, who took a leadership role following the arrest of the chief organizer, Pat Chambers, reported a threat by health authorities to close the strikers' camp near the town of Corcoran. In response Winter mounted an expedition to the San Joaquin Valley with Noel Sullivan in his Cadillac leading the way.

In the group were two literary interpreters, Langston Hughes, the black novelist and poet, who was visiting in Carmel as Sullivan's guest, and Marie de L. Welch, the Los Gatos poet, who described her impressions of the experience in verse.[26] Winter's own journalistic account of the death of a striker's child elicited another contribution from James Cagney.[27] Noel Sullivan's response was immediate: at the camp he wrote a check to pay for the emergency repair of the water pipes.[28]

Steffens, meanwhile, in his characteristic mild-mannered, joking style, was debating general ideological issues with his fellow journalists. He of course took the negative position on the question "Can Capitalism Survive?" He suggested that although the alternative of Communism might at first seem alarming, people could be helped to get over their fright in the way that cab drivers in New York had introduced their horses to the first automobiles by walking the animals up and down in front of the machines.[29] As he used humor to disarm his audience, he appealed to their inclination to be modern, up-to-date, and attuned to the doctrines of the current age.

His audiences laughed as they disagreed with him. The atmosphere of the debates reflected their collegial relationship. Steffens and Chester Rowell, the editor of the *San Francisco Chronicle,* had been associated with newspapers in the state for forty years. Steffens had been a correspondent for the *Sacramento Record Union* in the mid-1890s when he was working as an investigative reporter on the East Coast.[30] Rowell meanwhile had made his reputation on the *Fresno Republican* as a rural editor in the mold of William Allen White before coming late in his career to the oldest of the four leading dailies in San Francisco. An early supporter of the reformer and Progressive politician Hiram Johnson, Rowell was also known as an internationalist and a civil libertarian. There was genuine respect in Steffens's praise of Rowell as "an important voice among us, rare and reasonable." Rowell, he noted, was "a Liberal," adding with a mixture of condescension and kindness: "Liberalism is dying. I know that subjectively and by the same token I know that I cannot express it as the immortals like Rowell can."[31]

Rowell's identification as a liberal defined the difference between them. As early as 1928 the New York writer Michael Gold had spoken of "a world rapidly dividing into two great camps of Fascism and Communism."[32] Rowell rejected this concept. From his base in California he became a self-appointed spokesman for democracy, which he perceived as being under assault from

both the right and the left. As the stormclouds gathering in Europe increased the pressure at home toward ideological extremes, he stood firmly on middle ground. "There is no danger of fascism in America," he wrote later, "unless either the danger or the bugaboo of communism frightens us into it."[33]

Steffens's views on Communism were also challenged by his old friend Fremont Older, the dean of California newspaper editors, a fearless man of principle and the promoter of talented reporters.[34] It was the first instance in their long association in which they took opposing sides. In his campaign to expose civic corruption in San Francisco at the time of the 1906 earthquake and fire, Older had consulted Steffens's 1904 book *The Shame of the Cities* and had enlisted his help. Later, again influenced by Steffens, Older had become disillusioned with muckraking.[35] They worked together in an effort to free two jailed labor leaders, James McNamara, who was serving a life sentence for his confessed role in the dynamiting of the *Los Angeles Times* newspaper plant in 1910, and Tom Mooney, who was falsely convicted of setting off a bomb at a 1917 Preparedness Day parade in San Francisco. The Mooney crusade cost Older his editorship of the *San Francisco Bulletin*, where he had worked since 1895,

21

Chester Rowell (left). Courtesy, The Bancroft Library, University of California, Berkeley.

22

Fremont Older. Courtesy,
The Bancroft Library,
University of California,
Berkeley.

whereupon William Randolph Hearst invited him to bring his cause to the
Call. After the *Bulletin* lost circulation under Older's successor, Hearst bought
it and merged the two papers. Although Hearst's *San Francisco Examiner* and
its Los Angeles counterpart, the *Herald-Express,* the centerpieces of his mul-
timillion-dollar media empire, were considered to be "archetypes of yellow
journalism,"[36] Older's experience with the publisher contradicted the general
impression of him as an undeviating reactionary. In the late 1920s, soon after
Steffens returned to California from Europe, Hearst offered him a job as a
columnist, which he declined.

Although his attitude toward Communism was in keeping with the edito-
rial policies of Hearst, it was characteristic of Older to make up his mind in-
dependently. In a commentary in 1932, he offered a philosophical view that
ignored contemporary events: if "Communism," which he asserted the Greeks
had practiced, "is one of the oldest forms of social control," then "it is our be-
havior toward each other that needs to be changed rather than our system of
government."[37] In April of the following year he cited a prediction Steffens

once made that "some day Christ would reappear upon the earth and no one might recognize Him." Older added, "No doubt Steffens sees [the spirit of Christ] in the communist government in Russia. As Christ was a communist, Steffens sees His spirit reflected in the five year plan. But there is too much tyranny in Russia to suit Christ."[38]

23

Charles Erskine Scott Wood, a friend of Older as well as of Steffens, later expressed a similar view, comparing the Moscow trials of dissidents to a "drumhead court martial." He reserved his "right to prefer American jurisprudence" but added, "I still believe the Russian political-economic experiment the greatest attempted by man and whoever reports me differently is mistaken."[39]

If Steffens encountered arguments from his contemporaries on his political philosophy, he had more success in promoting the specific cause of the CAWIU strikes, particularly among younger journalists. In his East Coast years he had been a mentor to the Harvard classmates Walter Lippmann, John Reed, and Heywood Broun. Back in California he cultivated a new generation of young colleagues. When Steffens first settled in Carmel, Allen Griffin, the editor of the *Monterey Peninsula Herald,* had sponsored his appearance before the local business community at a Rotary Club luncheon at the Del Monte Inn in Pebble Beach. Griffin became such a Steffens loyalist that in the summer of 1933 he challenged these same businessmen—who supported his paper with their advertising—by giving sympathetic coverage to the CAWIU strikes.[40]

Another protégé, Paul Smith, demonstrated Steffens's influence in his open-minded reporting on labor conflicts in 1934 and again in 1936, when Smith had succeeded Chester Rowell as editor of the *San Francisco Chronicle.* Smith had missed the agricultural strikes of 1933 because he went to Washington, D.C., to observe the changes under the New Deal, traveling across the country in a boxcar on a freight train. He was a young man who defied categorization. He had been a lumberjack before he became a banker and the financial page editor of the *Chronicle.* An admirer of Roosevelt, he was also a disciple of Herbert Hoover and frequently visited the ex-president at his campus home at Stanford en route to or from Steffens's house in Carmel.[41]

In 1933, Steffens was invited to lecture to students at Stanford, but a group he was to address at his own alma mater Berkeley had been banished from the campus. In a letter to the university's president, Robert Gordon Sproul, Steffens gently protested the situation. "The Social Problems Club at Berke-

ley," he wrote, "has begun to produce there a small but eager minority of students who are as interested as much [*sic*] in the intellectual life as the main student body is in, say, sports. I should like to encourage this nucleus of students to go on and think some things that the majority of us do not think. But I should like, as an old student, to feel that in doing this, I am working not against, but in sympathy with the policy of the University."[42]

During this period journalism students from Stanford and Berkeley were coming to Carmel to talk to Steffens. When they asked him how to cover news stories, he told them to leave their desks and go to where events were taking place. They should go to the strike areas, to the fields and the waterfront where the action was, to find out for themselves what was happening.[43] This seemed an unlikely scenario given the political orientation of most California newspapers, which solidly supported the employers' side of the story. In the Central Valley most of the smaller papers followed the lead of the *Bakersfield Californian* and the three dailies in the McClatchy chain in Sacramento, Fresno, and Modesto. The *Times* in Los Angeles had a long history of warfare with labor unions, originating with the policies of its founder, General Harrison Grey Otis. In San Francisco three of the four dailies reflected the conservative business orientation of their publishers, and the *News,* despite the involvement of George West, did not take an advocacy position on the agricultural strikes.

This was the situation as the CAWIU launched the October cotton pickers' strike in the San Joaquin Valley, a rural uprising of unprecedented size and scope. It lasted almost a month and involved a group of pickers variously estimated at 12,000 to 18,000 people in a geographical area that extended over six counties.[44] The conflict was intensely dramatic in its configuration and development, pitting growers and processors, who held the reins of economic power in their region, against a multiethnic group of workers led by organizers from a group that was considered to be highly controversial.

The significance of the cotton pickers' revolt was not immediately apparent, however. The first news bulletins on the strike were relegated to the inside pages of the metropolitan dailies. Filed by local correspondents on the scene, they followed an established pattern in describing a contest between growers and "agitators."[45] Far from sounding an alarm, these first reports minimized the importance of the harvest disruption. Under "News of the San Joaquin Valley," the *Los Angeles Times* on October 3 published an item on the "Cotton

Strike Situation for Today" with the headline "Bakersfield Area Quiet Despite Picketing."

It was not until October 9, when an outbreak of violence seemed imminent, that the uprising in the cotton fields reached the front pages. The *Los Angeles Times* headlined the story: "Strike War Flares Up; Cotton Growers Oust Agitators; California Roads Patrolled to Balk Picketing in Four Counties; Workers Driven Off Farms and Vigilantes Urged to Keep Them on the Run." In San Francisco, Hearst's *Examiner* described "the atmosphere of the valley" as "that of a smoldering volcano," while the rival *Chronicle* proclaimed: "Vigilantes Rout Strikers in Fight; Authorities Advise Farmers to Use Force Against Agitators." In the accompanying story a sheriff was quoted: "Don't shoot except in self-defense."

Beginning on the following day the format and tone of the stories that appeared in the Los Angeles and San Francisco papers changed. This appears to have been the consequence of an editorial decision to send staff reporters to the Valley because the strike had become too important a news topic to be relayed secondhand by local "stringers." The *New York Times* also sent a correspondent to the strike. The newcomers arriving on the scene encountered episodes of vigilantism inflicted on the strikers. A number of city reporters were present on October 10, the day on which three strikers were killed. Clifford Fox described the shooting at Pixley to readers of the *San Francisco Chronicle*: "A small army of ranchers fired pointblank into a crowd of striking cotton pickers." The correspondent for the *News* wrote: "I saw eleven unarmed persons shot down in cold blood. One was a woman. Two were killed."[46] The city reporters brought a perspective to the scene that was totally different from the local slanting that had colored the news up to that point. Their eyewitness accounts were so dramatic that the papers that sent them to the Valley—papers opposed to the strike—had no recourse but to print what they wrote verbatim. It was a question of news value outweighing editorial policy.

Incontrovertible evidence of what happened at Pixley was provided by photographs taken by one or more cameramen who were close enough to the action to be in the line of fire. Once again, it is remarkable that the pictures appeared in newspapers hostile to the strike. The *Sacramento Bee* reproduced two shots taken from a distance just before the massacre. The first showed Pat Chambers, the cawiu's chief organizer in the strike, addressing a crowd of

followers; the second showed a group of ranchers, armed with rifles, hiding behind their cars.[47] A photograph in the *Modesto Bee,* another paper in the McClatchy chain, told what happened next: it was a closeup of a wounded striker, half raised on his elbows, lying on the ground. The *Bakersfield Californian* also reproduced this picture of the striker "bleeding profusely from his wounds."[48]

26

The *San Francisco Examiner* gave a different view of the aftermath by presenting a formal shot of the strikers posed in front of their hall. They were gathered as if for a ceremonial occasion. No emotion showed in their faces or bodily posture to indicate that anything out of the ordinary had occurred. Yet this neutral study had the effect of generating sympathy for their cause, since by the time it appeared the public realized that the men were survivors of an armed attack. A picture in the issue of the following day made a similar impact. It was a closeup of union pickets carrying wooden staves to guard their camp; to viewers who knew that the cotton growers had guns, they looked defenseless. Even more surprising in light of the paper's editorial policy was the inclusion of a portrait of an attractive-looking union leader named Leroy Gordon addressing his followers, a portrait that belied the stereotype of an "agitator."[49]

Another photograph that appeared in the *Examiner* would have made an effective poster for the CAWIU, since it illustrated the method the strikers used to spread their message. They found a way to reach cotton pickers on far-flung ranches by going out, all crowded together, in a line of slow-moving vehicles. The picture showed a segment of one such picket caravan "patrolling the road south of Tulare." In the background a truckload of pickets had stopped to call the workers out of the fields. Two uniformed highway patrolmen with a motorcycle were off to one side monitoring the action. In the foreground a bearded man in bib overalls was blowing a bugle to get the attention of the cotton pickers. He was an impressive figure, large, solid, and dignified. He looked as if he might be a tenant farmer from the south central states. Next to him was a slender man with a mustache who appeared to be Mexican. He was eager and animated as he bent forward from the waist to shout his message. Captured by the camera side by side in a moment of unselfconscious action, the two seemed to embody the union's proclaimed goal of ethnic cooperation. This photograph, more than any other, had the effect of making the strikers and their actions appealingly human.[50]

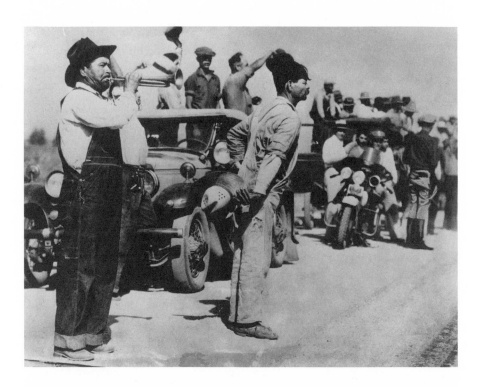

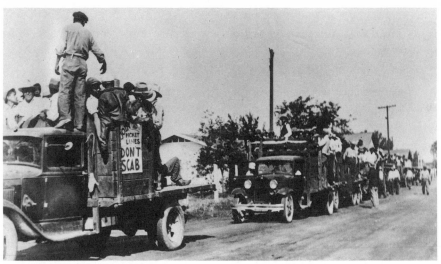

(*top*) Calling the cotton pickers out of the fields, 1933. (*bottom*) Picket caravan with truck sign, PICKET LINES DON'T SCAB. Both photos courtesy, The Bancroft Library, University of California, Berkeley.

A number of pictures that portrayed the CAWIU and the strike in a sympathetic light were the work of Otto Hagel and Hansel Mieth, early political refugees from the Nazi movement in Germany. As acknowledged supporters of the union who on occasion joined the workers picking crops in the fields, they had closeup access to scenes involving strikers and organizers. In addition to still photographs, they took motion-picture footage of strike rallies and incorporated it into a short film on the plight of the poor in America. The film attacked the New Deal, represented by the National Recovery Administration (NRA) eagle, a symbol that was displayed everywhere that summer. In a further political statement, Hagel and Mieth juxtaposed scenes from the 1933 Chicago World's Fair with shots of desperate people scavenging at a public dump. Unlike the Movietone News feature on the cotton pickers' strike that was shown in theaters across the country, the Hagel-Mieth film was a propaganda vehicle for the union not intended for general audiences.[51] Continuing as a freelancer, using a small 35-millimeter camera he brought from Germany, Otto Hagel later covered the 1934 longshoremen's strike in San Francisco and the 1936 Salinas lettuce packers' strike.[52] Mieth took pictures for the WPA in San Francisco. Still later they became contributors to the Luce magazines *Life* and *Fortune*.

In the San Joaquin Valley in mid-October of 1933, Hagel and Mieth were joined by staff photographers from a number of the larger newspapers. Some of them may have been predisposed in favor of the strikers; others were simply looking for good human-interest shots. The remarkable fact is that so many of their photographs appeared in newspapers that supported the growers' position in the strike. One in the *Los Angeles Times* showed a group carrying a sign that read: "General Strike. Stay away from the Cotton Fields and Join the C.A.W.I.U. Help win the strike."[53] In a similar vein the *San Francisco Chronicle* published pictures of a strikers' camp; of a volunteer teacher holding classes for strikers' children in their tent city; of Leroy Gordon, the personable organizer, conferring with a Pentecostal minister; of a strike "martyr's funeral" in Tulare.[54]

The funeral was described in the *San Francisco Call Bulletin* by a history-minded reporter, Marie Hicks Davidson. She set the scene by recalling previous outbreaks of violence in the southern San Joaquin Valley, including the Mussel Slough tragedy, which had inspired Frank Norris's novel *The Octopus*. She went on to evoke the atmosphere in Tulare in the aftermath of the shoot-

ings: "The pickets loitered on the outskirts of this little city of trees and gardens. In the cemetery, to the east of town, two of their own martyrs now to their cause were buried Saturday with one of the most dramatic funerals ever held in this country. Their women and children are huddled together at Corcoran, where a camp of 3000 has its being in truly primitive squalor."[55]

The *Chronicle* also published long human-interest features on the strikers by a reporter named Enid Hubbard.[56] The impact of the experience is evident in the statement of a newspaperman who was approached by a disgruntled cotton grower. Resentful about the stories that were appearing in the San Francisco Bay Area press, the grower suggested that "a reporter who would send out news as the growers wanted it sent could make a good deal of money." The offer was spurned with sarcasm: "Yes, why don't you go and find such a reporter?"[57] The news people on the scene were swept in the opposite direction by what they were seeing. The *Chronicle* continued to give front-page prominence to the dispatches filed by Clifford Fox. His story in the October 12 issue began: "The moon was red over the cotton fields tonight." It appeared under a banner headline: STRIKERS FACE STARVATION.

In what seems to have been a carryover from the news reporting, an editorial that appeared the following day in the *Chronicle* deplored a situation in which "county supervisors, District Attorney and sheriff, a chief of police and 'other officials' sat in on a plan to 'starve out' the cotton field strikers." When the governor, James Rolfe, decided to send food relief to the strikers, the *Los Angeles Times* denounced the move.[58] The *Chronicle* made a distinction, however, between the strikers and the organizers: an October 17 editorial stated that "neither the I.W.W. nor Communist agitators are the right leaders for this mass." Chester Rowell, writing in his own column, put quotation marks around the word *agitators*.[59]

3

ARBITRATION AND ANALYSIS

The publicity generated by the cotton pickers' strike increased the pressure on the state and federal governments to step in and settle it. The governor received pleas for intervention from the newly appointed Northern California National Emergency Relief Administration mediator, Rabbi Irving Reichart. After the killing of the strikers at Pixley, Reichart released a statement to the press: "It is high time for the state to issue an ultimatum. The choice lies between immediate arbitration or martial law."[1] Spokesmen for both sides of the controversy took action. Steffens flew to Sacramento for an interview with the governor and addressed a letter to the president.[2] A representative of California agriculture petitioned the Roosevelt administration: Colonel Walter Harrison, who had recently organized a successful resistance to a CAWIU-led grape pickers' strike near Lodi, sent a telegram to Washington warning that the state's multimillion-dollar cotton industry was in jeopardy.[3]

The New Deal's response was channeled through Reichart's superior

George Creel, the regional representative of the Federal Emergency Relief Administration, who acted as the spokesman for the National Labor Board. Creel, who had worked as a publicist during the wartime administration of Woodrow Wilson, has been described by the historian Kevin Starr as "a master manipulator of mass media and public awareness." According to Starr, Creel regarded the cotton pickers' strike as "a dangerous precedent." Occurring at a crucial time, when New Deal policies were being tested, it challenged the power of the federal government to hold labor and management in balance.[4]

Creel took action to bring about a settlement. After conferring with Governor Rolfe, he went by plane to the strike area for what a newspaper reporter called "an official survey" of the situation. His purpose, Creel said, "was to make immediate arrangements for the hearings that will determine the facts and restore peace to the area of disturbance."[5] He was accompanied by two members of the blue-ribbon fact-finding committee appointed by the governor: E. J. Hanna, the Catholic archbishop of San Francisco, and Dr. Ira B. Cross, a professor of economics at UC Berkeley. The third committee member, Dr. Tully Knoles, the president of the College of the Pacific in Stockton, arrived separately. The fact that Creel and Rolfe were able to recruit individuals of this stature on such short notice is an indication of the public interest aroused by the strike.

The mediators faced a formidable challenge at the hearings that opened on the afternoon of October 19 and continued the following day. In the packed civic auditorium in Visalia, amid onlookers and the press, the opposing sides sat "grimly."[6] Tensions had been exacerbated by a recent grand jury indictment of eight Valley ranchers for the first-degree murder of two strikers at Pixley. The indictment coincided with a criminal syndicalism charge brought against the CAWIU's Pat Chambers.[7] On the second day of the hearings, when union witnesses were about to testify, Caroline Decker and the CAWIU attorney, A. L. Wirin, issued an ultimatum that the strikers' committee would not participate further unless Chambers was present.[8] When the small, wiry leader walked into the room accompanied by a deputy sheriff, "it was the signal for wild applause from the strikers."[9] This was followed by a protest from H. C. Merritt Jr., the owner of the Tagus Ranch near Tulare, where Chambers had led the successful strike among the peach pickers in August. Merritt stated that he "did

not want to dignify any criminal or communist organization by submitting to questioning."[10] He was brought into line by the moderator, Cross, who also promptly silenced Chambers when he threatened to reopen the feud.

The outburst of dissension aroused the professional interest of the UC Berkeley social scientists Paul Taylor and Clark Kerr, who were attending the hearings in a semiofficial capacity. Taylor, a ruddy-faced, handsome thirty-eight-year-old assistant professor, had been asked by the university provost to help Cross, Taylor's senior colleague in the Economics Department. On the basis of an ambitious, multivolume history of Mexican immigration to the United States on which he had been working for half a dozen years, Taylor was regarded as an authority on farm labor, although his humanistic approach had drawn criticism from faculty members in the School of Agriculture.[11] He in turn had recruited Kerr, a small, dark-haired twenty-two-year-old Swarthmore graduate who, after earning a master's degree at Stanford, had come to Berkeley to work for his doctorate under Taylor. At the hearings he acted as a guide to some of the outside observers. One was Ella Winter, who also testified on behalf of the strikers. Another was Norman Thomas, the Socialist Party leader, who the following year would sponsor the sharecroppers' revolt led by the Southern Tenant Farmers Union in Arkansas in competition with the Communist Party's Alabama Sharecroppers Union.

Thomas came to Visalia on the heels of a debate with Lincoln Steffens in San Francisco. Clark Kerr, during his undergraduate years in the East, had also debated with Thomas, arguing for the reform of capitalism against Thomas's advocacy of socialism.[12] At Visalia, Kerr was exposed to an aspect of California political life that would become familiar to him a quarter of a century later when he became president of the state university system. Resentment against Berkeley liberals was evident at the hearings. The attorney for the California Farm Bureau Federation, Edson Abel, stated in his opening remarks that the growers did not believe "that their case will be considered with impartiality by the personnel on the committee."[13] The committee chairman, Cross, a labor specialist, was a replacement for a professor of farm management who was unable to serve. Cross's response to the criticism was to act in an evenhanded, judicious, occasionally conciliatory manner. Although the strikers eventually had an opportunity to give their side of the story, the hearings opened with the testimony of the growers and their representatives, and at the conclusion,

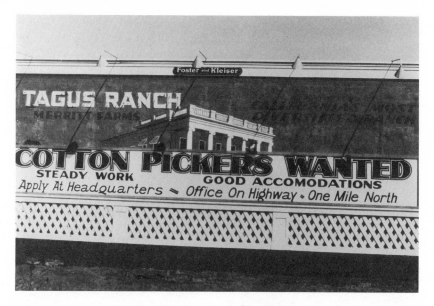

Billboard, 1927, advertising the Tagus Ranch, where the CAWIU led a successful peach pickers' strike in August 1933. Photograph by Paul Taylor, from the collection of Richard Steven Street.

Cross honored their request to deal with cotton pickers, rather than union organizers, in working out a compromise wage settlement.

The final negotiations were to be handled by George Creel, representing the governor and the National Labor Board, but Cross asked Paul Taylor to help prepare the ground. It was a fortunate assignment. Taylor, who shared the growers' preference for negotiating with the strikers, rather than the organizers, chose a man who would have special relevance in that regard: W. D. "Bill" Hamett, the rank-and-file leader of the strike, who had testified at the hearings and had impressed Taylor as "a man of experience and understanding."[14]

Hamett had an interesting history. He had been recruited by Pat Chambers for the peach pickers' strike at the Tagus Ranch and had shown leadership qualities in that action. During the cotton pickers' strike he demonstrated his eloquence. Although he was arrested and spent time in jail, he managed to make more than one hundred speeches. A newspaper reporter quoted his ultimatum, "We'll fight to the last ditch until we starve." The reporter described him as a "gaunt-framed . . . former Oklahoma justice of the peace and Ozark evangelist."[15]

In fact, Hamett was born in Texas, grew up in Oklahoma, and was a lay preacher for most of his life while he earned a living at a variety of jobs, most of them in agriculture. Forty-seven years old in the summer of 1933, he was the designated head of a large clan that spanned three generations, including his father, who had left Georgia after the Civil War, made an archetypal journey west in stages, and arrived in Tulare County in 1913.[16] Through Hamett, Paul Taylor was introduced to a group for which he became a spokesman a few years later. Taylor had families like the Hametts in mind when he wrote that the dust bowl migrants, who arrived in the second half of the decade, came to California following "channels cut historically."[17]

It should be noted that Hamett was a member of a very small minority among the strikers. The vast majority were Mexicans who by heritage and

W. D. (Bill) Hamett.
Courtesy of Roy Hamett,
Madera, California.

working experience were closer than the Anglos to the philosophy of the CAWIU. Union organizers addressed them on the basis of shared radical goals—as when proclaiming, in their own version of Spanish, during a 1932 strike, "Estamos los rojos! Venemos para assistar ustedes."[18] The Mexican leaders, formed by the traditions of their 1911 Revolution, had developed ties to the labor movement on both sides of the border.[19] A considerable number of them had worked in unionized industries outside agriculture. They regarded themselves as belonging to the working class, whereas some of the Anglo strikers like Hamett considered themselves to be small farmers victimized by the depression as well as by the big operators who controlled the cotton industry in California.

35

Hamett had worked in agriculture in California for nine years, at times for wages—baling alfalfa, irrigating crops—at other times, unsuccessfully, as an independent entrepreneur. He had tried and failed in a dairy business. He had tried and again failed in an attempt to adapt Oklahoma farming methods to the West Coast by growing cotton on one-fourth shares. His problems bore out the argument of the union that small operators in the San Joaquin Valley were at the mercy of the finance and ginning companies that set the prices across the board. As a small farmer trying to make a start in an agricultural system geared to large-scale production, he was a textbook example for Paul Taylor, who was a critic of California land-tenure patterns. Taylor revered the nineteenth-century agrarian model of the agricultural ladder by which the hired man was enabled to work toward the status of independent landowner. Largely because of circumstances beyond his control, Hamett was forced to reverse this process and to return to farm labor full-time.

A shrewd individual accustomed to command, Hamett tried to control the terms of his employment by organizing his clan into a mobile harvest crew and contracting for their services. He was confronted with harsh economic constraints, however. Although growers made the point that California farm wages were the highest in the country, Hamett and others complained at the start of the 1933 season that they were not being paid enough to live on—that wages were set at the 1932 level, while commodity prices were rising under the impetus of New Deal programs. As noted earlier, this discrepancy was the chief motivating factor for the strikes led by the CAWIU. Theoretically, the union was organizing workers to revolt against the capitalist system; in fact, its real achievement was to raise farm wages in the state to a more equitable level,

from an average of 15 cents an hour to about 25 cents an hour.[20] Hamett once asked: "What do we care whether we are Reds or what we are if we can get our wages raised?"[21] It was a rhetorical question. He had a younger cousin working in the CAWIU's Tulare office, a man named Cecil McKiddy, who joined the Communist Party, but since Hamett's goals were pragmatic, rather than ideological, he only joined the union.

Sam Darcy, the district leader of the Communist Party, complained about the racial prejudice of the Anglo strikers, which jeopardized the union's goal of worker solidarity.[22] (Apparently this was not a one-sided issue. According to Cletus Daniel, there was a longtime antipathy between the Mexicans and Filipino workers, a few of whom took part in the strike, and all of the groups had a bias against the black cotton pickers, who were also a small group in the strike.)[23] Darcy also complained about the pugnaciousness of the Hamett clan, which went against the union's policy of nonviolence. Pat Chambers disassociated himself from these questions by praising the solidarity within both the Mexican and Anglo groups, a trait he attributed to their close family ties.[24] Caroline Decker spoke of the advantage enjoyed by Americans, who could not be deported. She thought that citizenship gave "the Okies and Arkies . . . the courage to step forward and ask for things."[25]

Hamett was a man who adapted to circumstances. At the mediation hearings, while the other strikers confined themselves to answering questions put to them by Decker, he took the role of a prosecuting attorney, cross-examining the spokesmen for the cotton industry with a steely assurance born of his own hard-earned experience. Then, taking advantage of the presence of representatives of the federal government, he directed his appeal to Washington. "In the words of the president of the United States," he declared, "any industry which cannot pay a living wage should shut its doors."[26] He made a reference to the labor clause of the National Industrial Recovery Act. This law proved to be a continuing concern for him; at a later date he protested the administrative decree that excluded farm workers from its benefits.[27]

Hamett's stand, which seemed to override the Communist Party's repudiation of the New Deal, impressed Paul Taylor, who asked him what wage settlement the strikers would accept. Hamett proposed 80 cents for a hundred pounds of cotton, an exact compromise between the strike demand and the wage set by the Agricultural Labor Bureau of the San Joaquin Valley. George Creel advised the negotiators that 75 cents was all the growers could pay with-

out loss to themselves.[28] Hamett was called to Fresno to meet with the state deputy labor commissioner. After some resistance from both sides, the 75-cent settlement was imposed by threats from the federal government to cut off food deliveries to the strikers and to terminate bank loans to the growers.[29] Taylor and Kerr took note of the fact that Hamett was punished for his leadership in the strike or for his part in the negotiations: although the settlement specified that the strikers should be hired without prejudice, an associate reported that Hamett was blacklisted in Pixley and Tulare and had to travel as far away as Buttonwillow, west of Bakersfield, to find a cotton-picking job that fall.[30]

Contemporary Analysis

The reference to Hamett's reemployment problems appears in the documentary history of the strike that Taylor and Kerr put together over the next few months at the request of the university provost.[31] The two found a precedent for their assignment: a Berkeley professor of an earlier generation, Carleton Parker, had conducted a study of farm labor conditions in California after the 1913 IWW-led strike among hop pickers at Wheatland.[32] The Commission on Immigration and Housing, created by the Progressive Republican governor, Hiram Johnson, had sponsored Parker's work, but the impetus for reform had died after World War I when the IWW organizers became the first targets of the newly enacted criminal-syndicalism laws.

In an appreciation written in 1983, Kerr classified Taylor as belonging to a group that included Parker, Thorstein Veblen, Stanley Mathewson, Elton Mayo, and E. Wight Bakke. He called them "an unusual breed of what might be called economic anthropologists" who "made contact with reality, not through somebody else's statistics or through documents, but by talking to people and by thinking about what they heard." Taylor, he thought, never fit into the category of "mainstream economics."[33] From the beginning of his education, Taylor's interests were broad. At the University of Wisconsin he studied under the economists John R. Commons and Richard Ely. He also took a summer course in law, his father's profession, which proved to be a useful preparation for his later writing on reclamation issues in the courts. After a German gas attack during his war service in France in 1918 left him with damaged lungs, he went to the University of California for the mild climate, rather than to Columbia, where he had been offered a graduate schol-

arship. In the Economics Department at Berkeley, he settled down to write a doctoral dissertation on the Sailors Union of the Pacific but, as a diversion into another field, took courses with the historians Herbert Bolton and Herbert Priestly. His first published article, on Spanish seamen in the New World, appeared in a historical journal.[34]

Taylor's Mexican immigration study, which he began four years after joining the Berkeley faculty, was sponsored by the Chicago-based Social Science Research Council, specifically by Grace Abbott's commission on the scientific aspects of human migration. The work took him down some interesting cultural bypaths. He submitted an article on a potter from Jalisco, illustrated with his own photographs, to an anthropological journal and contributed a group of *corridas,* or ballads, he had collected to an anthology edited by J. Frank Dobie of the University of Texas.[35]

In his longer studies Taylor took an approach similar to that of the Mexican anthropologist Manuel Gamio, who was studying the shift of population across the border from the perspective of the immigrants.[36] Aside from government researchers investigating the migration in terms of its impact on a particular state, such as California,[37] Taylor and Gamio had the field to themselves. When their paths crossed, Gamio was helpful in providing Taylor with sources of information inside Mexico, although Taylor's focus was on recently settled *barrios* in Colorado, Texas, Illinois, Michigan, Pennsylvania, and California.

The California study brought Taylor into the Imperial Valley, which for him was not the romantic place celebrated by the novelist Harold Bell Wright. "What I saw hit me in the face," he wrote fifty years later. "I found myself in the midst of an agricultural society with a labor pattern the opposite of all that as a youth I had known in the Middlewest." He found an economy divided along ethnic lines:

> Production was highly organized by American managers employing Mexican workers off and on to meet seasonal needs. Mexicans constituted more than one-third of the valley population. They were separated from the American population in domicile, in the schools, and in employment status. For them there was no "agricultural ladder." In 1926, a quarter of a century after Colorado River flowed into the valley, only

six Mexicans had become owners of farm land, with a total assessed value of $5,910 and improvements valued at $600. Mexicans and Americans, I concluded, "live socially in two worlds."[38]

The standard liberal reaction to the Imperial Valley was shock; it was characteristic of Taylor that he thought back on earlier influences in his life. He had spent time as a boy on his grandfather's 200-acre farm in the dairy country outside Madison, Wisconsin. Growing up in Sioux City, Iowa, a railroad division point, he watched harvesters waiting in the boxcars for a free ride out to their various job destinations in the "wheat belt." He found out later how hard they worked. After his senior year in high school, he shocked grain on a 2,000-acre spread in the Missouri River bottoms for room and board and $1.50 a day. Not a princely sum, but neither he nor the other hired hands were locked into the situation for all time. He had grown up believing that men labored on the land in the expectation, if not the immediate enjoyment, of equality. Clark Kerr had a similar upbringing and orientation. Born in Stony Creek, Pennsylvania, Kerr was raised on a 140-acre farm "that was at least eighty percent self-sufficient in a small valley that was a true community. When the bell in the church steeple tolled, it really tolled for all of us."[39]

Taylor took for his guideposts the 1862 Homestead Act and the 1902 reclamation law, both passed by Congress to widen land distribution. If he had a blind spot in his uniform endorsement of these laws, it was that he did not give enough attention to climate and physical geography as factors in land use—the difference, for example, between the fertile Mississippi Valley and the arid country west of the Rockies. Some of his writings indicate that he was aware of these differences, as well as of changes brought about by the increasing mechanization of agriculture. Yet he kept an emotional allegiance to principles articulated by Jefferson and Lincoln and Theodore Roosevelt and associated with a past era.

As his monographs on Mexican immigration began to appear, Taylor became aware of adverse reaction at Berkeley. "I found I had a hot subject," he said later. He may have exaggerated the opposition of colleagues in the School of Agriculture who viewed farm labor as a cost factor in production. It says something about his reputation that he was invited to teach a course in rural sociology at the Giannini Foundation on the campus. Yet his application for

publication funds for the final volume of his Mexican migration study was turned down. He had to find a private benefactor and another university press to complete the series. His departmental chairman, no doubt vexed by his frequent absences from the classroom over a five-year period, denied his request for further time off. Only by appealing to Robert Gordon Sproul, the president of the university, did he win the additional leave.[40]

Taylor strayed from the mainstream topics assigned by his chairman, such as workmen's compensation, to a study of the self-help cooperatives that sprang up in the pre–New Deal period of the depression. He had a longtime interest in agricultural experiments, dating from visits to a Hutterite colony and the Amana Society in the Midwest. He encouraged Clark Kerr to write an exhaustive thesis on "Productive Enterprises for the Unemployed" and collaborated with him on articles on the subject. They defined self-help as "a bridge between unmarketable food and unmarketable labor." They noted that conservatives called the cooperatives "radical" and Communists called them "opiates of the people" and "self-starvation societies."[41] Kerr found a common denominator between those for whom self-help was "a gesture of independence and pride" and the cotton strikers who demanded higher wages. He thought both groups showed gumption "in a period in which it was not uncommon to see people just lie down and quit."[42]

Taylor and Kerr set the tone for their anatomy of the cotton pickers' strike in their opening sentence: "As the faulting of the earth exposes its strata and reveals its structure, so a social disturbance throws into bold relief the structure of society, the attitudes, reactions, and interests of its groups." Like geologists tracing the origin of an earthquake, they examined the strike by walking around and around it, figuratively speaking, viewing it from all angles. When the CAWIU leader Caroline Decker was asked many years later about her overall impression of the strike, she replied that it was impossible to have been everywhere that events were happening.[43] But that is what Taylor and Kerr attempted to do. Kerr, who carried out most of the field research, stayed in the Valley a month after the strike was over, driving from place to place in a Model-A Ford. Taylor came down from Berkeley on weekends to monitor his progress. He urged Kerr to cast a wide net for information. "The opportunity was rich," Taylor said later, "because special interest[s] had not yet sought to control publicity."[44] Although people spoke freely, it was, to continue the

earthquake analogy, a period of aftershocks. Allegiances and hatreds formed in the heat of battle had deepened.[45]

Kerr interviewed people on all sides of the controversy: growers, organizers, strikers, law enforcement officials, local citizens. Although they are not identified in the published monograph, their names are in the files Taylor deposited in the Bancroft Library. Taylor told Kerr to "take down what people said in their own words." In an era before tape recorders, he relied on paper and pencil.[46] He also collected a large number of press reports from newspapers—small-town and metropolitan, nonpartisan and special-interest.

With Taylor's supervision, Kerr set down this mass of information, some of it in its original form, the rest abridged. The chief editorial change they made was to present it thematically, to give it some order and continuity. To avoid imposing their own interpretation on events, they offered conflicting versions of what happened, leaving it to readers to sift the evidence and draw their own conclusions. The kaleidoscopic report is as many-faceted, if not as confusing, as the original conflict. They related incidents of vigilantism by growers and provocative actions by strikers.[47] They showed George Creel reassuring the residents of a strikers' camp that they were acting within their legal rights (although he denied National Labor Board recognition to the CAWIU)[48] and telling the cotton growers that he would help them to import replacement pickers.[49] They described a power struggle between the CAWIU leaders and the Mexican consul for the loyalty of the immigrant workers.[50] Several years before the dust bowl migration became a cause célèbre, they quoted what seems to be a reference to "Okie" scabs.[51] From the medley of many small details, significant facts jump out of the text. The sentiment of the local communities is revealed by the statement that of the 113 individuals arrested during the strike, only 8 were growers.[52]

Taylor once stated his working philosophy: "As scientists we cannot afford to leave documentation of the social scene to the literary polemics of Jack London and Upton Sinclair, on the one hand, and the interested recording of the Better American Federation, the Los Angeles Times, or Chambers of Commerce on the other."[53] If he and Kerr demonstrate a bias, it is in favor of the arbitration efforts of Creel and the National Labor Board. While the Communists asserted that the government was on the side of the growers and the growers complained that the officials favored the workers, Taylor and Kerr endorsed

the efforts of Washington and Sacramento to settle the conflict, a stand that reflects their own connection with the events.

Another history of the CAWIU and the cotton pickers' strike was initiated by a man who had a pro-labor, rather than a New Deal, orientation. Porter M. Chaffee was an ex-Communist who had firsthand knowledge of the organizational details of the union. He put together the material as part of a projected study of migratory labor in California undertaken with fellow staff members in the Oakland office of the Federal Writers Project.[54]

Chaffee's involvement with the union was a passing episode in a long, varied life far removed from academia. His radicalism was rooted in a romantic western American tradition. He was born in San Francisco in 1900 and went to the Oakland grammar school that his early hero Jack London had attended. After dropping out of high school and taking work as a mail clerk in a building that overlooked the San Francisco harbor, he was inspired to sign up as a seaman on merchant ships bound for England, Belgium, China, and Japan. Like many labor activists, he claimed that he got his higher education from reading the "Little Blue Books"—reprints of well-known works from Plato and Shakespeare to Marx and Engels and continuing on to Will Durant—published by E. Haldeman Julius of Girard, Kansas, editor of the socialist-oriented *Appeal to Reason.*

Chaffee read widely during a long recuperation from an infection in his shoulder, the result of a seemingly minor accident that occurred when he was hauling grapes in the Napa Valley. While he was in a hospital in Santa Cruz, he met another teamster who introduced him to labor organizing. When he was well enough to travel, Chaffee crossed the country several times, stopping along the way to gather impressions and talk to people. Riding freights and hitchhiking, he headed home to California from the East Coast in the spring of 1927, collecting material for a memoir he completed but never published, in which he described his encounters with hobos, policemen, salesmen, bootleggers, and butchers.[55] His effort was a little premature; a few years later during the depression, sagas of the road became an American literary genre.

At the end of his travels Chaffee joined the Communist Party. He worked for a while on the *Daily Worker* in New York City and submitted poems to the *New Masses.* On returning to California in 1932, he became an organizer for the fledgling CAWIU in the Watsonville-Salinas area. When he was transferred

to the San Jose headquarters at 81 Post Street, he met, among other leaders of the union, Pat Chambers and Caroline Decker. Chaffee appeared on the platform with Decker at various union rallies. Almost a quarter of a century later, he remembered vividly her combination of fiery eloquence and feminine allure. She was just over twenty years old, petite, well-dressed, "a dazzling blonde." When she stood up to speak, "she'd electrify them."[56] Chaffee did not talk about the contrast between Decker and Chambers, who was ten years older, not so well educated—he had been a construction "boomer"—and neither particularly eloquent nor glamorous. Chambers appears in photographs as indistinguishable from the rank-and-file strikers. Yet he impressed Chaffee as "the most outstanding leader the CAWIU ever produced."[57]

In Chaffee's history of the CAWIU, he avoided personal commentary. The monograph is factual, rather than impressionistic or propagandistic, although it contains information he acquired as a Party member—for example, on the stages by which the CAWIU and its umbrella agency, the Trade Union Unity League, were created and dissolved. It was at about the time of the dissolution that Chaffee, who had experienced some of the sacrifice involved in membership, petitioned to sever his formal connection with the Party in order to devote himself to supporting his wife and to starting a family. "People don't know the terrific energy it takes to keep yourself alive in a movement," he said later.[58]

Chaffee produced his straightforward history of the CAWIU three years after quitting the Party. It contains material available only to an insider. Yet on balance it is much less satisfactory than the Taylor-Kerr documentary history, which is broad-based and wide-ranging. Taylor and Kerr were free to explore the controversy in its full complexity. One suspects that Chaffee was walking a fine line, tackling the subject in the first place because of his former allegiance and connection, but constrained to produce a document that would pass the standards of a government agency. His work was never authorized, nor was it ever published. Chaffee got the impression that when the Federal Writers Project ended, his manuscript was discarded—as he put it, "deep-sixed." In the late 1970s he learned from young academics that it was preserved in the Bancroft Library.[59]

Taylor and Kerr could find "no academic channels available" to publish *their* monograph.[60] The manuscript sat in Taylor's files until the end of the 1930s. After he testified late in 1939 at the West Coast hearings of the U.S. Senate's La Follette Committee investigating vigilantism in California farm-

labor disputes, he inserted the manuscript, illustrated by press photographs (and some he had taken himself)[61] and buttressed by supporting documents, into the appendix of the committee's report, which appeared in 1942. In this format it became a standard reference work for students and researchers until it was reprinted in 1983 in an anthology of Taylor's writings from the depression decade.[62]

One of Taylor's students, Stuart Jamieson, covered the cotton pickers' strike in a chapter on the CAWIU in his 1945 dissertation, *Labor Unionism in American Agriculture,* which Taylor arranged to have published by the Bureau of Labor Statistics of the U.S. Department of Labor. The analytical tone and the scholarly presentation of the material in this ambitious and useful work is similar to that of the Taylor-Kerr monograph. Factual immediacy was a general characteristic of all the journalistic and documentary reports on the cotton pickers' strike. The emphasis of the professional observers trying to bring the confusion of events into focus was on accuracy and verisimilitude.

A change occurred at the next level, when the facts were translated into imaginative art.

4

"A WILDLY STIRRING STORY":
STEINBECK'S INTERPRETATION

From their home in Carmel-by-the-Sea, Lincoln Steffens and Ella Winter played the role of intermediaries in the most remarkable fictional interpretation of the CAWIU strikes. As noted earlier, they had lived in the artists' colony since the summer of 1927, when they arrived from Europe with their two-and-a-half-year-old son, Pete. One of their contemporaries described Carmel in that era as "a lively little village of exclusive Bohemians."[1] It was certainly livelier after the Steffenses moved there. While their Welsh housekeeper managed their domestic establishment, they became involved in the social and cultural scene.

Steffens wrote a column for, and Winter helped to edit, the *Carmelite*, a weekly paper that showcased the work of local photographers and poets. They devoted an issue to Robinson Jeffers, who with his beautiful wife, Una, became their intimate friends after they were introduced by Charles Erskine Scott Wood and Sara Bard Field.[2] The two couples handled their political differences amicably.[3] Carmelites were accustomed to the Steffenses' views, since not long

after their arrival they had held a debate at a community forum on Lenin's doctrine of economic democracy.[4] When public opinion turned leftward in the early 1930s, a few friends joined Winter in the John Reed Club to study various aspects of Communism.[5] By the fall of 1932 the club had twenty members, including the Paris-based sculptor Jo Davidson, the Welsh-born Russian authority Albert Rhys Williams, the local literary figure Orrick Johns, and another village celebrity, the playwright Martin Flavin.

A similar mixture of local residents and out-of-town visitors attended gatherings in the studio living room of The Getaway, the Steffenses' picturesque house on San Antonio Street a few blocks from the beach. After the settlement of the cotton pickers' strike, a number of the CAWIU organizers were invited there to celebrate and to meet people from the neighborhood. Although Caroline Decker and Jack Warnick stayed in a cottage Ella Winter had acquired in another part of town, Decker was the focus of interest among the guests at The Getaway. Jo Davidson and the British writer John Strachev vied with each other to praise her. Jimmy Cagney, up from Hollywood, offered to teach her to tap dance.[6]

Decker was invited to address the John Reed Club, which met on Sunday evenings in a converted barn in the downtown area of the village. Earlier speakers had been Joseph Freeman of the *New Masses* and Loren Miller, who had produced a film on the Soviet Union. Langston Hughes, returned from a year in the USSR and living as a guest of Noel Sullivan in a cottage a few blocks from the Steffenses' house, reminisced about his Russian travels.[7] Hughes spoke to the club on October 22, not long after he and Sullivan joined Ella Winter's emergency expedition to the San Joaquin Valley. With that experience fresh in his mind, he agreed to collaborate with Winter and a Carmel writer named Ann Hawkins on a pageant about a cotton pickers' strike led by a twentieth-century Joan of Arc figure. This tribute to Caroline Decker was not successful, however. The result of their combined exertions was a long, artificial propaganda vehicle too complicated and too cumbersome to be performed.[8]

Winter and Steffens persisted in their efforts, bringing the subject of the strikes to the attention of the young novelist John Steinbeck, who at this period was coming over to see them fairly often from his cottage in nearby Pacific Grove. Steinbeck was still relatively unknown. He had published three works of fiction without commercial success, although they had attracted some

favorable critical attention. When he was introduced to the subject of the farm strikes, he was at a critical juncture in his career. He had just started to find out what he could do as a writer. He had begun to leave his own distinctive imprint on material that grew out of his background. But he had not yet addressed the social, economic, and political issues of the Great Depression.

At the Steffenses' large gatherings—described by an onlooker as "a constellation of luminaries"[9]—Steinbeck appeared to be ill at ease. Another young habitué of the household, Martin Flavin Jr., the son of the playwright, thought that Steinbeck was "naively a bit afraid of being identified with intellectuals."[10] The problem may simply have been shyness with strangers. Steinbeck seemed comfortable with Steffens, however. He sat in on one or more of Steffens's meetings with journalism students and took note of his advice to them to go out in search of firsthand information about current controversies.[11] He also conversed fairly often with Steffens alone in the study-bedroom where the journalist spent most of his time after suffering a noncrippling but serious stroke in the middle of a strenuous lecture tour in December 1933. Restricted in his activities and largely housebound, Steffens was available for conversation with whoever came to see him. He enjoyed these personal encounters. He had a reporter's gift for disarming people and eliciting information from them, and for all his experience of the world, he kept the unpretentiousness of his youth, when his friends had been draymen, jockeys, and trans-Sierra pioneers in the frontier settlements on the outskirts of Sacramento. He was as thoroughgoing a Californian as Steinbeck.

The circumstances of Steinbeck's early life gave him an initial perspective on California agriculture that was different from that of commentators like Paul Taylor and Carey McWilliams, who came from outside the state. Salinas, where Steinbeck was born on February 27, 1902, was the seat of Monterey County and the market town for the surrounding agricultural valley. At the turn of the century it had a population of slightly under 3,000. Steinbeck grew up in a community and a family in which energy and innovation were not stifled by tradition, although his parents, the descendants of early settlers in the region, were regarded as solid, substantial citizens. His father, John Ernst Steinbeck, for a time ran a flour mill and a feed store until he suffered financial reverses. A conscientious, considerate man, but not a go-getter, he was happier in his later job as county treasurer.

The author's mother, born Olive Hamilton, was of Irish extraction. Al-

though her family were not people of wealth, they owned real estate in the town, as well as an arid 1,600-acre ranch near King City, fifty miles to the south.[12] Before her marriage she had been a schoolteacher in the sparsely populated Big Sur country later made famous by Robinson Jeffers, a place that had stimulated her imagination.[13] In her middle years her four children knew her as a storyteller and interpreter of myths and legends, an organizer of picnics and outings, an art lover who brought books and music into their comfortable two-story house on Central Avenue. Salinas knew her as a practical homemaker and energetic volunteer in local affairs.

Olive Steinbeck's involvement in the community, and her husband's preoccupation with business, conferred freedom on their children. John Steinbeck, like Lincoln Steffens, had three sisters and rode a pony to the outskirts of town in search of adventure. His younger sister Mary, a tomboy, often accompanied him on expeditions outside the familiar, respectable neighborhood and into a richly varying countryside.[14] On their way to a swimming hole in the Salinas River they passed orchards and field crops: sugar beets, beans, and alfalfa. (Lettuce and broccoli, so important in the Salinas Valley economy today, had not yet been introduced.)

John experienced a harsher kind of rural life on visits to the dry ranch near King City that belonged to his mother's relatives. Not far away was a trackless wilderness, part of the Los Padres National Forest, where mountain lions and wild boar roamed. On summer days at the ranch, the sun seared the earth like a branding iron and dust filled the corrals. In the same season he might stand shivering in the cold tidal pools of Monterey Bay when the family vacationed at their cottage in Pacific Grove. In these and other places, the young Steinbeck encountered growers, merchants, beet pickers, fruit tramps, ranch hands, sardine fishermen, and the rodeo riders who came to Salinas every July. He learned about insiders and outsiders in the commercial life of the town: the cheerful public bustle in the downtown shops contrasted with the secrecy that surrounded Jenny's Place on the outer fringes.

It took him time to develop his own ideas about the many-layered, multiethnic society that surrounded him. In his early years he occasionally acted out local prejudices. In response to the "yellow peril" propaganda in the California press, he and some other boys started a club to spy on nearby Japanese farmers. He later remembered their action as a lighthearted caper that had an ironic conclusion: the club came to an end when a son of one of the Japa-

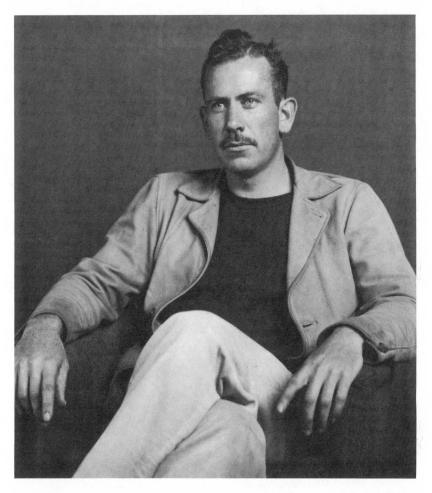

John Steinbeck, ca. 1935. Photo by Sonya Noskowiak, copyright © Arthur Noskowiak. Collection of the Center for Creative Photography, University of Arizona, Tucson. Reproduced with permission.

nese farmers, who was the boys' chum, asked to join.[15] Steinbeck carried into his adult years a more troubling memory of an incident in which he and Mary taunted a German neighbor who was ostracized in the community during the 1914–1918 war. Their behavior was disturbing to him in retrospect because it was spontaneous and unpremeditated. He kept his original impression of this episode even when as a famous writer he softened and lightened events in his past for the readers of a popular magazine.[16]

Steinbeck's bland tone in his mature years surprised people who remem-

bered his youthful rebelliousness. In adolescence he began to distance himself from the opinion makers of the community and from his high school contemporaries who belonged to the set approved by those opinion makers. This was the beginning of an alienation from his hometown that eventually extended to other middle-class settings and institutions. As a teenager he felt awkward and unacceptable when judged by the prevalent standards; at the same time, he rejected them as an obstacle to his freedom of expression. He had made up his mind that he was going to be a writer, and he spent a lot of time in his room working on stories that he read aloud to chosen friends. He sent a few to magazines, under a made-up name and without enclosing a return address, so that he was protected from the judgments of editors.[17] His combination of diffidence and arrogance annoyed some of the neighbors who admired his parents. He continued his maverick ways at Stanford, which he entered when he was seventeen, by taking mainly courses that interested him—in creative writing, literature, and biology—and ignoring the rest of the curriculum.[18]

During these years Steinbeck had some work experiences that provided him with material for his fiction. While he was in high school, through his father's influence, he got summer jobs near Salinas on ranches owned by the Spreckels Company. Although he was not athletic, he was tall and husky and could keep up with the other workers. He learned some colloquial Spanish from the Mexicans and a little Tagalog from the Filipinos. He returned to a Spreckels ranch on his own when he dropped out of college for a time at the beginning of his sophomore year after running into trouble with course requirements and grades. Carlton Sheffield, who began a lifelong friendship with Steinbeck at Stanford, recalled the circumstances: "He found work as a ranch hand and laborer near the tiny settlement of Chualar, a few miles below Salinas, which he avoided. Living in a bunkhouse, he did all types of heavy ranch work, rising eventually to the job of straw boss. . . . And he continued sporadic attempts at writing when time and weariness permitted."[19]

Sheffield does not say whether Steinbeck kept his notebooks out of sight, as he did in the mid-1930s when he was traveling with the migrants and taking pains to be inconspicuous. At Chualar he joined his bunkmates in discussions after work. A comment he made in a letter reveals that he kept a sense of separateness from them. "I have been working on a ranch down the country," he wrote, "and, incidentally, arguing Socialism with the laborers. Do you know, Bob, nothing can kill Socialism in the minds of thinking people quicker

than the arguments of the grubbers. It is so plainly a matter of getting something for nothing with a little revenge thrown in that the idea is sickening."[20]

The fictional use that Steinbeck made of the Chualar interlude on his return to the university suggests that he had undergone culture shock and felt a need to show off his experience of life in the raw. The *Stanford Spectator* published a tale he wrote about miscegenation, a highly controversial subject in the 1920s: a runaway albino girl falls under the spell of a Filipino farm-crew leader, who appears to her to be "black."[21] Although the story is vigorously written, it is not convincing. The protagonists are too bizarre to be credible. Only the background characters, a group of farm workers in a bunkhouse, come alive, in an authentic scene that foreshadowed what the writer would achieve with similar material fifteen years later in *Of Mice and Men*.

The next story Steinbeck published in the *Stanford Spectator* had the descriptive subtitle "A Fantasy."[22] He continued in this vein for several years after he left the university in 1925, without graduating. His first published book was a historical romance: *Cup of Gold*, which appeared in 1929, was based on the life of the seventeenth-century pirate Sir Henry Morgan. Steinbeck told the publisher of another early book, *To a God Unknown* (1933): "Its characters are not 'home folks.' They make no more attempt at being sincerely human than the people in The Iliad."[23]

In *The Pastures of Heaven* (1932) he came closer to home; in fact, local critics thought he came too close in writing about whores and outcasts in Corral de Tierra (he called it Corral de Cielo), a valley on the outskirts of Salinas. His mother's book club rejected the novel as "filth,"[24] but he was unrepentant. "I notice a number of reviewers . . . complain that I deal with the subnormal and psychopathic," he wrote. "If said critics would inspect their neighbors within one block, they would find that I deal with the normal and the ordinary."[25]

In fact there were few reviews of any kind. Steinbeck's early work attracted little notice and sold poorly. With the onset of the depression, the small publishers willing to take a chance on his novels could not afford to promote them. When he mailed off his manuscripts, they seemed to drop into a void. "Rejection follows rejection," he had complained in 1931 while awaiting word on his second book.[26] He was not bothered by the lack of money. He was in the same situation as the other aspiring artists and writers who were his friends. When they weren't working, they had a good time together, drinking cheap red wine, putting together parties, and inventing some memorable pranks.

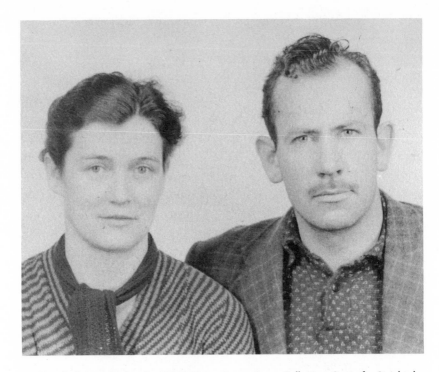

Carol and John Steinbeck in the 1930s. Sharon Brown Bacon Collection, Center for Steinbeck Studies, San Jose State University Library. Reproduced with permission.

Three months after the stock market crash, Steinbeck married Carol Henning of San Jose, who enjoyed sharing his bohemian life and who worked at temporary jobs to help keep them afloat. His father gave them the use of the family cottage in Pacific Grove and a small monthly allowance.

Despite Steinbeck's worries over rejection in 1931, a significant break came later that year when the new literary agency of McIntosh and Otis agreed to represent him. It was the beginning of a permanent business association and of a close friendship with the two partners, Mavis McIntosh and Elizabeth Otis. The following year a Chicago bookseller brought his work to the attention of the publisher Pascal Covici, who brought out his next several books and later became his editor at Viking.

The end of his apprenticeship, the evidence of his mastery of themes central to his concerns as a writer, came in 1933 during a family crisis. In March of that year his mother suffered a stroke that left her partly paralyzed. His father was so shattered by the situation that his health broke also. When it be-

came apparent that he could not manage alone, John and Carol moved back into the Central Avenue house for a time. In order to keep his sanity and to prove his professionalism, to himself at least, Steinbeck wrote whenever he could snatch a minute between chores. He was afraid that his work would reflect the strain and disjointedness of his days, but in fact he discovered a deeper vein of feeling. Sitting outside his mother's sickroom door, he completed the stories "The Red Pony" and "The Chrysanthemums," both set on ranches like the one where her family had lived. Before she died in February 1934, he had finished a comic novel. "Its tone, I guess, is direct rebellion against all the sorrows of our house," he told a friend. His father had become "a fumbling, repetitious, senile old man, unhappy almost to the point of tears."[27] The elder Steinbeck did not live long enough to witness his son's first commercial success with the popular *Tortilla Flat*, published in the spring of 1935.

Steffens and Winter took note of the publication of *Tortilla Flat* by putting out some publicity of their own that distressed Steinbeck even though their efforts were well meaning. The problem was that Winter's keen powers of discernment were not equaled by her written expression. She persuaded Steinbeck to have his photograph taken by Sonia Noskowiak, a student of Edward Weston, to appear on the Sunday book page of the *San Francisco Chronicle*. It turned out to be a remarkable portrait, but the accompanying profile that Winter wrote was of a different caliber.

She began with a description of Steinbeck's appearance. He was, she stated, "of giant height, sun-burned, with fair hair and fair moustache and eyes the blue of the Pacific and a deep, quiet, slow voice. He belongs to this Coast, the Monterey Bay, the ranges and cliffs of the Big Sur Country." He reminded her of Robinson Jeffers: "his height, his slow talk, his entwinement with the hills and stones, canyons and people of this strange coast." She referred to the "tiny dark brown frame house . . . in a little dirt lane in Pacific Grove" where Steinbeck lived with his "tall, black-haired and soft-voiced wife Carol," and to their practice of fishing in Monterey Bay to eke out their budget of $25 a month.[28] Steinbeck was affronted. He complained that she had betrayed him by "promising to lay off the personal and then pulling out all the stops."[29]

Steffens also intruded on what Steinbeck undoubtedly considered to be private ground, noting in his column in the *Pacific Weekly* (the successor to the *Carmelite*) that although Steinbeck was "good company," he was "just now rather wrecked emotionally by the death of his father."[30] Steffens rambled on

effusively: "John Steinbeck has published three novels but the publishers seem to have just discovered and gone after him. An odd life, his. In an 'ivory tower' but not built of stone, like Jeffers', but of mountains, valleys and trails. No liberal, he is feeling his way and it's a good way. You don't care to tell him anything, rather have him tell you."

54

Steinbeck's lighthearted tale about a group of *paisanos* on the outskirts of Monterey received a good deal of attention, not all of it favorable. As he had done when writing *The Pastures of Heaven,* he started with anecdotes that he had heard and remembered. Some of them had been relayed to him by a woman who taught languages in the high school in Monterey and was herself a descendant of Spanish Californians.[31] He put the stories into the framework of the Arthurian legend, turning them into a fable, but included recognizable details that attracted curiosity seekers to Monterey. The Chamber of Commerce protested that the celebration of a group of rowdy, disreputable characters tarnished the image of the historical capital of Mexican California.

The book presents a different problem for readers today. In the context of the 1990s, an Anglo writer's interpretation of Hispanic culture through comic stereotypes seems patronizing, if not offensive. Steinbeck was sensitive to the problem. In June 1937, in an introduction to a later edition of the book, he concluded: "I wrote these stories because they were true stories and I liked them. But literary slummers have taken these people up with the vulgarity of duchesses who are amused and sorry for a peasantry. These stories are out and I cannot recall them. But I shall never again subject to the vulgar touch of the *decent* these good people of laughter and kindness, of honest lusts and direct eyes, of courtesy beyond politeness."[32]

For Steinbeck, the ethnic factor was incidental. He was impressed that the *paisanos* lived by human values that were not competitive or materialistic.[33] In *Tortilla Flat* as in *The Pastures of Heaven,* he expressed his revolt against what he perceived as the social mores of his own middle-class background. He subscribed to the axiom, time-honored among writers—particularly American writers of the first half of the twentieth century—that equates hypocrisy with privilege, and truth with powerlessness. This same philosophy would underlie his tragic drama *Of Mice and Men,* and he would give it a political dimension in *The Grapes of Wrath.* But in writing *In Dubious Battle,* which took as

its frame of reference the strikes of the CAWIU, he had something else on his mind.

It is interesting that in his first full-length experiment with a contemporary theme that had controversial political and economic ramifications, Steinbeck went out of his way to divorce himself from partisanship, ideology, and moral judgment. It is another example of his independence. He had been defiant against the norms of respectable society, but in his first encounter with radical doctrine he was skeptical. His detachment may have been a reaction to a propagandistic slant in the way the material was presented to him. Remembering the Steffenses' publicity in connection with *Tortilla Flat,* he may have been leery because he knew they had a strong interest in his next book, on which he began work in 1934.

During the preceding year Steinbeck had been exposed to talk about the CAWIU-led strikes. Young strikers and their supporters, sometimes accompanied by Ella Winter, came to the Pacific Grove cottage. These gatherings, which Carol Steinbeck encouraged, were described by Steinbeck's 1984 biographer, Jackson Benson. The young people "came to talk and to be fed—they always seemed to be half-starved. They glowed with a spirit of holy mission, something that Steinbeck found interesting, if not admirable. Since you were either for them or against them—there was no compromise—he did more listening than talking."[34]

Steinbeck heard further details of the strikes from labor people he met at The Getaway, and in early 1934 some of the strike supporters in the Steffenses' circle introduced him to two CAWIU organizers who were in hiding in the home of a sympathizer in the small coastal town of Seaside. The two men had come to the Monterey Peninsula expecting to be guests of the Steffenses, only to learn that they were in danger of arrest for their activities in the strikes of the previous summer. Intermediaries arranged for Steinbeck to interview them and pay them for their story.

One of the men was Cecil McKiddy, the cousin of W. D. Hamett, the rank-and-file leader of the cotton pickers' strike. A young Oklahoman and a member of the Communist Party, McKiddy had acted as secretary of the CAWIU office in Tulare. (Many years later Ella Winter referred to him dismissively as "an errand boy.")[35] Judging from Steinbeck's fictional interpretation of the situation, the other man was older and better informed. His experiences are

similar to those of Pat Chambers in the Tagus Ranch peach strike and the cotton pickers' strike. He went by the name of Carl Williams.[36]

Chambers's real name was John E. Williams.[37] He acknowledged meeting Steinbeck, but was purposely vague about the details.[38] They met through the Steffenses, but the circumstances and the time (or times) of meeting are not clear. It is tempting to identify Chambers as Steinbeck's source, but there are logistical problems in doing so. In December 1933, Chambers was acquitted in Visalia of a criminal-syndicalism charge stemming from his October arrest during the cotton pickers' strike. Soon afterward, in January and again in March 1934, he was arrested during a brutally suppressed CAWIU strike in the Imperial Valley, several hundred miles south of Monterey County.[39] It was around this time that the interviews took place. We may never learn whether the information came from McKiddy, from his vaguely identified companion, or from them both, but it is clear from internal evidence in the novel that Steinbeck was told in detail about Chambers's career as a labor organizer.

Steinbeck originally intended to write a straight biography of a Communist, but one of his literary agents persuaded him that fiction was a better medium in which to tell his story. In following this advice, he transformed facts in a highly individual way, removing them from their political context. He first used material from the Seaside interviews in "The Raid," a story about two organizers awaiting an attack by vigilantes on their local headquarters.[40] In contrasting their fear beforehand with their euphoria afterward, Steinbeck seems to be testing a theory of human behavior. He was interested in their responses, but not in the violent action, which occurs offstage, or in the labor conflict that provokes it.[41]

In Dubious Battle continued in the same direction, with psychological probing on a larger scale. Steinbeck used the novel as a vehicle to illustrate an idea that had preoccupied him for some time: that individuals behave differently when they become part of a group. In conversations with his scientist friend Ed Ricketts, he had explored the possibility of a biological basis for this theory of "phalanx," as he called it. He tried to explain it to Carlton Sheffield: "All of the notations I have made begin to point to an end—That the group is an individual as boundaried, as diagnosable, as dependent on its units and as independent of its units' individual natures, as the human unit, or man, is dependent on his cells and yet is independent of them."[42]

The strikers in *In Dubious Battle* are almost as impersonal and faceless as

the vigilantes who threaten them. Steinbeck represents them as a single entity, a mob that is animated alternately by hunger and satiety, anger and passivity. In depersonalizing the group, he ignored the multiethnic model: there are no blacks or Mexicans in his group; they are all Anglos. He took great pains to reproduce accurately the speech of white workingmen.[43] This meticulousness is interesting in view of the fact that he hardly differentiates between one individual and another.

There are a few exceptions to this general pattern of anonymity, including one character who has historical interest. Cletus Daniel has pointed out the resemblance of the character London, the head of a large clan who is hand-picked for leadership by the organizers, to W. D. Hamett.[44] The identification is plausible since Hamett's cousin Cecil McKiddy was one of Steinbeck's informants. The book contains recognizable details from the Tagus Ranch peach strike and the cotton pickers' strike, in both of which Hamett was involved, although Steinbeck scrambled these references, perhaps partly to protect his sources, but also for his own artistic purposes. He changed the outcome. His fictional strike, doomed from the start, disintegrates at its climax. It takes place, moreover, in a historical vacuum. There are no newspaper reporters; there is no public monitoring, no intervention by the government.

The CAWIU leaders settled for pragmatic gains, but Steinbeck's fictional leaders proclaim a different goal. At the beginning of the novel the seasoned organizer Mac instructs the apprentice Jim: "Hell, we don't want only temporary pay raises, even though we're glad to see a few bastards better off. We got to take the long view. A strike that's settled too quickly won't teach them how to organize, how to work together."[45]

The action of the book takes Mac and Jim by freight train across the state to the Torgas Valley, where a strike among apple pickers is imminent. This is another instance of Steinbeck's changing the facts, since the real apple pickers' strike took place in Watsonville, near the coast. If the fictional Torgas Valley represents the San Joaquin Valley, the climate would be more suitable for growing peaches. Steinbeck got off the hook by not naming California at all, although it was recognizable as the background.

As Mac and Jim explore the situation, encourage the protest, recruit indigenous leaders, and call on the help of sympathizers in the nearby town, Mac teaches Jim. A new Party recruit who is discovering an almost religious joy in service, Jim is like someone half alive who now is waking to every fresh expe-

rience. His naïveté must be curbed, his impulses channeled into usefulness. "Don't you go liking people, Jim," Mac tells him. "We can't waste time liking people."[46]

Later Mac declares, "There's no such things as personal feelings in this crowd. Can't be. And there's no such things as good taste. Don't you forget it." By this time Jim has learned the lesson. "We've got to use every means. . . . We've got to use every weapon"[47]—even though the weapons are rocks. "No guns, no money," Mac complains. "We got to do it with our hands and our teeth."[48] In the battle against the growers' representatives and their stool pigeons, Mac gives no quarter. He is contemptuous of an editor's reference to "'paid foreign agitators.' Me, born in Minneapolis! An' Granpaw fought in the Battle of Bull Run." He turns to Jim. "An' you're about as foreign as the Hoover administration."[49] Mac and Jim play down their Communist affiliation. Dr. Burton, a physician who helps the strikers, tells Mac that he changes his speech to sound like whomever he happens to be with. Mac explains, "You know, Doc, men are suspicious of a man who doesn't talk their way. You can insult a man pretty badly by using a word he doesn't understand." He adds, "It's not the same in your case, Doc. You're supposed to be different."[50]

Dr. Burton acts as the author's sounding board as he carries on philosophical discussions with the organizers. He seems to speak for Steinbeck when he says, "I want to see the whole picture—as nearly as I can. I don't want to put on the blinders of 'good' and 'bad,' and limit my vision. If I used the term 'good' on a thing, I'd lose my license to inspect it, because there might be bad in it." At one point Mac asks, "How about social injustice? The profit system?" The doctor responds by talking about streptococci. He also refers to his presence on the scene as that of a student of human behavior: "I want to see, so I go to the seat of the wound." Mac rebukes him: "If you see too darn much, you don't get anything done."[51]

Later Burton says of the strike, "It all seems meaningless to me, brutal and meaningless." Jim, the convert, declares, "It has to go on. It can only stop when the men rule themselves and get the profits of their labor."[52] Jim insists: "Out of all this struggle a good thing is going to grow." Burton is not convinced. "Damn it, Jim, you can only build a violent thing with violence."[53] The words are prophetic in light of the outcome of the novel. Both Jim and Burton are the victims of the vigilantes, although the doctor's fate is uncertain: he simply disappears.

58

Jim by this time has challenged Mac for showing signs of losing his militancy under the relentless pressures of the strike. *In Dubious Battle* is an effective novel because the two protagonists are not heroic. They are fallible men who alternate between courage and weakness, kindness and cruelty, and who acknowledge fear, hunger, fatigue, and inattention to duty. Jim is comforted by an intimate, although innocent, relationship with a young woman, the daughter-in-law of London, whom he and Mac helped during her first experience of childbirth. Even as he begins to pull free of Mac's authority and to become a leader in his own right, Jim longs to escape from responsibility, to simply walk away and passively register impressions. "I never had time to look at things," he mourns just before he is killed.[54] Mac, who was becoming too tender and protective of Jim, reverts to calculated cold-blooded action under the shock of his death. On an earlier occasion he had considered displaying the corpse of another victim in order to "shoot some juice" into the apathetic mob. Now he carries Jim's faceless body onto a platform in the strikers' camp, props it against a corner post for all to see, and stands before the assembled gathering. "Comrades," he addresses them with emotion, for the first time using a term that gives away his identity: "This guy didn't want nothing for himself."[55]

On the day Steinbeck finished the novel, January 15, 1935, he explained to a friend how it evolved: "I had planned to write a journalistic account of a strike. But as I thought of it as fiction the thing got bigger and bigger. . . . I don't know how much I have got over, but I have used a small strike in an orchard valley as the symbol of man's eternal, bitter warfare with himself."[56]

In the end, as he said, "the thing got bigger and bigger." He created an allegory that overpowered not only the factual background of the strikes but also the psychological theory with which he had started. As *In Dubious Battle* acquired a cumulative momentum of its own, it became a product of the author's imagination and a work of art.

The manuscript was criticized from a Marxist perspective by a publisher's reader (or readers) at Covici-Friede. As Steinbeck reported it, the critic complained that the ideology was incorrect and voiced fear that "the book would be attacked by both sides." Steinbeck thought that if this happened, it would indicate that his work was unbiased.[57] When the reader's objections were overruled by the senior partners in the firm, Steinbeck instructed his agent, Elizabeth Otis: "In any revision of I.D.B. I hope that you will tell Mr. Covici that

59

neither theme nor point of view will be changed."[58] He expressed satisfaction with the manuscript. It was, he thought, "a conscientious piece of work."[59] Yet he expected "a critical panning."[60]

When the book was published early in 1936, the commentary, both by reviewers and by people who knew the background, was mixed. To Clark Kerr, who had studied the cotton pickers' strike, the novel seemed to be "right in its totality and wrong in its detail. The general picture, the dynamism, the feeling rising, then decaying, seemed right. The details seem to have been made up by someone who was not on the scene."[61]

Pat Chambers and Caroline Decker were critical. Decker later explained her feelings: "You know, when you're heart and soul and up to your ears involved in something as important as we were doing, you get very emotionally disturbed when someone has set forth a view that you think is inaccurate."[62] In an interview over forty years after the book appeared, Chambers objected: "The whole thing was negative, did not actually portray a condition that existed at that time where human beings out of necessity looked upon each other for support."[63] Yet another CAWIU organizer, Dorothy Ray Healey, who was involved in strikes later than those that were described to Steinbeck, praised *In Dubious Battle* as "the best fictional description . . . of a Communist-led agricultural strike that I've ever read. I think it is a better book than *The Grapes of Wrath,* at least as far as the description it offers of the momentum of that kind of struggle."[64]

Two women who had no connection with the background voiced objections, however. Mary McCarthy, writing in the *Nation,* complained that too much of the action of the novel took place offstage and that there was not enough intellectual content to compensate for this. She found the book "academic, wooden, inert." She added, "If a revolutionary general with a talent for prose—say Trotsky—had cast his reflections upon the technique of class warfare into the form of a novel . . . the result might have been exciting," whereas "Mr. Steinbeck, for all his long and frequently pompous verbal exchanges, offers only a few, rather childish, often reiterated generalizations."[65] Margaret Marshall, writing over three years later in the same magazine, criticized "the primer-like explanations by Mac, the Party leader, on how to arouse the masses which at times borders on the burlesque." Yet she found the novel "exciting."[66]

John Chamberlain of the *New York Times* agreed. "Call it fantasy if you like. Call it Communist propaganda, or call it subtle anti-Communist propaganda,

the point is that 'In Dubious Battle' is a wildly stirring story. It is stirring in the way that Liam O'Flaherty's 'The Informer' is stirring, as a 'melodrama of the conscience.' . . . As a thinker, Mr. Steinbeck may be crazy; as a dramatic artist he is as brilliant as he is versatile."[67] Chamberlain's colleague on the *Times Sunday Book Review*, Fred T. Marsh, was even more enthusiastic about *In Dubious Battle*: "It seems to me one of the most courageous and desperately honest books that has appeared in a long time. It is, both dramatically and realistically, the best labor and strike novel to come out of our contemporary economic and social unrest."[68]

Steffens, who had encouraged the enterprise in the first place, wrote in a similar vein in the *Pacific Weekly*. The book, he said, was "a masterpiece of narrative and honest reporting in fiction form." Steinbeck, he said, was "disturbed by the controversy over whether it is propaganda or not. I am disturbed over this feat of an honest man; I did not believe, and often denied, that an honest man could see so straight. My retreat is expressed by the phrase that the honest genius is an artist."[69]

Ella Winter was not so completely enthusiastic. She objected to Steinbeck's depiction of the manipulative strategies of Communists. She thought that he had marred an effective novel by airing his "pet theory" about leaders, individuals, and group-men. Even before the novel was published, Steinbeck had defended himself against charges of inaccuracy: "In this book I was making nothing up. In any of the statements by one of the protagonists I have simply used statements I have heard used."[70] Winter, however, complained about the "wild talk" about the need to spill blood in order to galvanize strikers, "talk which this individual never heard from any strike leader."[71]

Steffens overlooked these questions when he told Sam Darcy, the West Coast head of the Communist Party: "It's a stunning, straight, correct narrative about things as they happen. Steinbeck says it wasn't undertaken as a strike or labor tale and he was interested in some such theme as the psychology of a mob of strikers, but I think it is the best report of a labor struggle that has come out of this valley."[72]

5

THE CONVERSION OF CAREY McWILLIAMS

Carey McWilliams, who would be paired with Steinbeck by their ideological foes, became a convert to the California farm labor cause in 1934 at a time when the CAWIU was under attack in the wake of the previous season's successful strikes. The thirty-year-old lawyer and writer was already something of a phenomenon. Before he became a political activist he had made a reputation as a cultural reporter and a regional historian, but he pursued these activities outside his regular career as an attorney for a conservative law firm.[1] He disguised a bohemian spirit behind a neat, bespectacled, sober appearance appropriate to the world of business and commerce. The satirical wit and wide-ranging intellectual curiosity that enlivened his writing were teamed with conscientious industry and attention to detail, so that he was able to keep up with a heavy work load during office hours and then turn his mind in a completely different direction without any wasted motion. He seemed, in fact, to draw energy from the contradictions in his life.

McWilliams's literary career began as the response of an impressionable outsider to the social climate of Southern California. In 1922, at the age of seventeen, he had come to Los Angeles from northern Colorado, where he was born on December 13, 1905, in the small community of Steamboat Springs. He had spent an idyllic childhood with an older brother on the family ranch, but unlike Paul Taylor, he did not grow up under the influence of an agrarian tradition. His father was a cattle broker whose reputation and fortune were tied to the fluctuations of the beef market. During his prosperous years the senior McWilliams served in the state senate. After the market plummeted following the Armistice in 1918, his health broke, and the comfortable family life came to an end when he died a little over two years later. The experience caused his younger son to mistrust financial speculation, but the boy had no time to brood. Faced with the necessity of making a fresh start, he followed his widowed mother to the West Coast.[2]

In the early 1920s Los Angeles was in the middle of a postwar boom in real estate, oil exploration, and the burgeoning movie industry. The city was already showing signs of becoming a sprawling megalopolis. Young McWilliams's first impression—which would be echoed by many other new arrivals—was that "it lacked form and identity. There was no center." His initial reaction was that he "loathed the place."[3] But he was fascinated by the people he met in his first job, in the credit department of the *Los Angeles Times*. He was assigned to collect advertising money from "an army of deadbeats, con men, fly-by-night promoters, 'business opportunity' crooks, bad check artists, noisy tent-style evangelists, proprietors of cheap dance halls, flashy oil promoters . . . and not a few realtors who later became civic leaders and multimillionaires."[4]

The lure of sudden wealth was an indestructible part of the California dream. As McWilliams watched these individuals plumbing the commercial possibilities of the area, it may have occurred to him that he might profit from writing about *them*. In any case, he filed away his impressions for future reference. According to one of his later editors, he had "a storage tank of a mind."[5]

McWilliams's job on the *Times* paid his undergraduate tuition at the University of Southern California. The future pattern of his career was established in college. He hewed the line academically while he rebelled against the cam-

63

pus environment, with its emphasis on organized religion, fraternities, and football. Despite his heavy schedule of work and classes he found the time to write editorials for the *Daily Trojan* that were intended to shake up the administrators of the conservative Methodist institution. He became the associate editor of the paper. Most important, he joined a few other likeminded students in reading and writing about contemporary literature that was not included in the university syllabus. His first published article on books was a commentary on the poetry of Edna St. Vincent Millay for an off-campus magazine.[6]

Like a number of his contemporaries, McWilliams discovered a role model in H. L. Mencken, the iconoclastic editor of the *Smart Set* and the *American Mercury,* who was satirizing the business culture of the Harding-Coolidge era and the genteel tradition in the arts and humanities. There are echoes of Mencken's voice in McWilliams's early writing, echoes the young writer made no attempt to disguise. In fact, he went a step farther and sent Mencken an article that he had written about him for a college magazine. When Mencken replied, they began a regular correspondence.[7]

With Mencken's encouragement, McWilliams began to read the works of another cynic and satirist, the journalist and short-story writer Ambrose Bierce. Like many of McWilliams's heroes, Bierce belonged to the "maverick and outlaw" tradition of American letters. While he was still an undergraduate, McWilliams began a serious study of Bierce that brought him into contact with writers who had known him during his journalism years in San Francisco. Correspondence with the novelists Mary Austin and Gertrude Atherton led to meetings and friendships with them both. The poet George Sterling was unusually helpful in encouraging McWilliams and putting him in touch with other informants. McWilliams's pursuit of Bierce material, which started as the enthusiasm of an amateur, became a passport to a professional writing career when Mencken published his discoveries in the *American Mercury* and encouraged him to write a full-length biography.[8]

While McWilliams was engaged in the Bierce project, he completed his undergraduate studies, went to law school (also at USC), passed the bar exam, and won a job with a prestigious legal firm. Black and Hammack represented industrial corporations, oil companies, a number of "wealthy 'pioneer' first families," and clients from the "'old money' preserves" of San Marino and Pasadena. McWilliams, who became adept at civil litigation, was assigned to

handle most of the court cases. He was rewarded with a junior partnership and a salary of $1,000 a month. Soon after he established himself in his profession, he married Dorothy Hedrick, the daughter of a mathematics professor who later became the provost of the University of California at Los Angeles (UCLA). They had one son.[9]

65

On one level McWilliams was leading a life of upward mobility. On another he was pursuing interests that took him outside the middle-class establishment of his working hours. He formed his most meaningful friendships

Carey McWilliams in 1940. *Los Angeles Times* photograph, Los Angeles Photographic Collection. Reproduced with the permission of the Department of Special Collections, University Research Library, UCLA.

with artists, writers, and intellectuals he met through Sterling and Mencken or at the bookstores run by Jake Zeitlin in Los Angeles and Stanley Rose in Hollywood or in the offices of the regional magazines to which he was beginning to contribute.

Writing came easily to McWilliams, particularly the light satire that was the ready response of a newcomer to the Los Angeles scene. "Long before the end of the decade [the 1920s]," he commented in his autobiography, "I came to feel I had a ringside seat at a year-round circus." He was spurred by the public's curiosity about Southern California. "The effect of this upsurge of interest and attention was to create a growing market for 'L.A.' stories which those of us who were beginning to write were only too happy to supply."[10] Mining the rich vein that would later inspire the satires of Aldous Huxley and Evelyn Waugh, McWilliams took aim at the cults and fads that thrived in the temperate climate as readily as the hibiscus and the bougainvillea. The charismatic evangelist Aimee Semple McPherson was a conspicuous target; McWilliams told the story of her life as an American success story. In this type of journalism his emphasis was on entertainment, but in his catalogs of fascinating detail about his subjects he indicated the direction he would take in his more ambitious social histories of the region.

His articles appeared in the Los Angeles magazine *Westways* and in the *Overland Review* and *San Franciscan,* both published in the northern part of the state. He also reached a national readership through Mencken's *American Mercury,* the magazine that epitomized the postwar generation's irreverence for sacred icons. He sent Mencken one piece called "The Folklore of Earthquakes"; another, "Swell Letters in California," exposed romantic absurdities that had grown up around certain authors and their followers on the West Coast. The places connected with Mark Twain's journalistic adventures after the gold rush had become hallowed ground. In Napa County "rival committees of clubwomen" vied with one another to discover the location of Robert Louis Stevenson's *The Silverado Squatters.* Literature and the romantic tradition in California had from the beginning been linked to tourist promotion and profit, McWilliams noted. "The business of commemorating the great literary men of the State has become a fixed institution, and the art of reciting the State legends passes from generation to generation."[11]

In a different spirit he wrote about contemporary California writers (and, occasionally, individuals such as booksellers and naturalists) for the Los An-

geles magazine *L. A. Saturday Night,* published by a London-born friend, Samuel T. Clover, who "lived in a lovely old frame house stacked with books, overlooking Echo Park Lake."[12] McWilliams began the series, for which he was paid $15 an article, a month before he joined his law firm in 1927, and continued it on a regular basis.[13] His discussion of the work of George Sterling, Hildegarde Flanner, Henry Chester Tracy, Marie de L. Welch, and Sara Bard Field was serious and for the most part respectful. He also praised Charles Erskine Scott Wood, whose 1927 book *Heavenly Discourse* was considered to be an innovative examination of a number of historical figures and the ideas associated with them.[14] Two of McWilliams's subjects, Upton Sinclair and Gertrude Atherton, were well known to the rest of the country. In publicizing the work of others who were not yet appreciated by the general public— and in some cases never would be—he revealed a cultural life in California that was the antithesis of the booster image he lampooned in the *American Mercury.* In a later essay, "Writers of the Western Shore," he quoted Hildegarde Flanner's evocation of the region:

67

> Here is the centering of human energy and desire. It may be the quality of life has here more of future and hope and excitement, as well as more uncertainty, than in some communities long settled and not constantly changing. In any case, one is more aware, above the exploitation and commercialization, that here human energy and purpose, having reached the limits of physical advance, are bound to flow back upon themselves and in doing so must either stagnate or create.[15]

McWilliams forged his closest friendships with two writers, John Fante and Louis Adamic, who were also trying to express their conflicting reactions as newcomers to the California scene. More significant in terms of the development of McWilliams's ideas, they introduced him to the themes of immigrant and working-class experience, which would become two of his major interests. Fante, the son of an Italian bricklayer, grew up in Boulder, Colorado, and hitchhiked to the West Coast in 1930. After settling in Wilmington, near Long Beach, he began writing stories that caught the interest of Mencken. The first stories he published in the *American Mercury,* as well as his 1938 novel *Wait Until Spring, Bandini,* grew out of the tensions in his boyhood home: the revolt of his father, an unregenerate gambler, against the strict, virtuous Catholicism of his mother.

68

John Fante. Courtesy,
Black Sparrow Press,
Santa Rosa, Califor-
nia.

Fante's protagonist Bandini was electrified by Southern California. A critic, Neil Gordon, described the author's alter ego as "brash, wildly ambitious, rapturous, drunk with Los Angeles, nearly beside himself in a newly discovered universe of libido."[16] *The Road to Los Angeles,* which recounted Bandini's adventures on the West Coast, was characterized as "down and out L. A., unvarnished."[17] The novella was rejected by Knopf, which had been on the verge of proffering a contract through Mencken's intervention.

Fante was something of an anomaly in the 1930s. He drew on his working-class background and his experiences with Mexican and Filipino cannery workers on the Long Beach waterfront. Yet he was nonpolitical. In the words of a commentator, "He didn't raise the banner. So he didn't fit."[18] McWilliams's favorite Fante novel was *Ask the Dust* (1939), which "provides," he wrote, "a

fine-etched view of the underside of the Los Angeles scene of the period."[19] Although he turned to screenwriting to support his family, Fante produced eight novels and many short stories. In a sketch written toward the end of his life, Carey McWilliams recalled a scene in which the young Fante, working as a busboy in a saloon-restaurant in downtown Los Angeles, autographed menus and copies of the issue of the *American Mercury* that contained his very first story.[20]

69

Fante was between two and three years younger than McWilliams, but Louis Adamic, an immigrant from Carniola in Slovenia (which later became part of Yugoslavia) was more than five years older. Adamic was working at night at the pilot station in San Pedro Harbor and writing during the day when he and McWilliams met in September 1926. They became constant companions, exploring Southern California together and exchanging anecdotes about its eccentricities.[21]

In the summer of 1929 they drove north to San Francisco, a city that McWilliams loved. Describing its effect on him, he wrote, "I was a Nietzschean—I am becoming a Tolstoyan. I find myself loving humanity."[22] Carmel, on the other hand, proved to be a ripe target for his satire. In the *Saturday Review of Literature* he contrasted the original art colony, which itself had been called "a work of art," with the commercial development of the postwar years.[23] Gone forever, he claimed, was the earthly Eden discovered by Mary Austin, the unspoiled place where George Sterling had entertained "Mencken, Dreiser, Sinclair Lewis, Witter Bynner, [Jack] London, [John Cowper] Powys and Vernon Kellogg, where Van Wyck Brooks read passages of 'The Ordeal of Mark Twain' to Clarkson Crane on walks."

The village now contained "bric-a-brac shops, tea rooms, hospital hotels for rich alcoholics . . . schools of 'creative education' and institutes devoted to the cultivation of Russian folk songs." In his catalog of vulgarities McWilliams included the *Carmelite,* for which Lincoln Steffens, who was "rather naively regarded by the citizenry as a radical thinker," wrote "blazing editorials." (It should be noted that some of Steffens's "editorials" contained comments on Carmel similar to McWilliams's and that the changes in the environment that both of them criticized did not discourage the visits of such contemporary literary figures as Willa Cather, Ernest Hemingway, Gertrude Stein, and Alice B. Toklas.)

McWilliams was sarcastic about the *Carmelite*'s Robinson Jeffers issue, on

which Ella Winter had lavished so much attention. Although he had an appreciative attitude toward Jeffers himself—a pioneer who had arrived in 1914 before the village changed—McWilliams was not as impressed as he thought he was expected to be by the poet's romantic surroundings. Una Jeffers led her visitors "through the slightly ritualized ceremony of inspecting the Irish reed organ in the Hawk Tower, the grove of newly planted trees, and had us gape at the mottoes and legends in Old English that were painted on the beams and panels of Tor House."[24] Surrounded by these mementos of a more congenial past, Jeffers in a few brief sentences voiced his pessimism about the state of the nation in the decade to come. His remarks touched off a long discussion between McWilliams and Adamic after they drove away. They expressed their thoughts about Jeffers in separate essays that were published later in the year.[25]

In this period the two friends were writing about different aspects of literary life. In a chapbook entitled *The New Regionalism in American Literature*, McWilliams characterized the trend toward sentimental escape into the past as artificial, since "the modern mind must will to be naive."[26] Adamic criticized the expatriate generation, "the boys and girls born in Nebraska, New Jersey, Ohio, Oklahoma, North Dakota, and South Carolina, who were issuing anti-American pronunciamentoes written on menu cards in Parisian cafes."[27] He included this comment in an autobiographical novel, *Grandsons,* in which he confessed that satire was for him an inadequate form of expression: "My laughter was never pure mirth." He was troubled by his feeling that "most people in America were shadows flitting over the face of this beautiful continent. Shadows of what human life could be. Shadows of one another. They were not connected with any basic reality. They were hardly alive."[28] He first explored these ideas in a 1932 memoir, *Laughing in the Jungle.*[29] McWilliams discussed them in an essay, "Louis Adamic and Shadow America."[30]

The two friends kept in close touch after Adamic moved to the East Coast in the early days of the depression. Adamic was ahead of McWilliams—and of many other writers—in becoming interested in labor conflicts. In his 1931 book *Dynamite: The Story of Class Violence in America,* he described the warfare between unions and employers and gave an impartial account of the 1911 bombing of the *Los Angeles Times* and its impact on socialist politics and labor organizing in Southern California.[31] He revealed his foreign origin in the way he confronted controversies in his adopted country without cultural preconceptions, with a boldness and forthrightness that occasionally bordered on

71

Louis Adamic in the 1930s. Courtesy of the Manuscripts Division, Department of Rare Books and Special Collections, Princeton University Library.

naïveté. The central theme of much of his writing was the immigrant experience as he lived it, his homesickness for the country of his birth, his idealization of his adopted country, the contrast between expectation and reality.[32] There is an emotional tension in his work in the 1930s that reflects his restless search for a meaningful life between these two worlds. It is notable that his books, written out of his own personal need for expression, acquired an ideological dimension in the political atmosphere of the late 1930s and early 1940s. Adamic, the least political of men, became a spokesman for multiethnic pluralism. His writings attracted the interest of Eleanor Roosevelt and other influential liberals. During World War II he edited the magazine *Common Ground,* sponsored by the Common Council for American Unity, which was dedicated to promoting understanding between different racial and nationality groups.

Adamic's influence helped to turn McWilliams toward what might be described as the major phase of his writing career, culminating in his groundbreaking books on the history of various immigrant and "minority" groups in the United States.[33] McWilliams's interest in this subject dated to articles that Adamic encouraged him to write or commissioned for *Common Ground*, although his first ventures in this direction appeared in the late 1930s in other publications. He wrote a short piece for the *American Mercury* on the deportation of Mexicans by Los Angeles social service agencies, an episode that has been reexamined closely by later historians.[34] He wrote a longer article for the *Nation* about a plan devised by the federal government to send Filipinos back to the home islands.[35] In this period he became a friend of Carlos Bulosan, who came to the U.S. from Luzon in 1930 and later published short stories and a semiautobiographical novel, *America Is in the Heart.*[36]

Upton Sinclair. Photographic Collection of the Huntington Library. Reproduced by permission of the Huntington Library, San Marino, California.

McWilliams's interest in issues involving immigrants was connected with his political activism, which began relatively late, in 1934. The evolution of his involvement in political issues in California can be traced in his relationship with a much older writer, Upton Sinclair. Unlike Fante or Adamic, Sinclair was never an intimate friend, but McWilliams considered him to be a person worth listening to, at least at the beginning of their acquaintance. In the 1920s, when McWilliams had "little active interest in politics,"[37] he admired the man whose social views challenged the establishment. In an article in *L. A. Saturday Night* he called Sinclair "a gadfly for the bourgeois but a God to the proletariat."[38] After Sinclair's novel *Oil!* was banned in Boston, McWilliams arranged an interview with him in Long Beach. It happened that they met on August 23, 1927, the day that Sacco and Vanzetti were executed on the opposite side of the continent. This was an event that "shook the literary community." In Malcolm Cowley's words, it "was a foreshadowing of the radicalization of American writers during the 1930s."[39] McWilliams had paid little attention to the case, but he was impressed by the fact that Sinclair was so deeply affected by it that he could talk of little else.[40]

73

A change in McWilliams's attitude was apparent a few years later when he visited Sinclair, who once described himself as "the prize prude of the radical movement,"[41] in the company of the New York sophisticate Edmund Wilson. By this time McWilliams was sufficiently prominent in local literary circles to be the logical escort for Wilson when he arrived in Los Angeles to gather material for his 1932 book *The American Jitters*. McWilliams led the way to scenes and situations guaranteed to startle an easterner—with the result that Wilson's vignettes of Southern California read like McWilliams's early lampoons. Wilson dropped the satirical mode, however, in describing the encounter with Sinclair at his home in Pasadena. Wilson was impressed by Sinclair's account of Hollywood's red-baiting of the Russian film director Serge Eisenstein.[42] McWilliams's recollection of their interview was that during several hours of talk followed by dinner in a restaurant, the socialist author, a teetotaler, never offered them a drink.[43]

Sinclair and McWilliams had a real falling out when the novelist ran for the governorship in 1934. After Sinclair lost the election he complained about the way McWilliams interpreted the campaign to the rest of the country.[44] In the first of two articles in the *New Republic*, McWilliams predicted correctly that

Sinclair would win the Democratic nomination by defeating the New Deal candidate, George Creel. Then, using the most effective tools in his satiric repertoire, he listed the supporters of Sinclair's EPIC ("End Poverty in California") campaign: "Single taxers, mind readers, members of the powerful Utopian Society, leaders of the unemployed cooperatives, a few Santa Barbara dowagers, the Hon. Lewis Browne, aged and infirm Democratic office-seekers, professional 'Catholic leaders', miscellaneous political has-beens, advocates of the Townsend Old Age Pension Plan, advocates of Synchrotax (a nostrum brewed in San Diego), followers of the Rust Taxation Plan, Theosophists from Ojai, Rosicrucians from San Jose" and finally, as an appendage, "the middle aged and middle class."[45]

McWilliams's second article, written on the eve of the November election, predicted the certain defeat of the Democratic nominee. "A press unanimous in its opposition has sought to establish that Sinclair is a Communistic-atheistic-imbecile irresponsible." As for the campaign, "The blunders have been about even. Both Merriam [the Republican incumbent] and Sinclair have generously tried to elect the other." McWilliams wrote of the "shaken economics" of the EPIC plan.[46] Faced with the choice at the polls, however, he voted for Sinclair.

Eighteen months after the election, and nine months after Sinclair had split his supporters by excluding Communists from an EPIC convention, Sinclair and McWilliams leveled charges at one another in the pages of the *Pacific Weekly,* which at that time made a point of presenting different left-of-center political views. McWilliams fired the opening salvo by labeling a Sinclair play in which a socialist criticizes a Communist "viciously reactionary . . . a gross, unpardonable slander on the working class in this country."[47] Sinclair, in his rebuttal, attacked McWilliams's interpretation of the EPIC campaign and denied a charge that he himself had failed to support the San Francisco waterfront strike in the summer of 1934. Their argument was joined by Anna Louise Strong, an authority on Russia. She accused Sinclair of betraying the ideals of EPIC by running for office as a Democrat. To this he replied, "My advice to the American people will be to stick to democracy and make it work."[48]

Sinclair accused McWilliams of following the Communist Party line.[49] Many years later, in his autobiography, McWilliams offered a rebuttal: "I was interested in Marxism in the 1930s—as who wasn't—but I never succeeded in mastering the sacred texts." It was his later experience as head of the Division

74

Harry Bridges as a young seaman in Australia. Reproduced with the permission of the Labor Archives and Research Center, San Francisco State University.

of Immigration and Housing in the Culbert Olson administration that pushed him, as he wrote in careful, lawyerly language, "beyond the liberalism of the period in the direction of a native American radicalism with which I could readily identify."[50] It can be said of him that he had a good ear for contemporary standards. He made the transition from 1920s satire to the radical rhetoric of the next decade without a noticeable break. A common thread running

through his writings in both periods is an occasionally didactic tone that may have been a carryover from his other career as a courtroom lawyer.

McWilliams's early articles on California political issues appeared in the *American Mercury* through the era of Mencken's editorship, but he was prepared to move on. Having made contact with Oswald Garrison Villard and Freda Kirchwey on the *Nation* and Edmund Wilson on the *New Republic,* he became a regular contributor to both journals.

McWilliams wrote a short article for the *American Mercury* on the 1934 CAWIU-led strike in the Imperial Valley.[51] He had come into contact with labor issues through *pro bono* legal work for the American Civil Liberties Union. He had come to know well a number of ACLU attorneys from Southern California, among them A. L. Wirin and Leo Gallagher, who had monitored vigilante actions against the CAWIU. McWilliams became increasingly active himself in behalf of workers in all kinds of occupations and industries who were striking in response to the guarantees of Section 7 (a) of the National Industrial Recovery Act (NIRA). He stated later that "curiosity, not ideological commitment, was responsible for my involvement with labor unions." He admired the "shrewd, practical approach" of the longshoremen's union leader, Harry Bridges, who "may have been deeply imbued with Marxist dogmas, but . . . never spent much time mouthing them in my presence." He credited Bridges with helping to increase overall union membership in the state by 800 percent between 1934 and 1939.[52]

McWilliams's extracurricular activities absorbed more and more of his time and influenced his attitude toward the cases he handled during his regular office hours. After he was assigned by his firm to advise a company president about his rights under the labor laws, the executive rebuked McWilliams's boss: "Don't send that fellow out again!"[53] McWilliams was approaching the time when he would no longer be able to juggle two disparate careers.

76

6

RAIDS AND REACTION

When Carey McWilliams became involved in the California farm labor warfare in 1934, it had entered a new phase. Steinbeck's *In Dubious Battle*, with its portrayal of sporadic and random acts of vigilantism, followed the scenario of the previous season's strikes. California farm employers, caught off guard by the outbreak of strikes in one part of the state after another, had responded individually, with some help from local police and sheriffs and the state Highway Patrol. A coordinated reaction by growers in different communities was difficult because the conflicts erupted so frequently and without warning. It was not until after the settlement of the cotton pickers' strike that the representatives of the state's largest industry and its business allies came together to form a centrally controlled antilabor, antiradical organization, the Associated Farmers, Inc.

The timing was significant. The action was taken after a postseason assessment revealed the financial impact of the recent disruptions. Although the balance sheet recorded an overall improvement over 1932, the profit margin

had been reduced by higher wages paid after strike settlements, by delays in marketing crops, and by the cost to rural communities of supplementary law-enforcement services.[1] Much of the impetus for a counterorganization and the funding to support it came from the auxiliary enterprises "engaged in financing, packing, and marketing California's enormous production," in the words of George West. The editorial page editor of the *San Francisco News* was one of the first commentators to report to a national readership on the creation and the membership of the AF.[2] Among the industries that founded the AF were the American Can Company, the Santa Fe Railroad, the C. & H. Sugar Company, and the Pacific Gas and Electric Company.[3]

Paul Taylor and Clark Kerr, in a November 1934 update on farm labor strife, described the new campaign of coordinated action against strikes without mentioning the Associated Farmers by name.[4] (Their article appeared a year after the initial organizing meeting in Los Angeles—sponsored by the Agricultural Labor Subcommittee of the State Chamber of Commerce—in which Claude Hutchinson, the dean of the University of California's College of Agriculture, played a prominent role.)[5] After giving a brief overview of farm labor strikes nationwide and the Communist involvement in them, Taylor and Kerr focused on the CAWIU-led strike in the Imperial Valley in early 1934, which was overwhelmed by the strength of the united opposition. They quoted a committee, appointed at the request of the State Board of Agriculture, the Farm Bureau Federation, and the State Chamber of Commerce, that denied the existence of the highly publicized conflict even as it was taking place. "Technically, the Committee does not find that there is a 'strike' in the Imperial Valley, nor that there is any 'strike' imminent in the Imperial Valley."[6]

Predictably, the two cast a favorable spotlight on government intermediaries, in particular Brigadier General Pelham D. Glassford, who was rejected by both the growers and the union when he was sent to the scene by Secretary of Labor Frances Perkins.[7] A West Point graduate and war hero who had resigned from the military, Glassford had demonstrated his independence and his communication skills in an earlier civilian role: as the chief of police in Washington, D.C., in 1928, he had mediated a truce between government officials and the Bonus Army before his former army associate, Douglas MacArthur, was ordered to drive the veterans out of the capital. Taylor and Kerr quoted a statement that Glassford made toward the end of his California assignment in 1934: "After more than two months of observation and investigation in Imperial

Valley, it is my conviction that a group of growers have exploited a 'communist' hysteria for the advancement of their own interests; that they have welcomed labor agitation, which they could brand as 'red,' as a means of sustaining supremacy by mob rule, thereby preserving what is so essential to their profits—*cheap labor.*"[8]

Taylor and Kerr also quoted a similar comment by Simon J. Lubin, whose connection with farm labor had begun twenty years earlier with the investigations conducted after the Wheatland hop-field riot by the newly formed California Division of Immigration and Housing. Lubin spoke to the Commonwealth Club of San Francisco on his return from the Imperial Valley as a member of a committee representing the federal government: "We have little or nothing to fear from the 'radicals' and 'agitators.' But there is genuine ground for fear—great fear—in the greed and selfishness, the intellectual sterility, the social injustice, the economic blindness, the lack of political sagacity and leadership, and the mock heroics and hooliganism we observe within our state today."[9]

Taylor and Kerr added the rebuttal of a spokesman for the California Farm Bureau: "If the professional sobbers will stop lending aid and encouragement to agitators who spit upon our Constitution and our flag, peace and quiet can more easily be maintained and the situation will soon clear up."[10] They quoted statements by a policeman and a Northern California newspaper editor advocating the use of crime-fighting methods to handle labor unrest. They noted that "county after county" in the state had passed "strict anti-picketing ordinances." They referred to a report that "the largest peach and apricot ranch in the world" was "rushing toward completion of a 'moat' three feet deep and four feet wide, behind which hand-picked employees were to be admitted through the guarded entrances."[11] This was the 4,000-acre Tagus Ranch, which every year produced a million dollars' worth of fruit, hay, and cotton. The owner, H. C. Merritt Jr., was determined to prevent a repetition of the peach pickers' walkout led by Pat Chambers in August 1933.

The CAWIU did not return to the Tagus Ranch. In June 1934 the union attempted a strike among apricot pickers on the Balfour-Guthrie Ranch in Contra Costa County. The ranch was owned by Philip Bancroft, a prominent Northern Californian and an active member of the Associated Farmers. The CAWIU organizers, who were competing with a Trotskyite leader of an AFL union, were overwhelmed by the sophisticated methods of surveillance and in-

timidation that were deployed to immobilize them. It was their last stand. Soon afterward the union was caught in a backlash from the waterfront strike that shut down West Coast ports from San Diego to Seattle beginning on May 9 and culminated in a four-day general strike in San Francisco and Oakland in mid-July. The fate of the CAWIU hung in the balance while the interest groups that had been active in the fields the previous summer shifted their attention to the docks.

The new conflict provoked a strong reaction from the business community. In response to the paralysis at the ports, which was estimated to cost more than $100,000 per day in lost revenue,[12] the San Francisco Chamber of Commerce, supporting the Shipowners Association, created an Industrial Association that was similar to the Associated Farmers both in its membership and in its antiradical rhetoric and tactics.

The equation was different on the labor side, however. Harry Bridges's International Longshoremen's Association (ILA) had the backing of the Communist Party, which had shifted its focus from the fields to the waterfront. But a significant factor in Bridges's success was his alliance with the entire roster of maritime unions and the Teamsters Union in a coalition supported by many other unions, almost all of which had been indifferent to the concerns of farm workers. City dwellers who had taken no position on the agricultural strikes supported the ILA's demands for a wage increase, a reduction in working hours, and control of the hiring hall. Eyewitnesses described the great sea of silent marchers flowing down San Francisco's Market Street—the only sound was the shuffling of feet—as thousands of sympathizers joined the funeral procession for two strikers killed by the police on July 5 near the Embarcadero.[13]

The press played an active role in the events. The mainstream dailies in the Bay Area—with the exception of the Scripps-Howard *News*—sided with the shipowners and the Industrial Association. In contrast to the situation during the cotton pickers' strike, when city newsmen sent to the San Joaquin Valley were given free rein, reporters covering the waterfront conflict were subject to stricter control from the boardroom. When Paul Smith tried to exercise his autonomy as financial page editor of the *Chronicle* by publishing an interview with Harry Bridges, he was overruled by Chester Rowell.[14] The independent wire services were also pressured to fall in line. The Shipowners Association went so far as to send a lobbyist to the New York headquarters of the Associ-

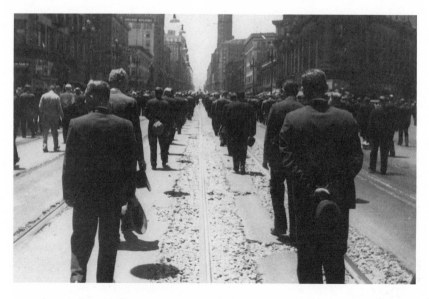

Funeral march down Market Street, San Francisco, during the 1934 longshoremen's strike. Photo by Otto Hagel. Reproduced with the permission of Hansel Mieth Hagel and the Labor Archives and Research Center, San Francisco State University.

ated Press. Katherine Beebe Harris, an AP reporter newly arrived on the West Coast, found that the local newspapers affiliated with her agency registered opposition to her objective standards of reporting. "We did only straight coverage," she recounted. "They wanted the story slanted."[15]

Publishers used other methods to influence public opinion. During a tense period on the waterfront during the third week in June—soon after the Teamsters Union refused to haul cargo unloaded by strikebreakers—the *Examiner* gave front-page coverage to an anti-Communist crusade launched by the American Legion at its San Francisco convention.[16] A few days later a number of papers reported a direct-action campaign that was taking place in the city: as the Industrial Association was preparing to confront the pickets on the Embarcadero, the offices of Communist-affiliated organizations were invaded by vandals, followed by the police, in coordinated raids. In describing a sweep at the office of the *Western Worker*, the *Chronicle* listed names and addresses of the newspaper staff in the back room but did not identify the "raiders" who broke into the front of the premises "with sledgehammers and crowbars." Although the press did not divulge their identity, it was generally known by

people familiar with the situation that they were agents of the Shipowners Association.[17]

The press showed its muscle during the general strike that shut down commerce and transportation in San Francisco and the East Bay in mid-July. After 180 unions voted to join the movement, the publishers of the *Chronicle, Examiner,* and *Call-Bulletin,* and of two Oakland papers, the *Tribune* and the *Post-Enquirer,* formed an ad hoc Publishers' Council. Their purpose was to coordinate editorial policy and civic action, working closely with public officials on the steps that were to be taken to protect the public and bring emergency supplies into the area. John Francis Neylan, the leading lawyer for Hearst Newspapers, directed the operation from an emergency office in the downtown Palace Hotel, working almost around the clock for the better part of a week. The group agreed that their first task was to reach the majority of readers who were sympathetic to the longshoremen's cause—readers who might have been influenced by pictures that appeared in their own papers of police attacks on union pickets, of the shooting of strikers at the "Battle of Rincon Hill," and of the great funeral procession on Market Street. If reporters were kept on a short leash, the photographers had simply recorded what happened.

The publishers decided to sound an alarm. On Sunday, July 15, the day before the mass shutdown began, the *Chronicle* and the *Examiner* ran front-page editorials in large type warning of the impending emergency. William Randolph Hearst arranged to have a report cabled from London on how the British had handled a similar crisis in 1926. It provided an editorial theme on the gravity of a situation in which the vital commercial life of a community was immobilized. Statements were written to the effect that a general strike was a revolution against constituted authority—that a radical group was attempting to seize control by intimidation. The strategy worked. After the experience of one or two days of stalemate when it seemed that inconvenience might turn into hardship, public opinion changed. According to Katherine Harris, "People thought the Communists were taking over."[18]

The Publishers' Council adopted a divide-and-conquer strategy toward labor. Leaders of conservative unions were singled out and warned about "the danger of being plunged headlong into a course that would cause organized labor to lose all the gains of many years." The publishers claimed credit for the

resignation of several unions from the Strike Board. They then challenged the representative of the federal Labor Department, General Hugh Johnson, the head of the New Deal's National Recovery Administration (NRA), who had come west to confer with the Strike Board representing the unions. At a meeting that went on for most of the night of July 16–17, Neylan and his associates used verbal strong-arm tactics to persuade Johnson to renounce his position that the ILA's demand for control of the union hiring hall was a condition of arbitration. Council members who monitored Johnson's speech at a Phi Beta Kappa ceremony at UC Berkeley the next day were satisfied that he had absorbed their message. On leaving town he was quoted as saying it was "the first time that he had ever been up against a newspaper oligarchy."

83

The publishers' self-congratulatory account of their actions appeared first in the trade journal *Editor and Publisher*.[19] The *New Republic* picked it up and gave it a satiric twist under the title "The Press as Strikebreaker."[20] The piece was the work of Robert Cantwell, a staff writer who had been in San Francisco in early July. Cantwell, a novelist, had come west to talk with Lincoln Steffens about a writing project and through Ella Winter had become caught up in the waterfront strike. During the period of the raids on Communist offices in the city, he accompanied Winter to a clandestine rendezvous with Sam Darcy, who

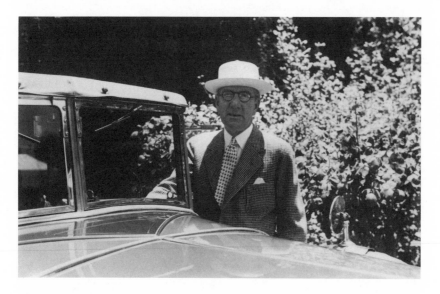

John Francis Neylan. Courtesy, The Bancroft Library, University of California, Berkeley.

came out of hiding to meet them at a prearranged location behind the Cliff House Restaurant. Winter handed Darcy a roll of bills, a $150 contribution to Harry Bridges's union from a Hollywood friend. If Winter was nervous about being an underground courier, she enjoyed describing the experience later.[21] When Cantwell got back to New York after driving straight across the country, he appeared to his colleagues like a soldier returned from a battlefield.[22] The reports that he and Winter wrote—separately—from the strike scene have the tone of war dispatches.[23]

In that era the *New Republic* published a variety of political ideas, ranging from the liberal opposition to Communism expressed by Archibald MacLeish to the endorsement of New Deal policies by the editor-in-chief, Bruce Bliven, to the left-of-center opinions of Malcolm Cowley, Edmund Wilson, and several other members of the editorial board. The editors gave Cantwell free rein to tell his story. On the subject of the Publishers' Council and the general strike, he took the position that the waterfront workers had been betrayed by Hugh Johnson, who had been bullied into withdrawing support for the union's entire list of strike demands. Cantwell and other pro-union hard-liners ignored the more judicious stance of Secretary of Labor Frances Perkins and the fact that New Deal labor legislation had provided a general, if not a specific, impetus for the strike.

Using aptly chosen quotations, Cantwell pilloried the Publishers' Council and its boastful spokesman in *Editor and Publisher*. Neither writer mentioned—or in all likelihood knew about—the emotional confrontation that led to the resolution of the conflict: Neylan summoned the shipping-company executives to his home near Woodside and issued an ultimatum; he told them that the newspapers were going to announce that the Shipowners Association had agreed to open discussions with the ILA.[24] That broke the deadlock. The Strike Board then voted by a narrow majority to submit all issues to arbitration. Except for the compromise that gave management joint control of the hiring hall, the settlement represented a victory for the ILA, although this point was not acknowledged by ideologues.

The highhanded attitude of Neylan's group toward General Hugh Johnson bears out an observation made by Lorena Hickok, who visited California in the summer of 1934 in her role as a roving reporter for Harry Hopkins's Federal Emergency Relief Administration. On August 15 she sent back to Washington a warning that an alliance had been formed between business execu-

tives, Republican candidates, and publishers (with the exception of the Scripps-Howard chain) to coordinate action for the fall elections. "I was informed," she wrote, "and I got this from several pretty reliable sources—that all over the state in the last few weeks newspaper publishers have been getting together in more or less secret sessions and laying plans publicly to put on a campaign to rid the state of Communists, but privately to fight Roosevelt." The New Deal was going to be painted with a red brush.[25]

The anti-Communist campaign ensnared the CAWIU. On June 29, when farm workers in Hayward called a strike in sympathy with the longshoremen, the *San Francisco Examiner* gave front-page prominence to an "interview" with Pat Chambers, Caroline Decker, and Albert Hougardy (a congressional candidate for the Communist Party). The statements of the Communist leaders had not been recorded by a staff reporter but relayed through "Associated Press dispatches from Sacramento." They were paraphrased in bold-type headlines: "Communist Chiefs Declare Open War Against California; Valley Farms To Be Battlefields In Platform To Overthrow Government; Open And Avowed Warfare Declared Yesterday By Communists; The War Will Be Real, With Gun Battles And Bloodshed; Its Object Will Be Overthrow Of The State Government To Be Followed By A Soviet Form Of Government." Hougardy was actually quoted as saying, "We have nothing to hide. We are merely carrying out the details of a program presented by the Communist International to unseat the existing capitalist system of government and substitute a control similar in principle and operation to that of Soviet Russia." Decker was alleged to have added, "If it is necessary—in order to get better living and working conditions for the working class—to overthrow the Government, then the Government will be overthrown."

It is instructive to compare the statements in the *Examiner* story with remarks made by Decker's husband, Jack Warnick, less than a year earlier in the *Call-Bulletin*. Fremont Older in his column described a meeting with a young, ardent, "strikingly handsome" fundraiser for the CAWIU who requested a donation for the children of starving cotton strikers. Older was skeptical. He believed that the strikers were hungry because "the more human misery [the fundraiser, who was unnamed] and his comrades could create, the better for the revolution." The strikes were a subterfuge, Older concluded. The union's real purpose was to slow down the New Deal recovery program, "if not to make it completely ineffective."[26] In a later column Older quoted Warnick's

reply: "Yes, we are for world revolution and the strikes are part of the prepa-ration. But we do not use the strikes as subterfuges. We tell the workers the truth, that these strikes are mere skirmishes—a training for the big battle to come." To the charge that the Communists were deliberately trying to create human misery, Warnick replied that the misery existed already. "We do not need to create more."[27]

In the summer of 1934 the time for free and open discussion had passed. Statements were inflated—or more likely, manufactured—by a hostile press for the purpose of inflaming public opinion. The *Examiner* reported that the president of the Associated Farmers believed that the threats of the Commu-nists were real.[28] What happened next seemed to be more than a coincidence. On July 20, the day after the general strike ended, the headquarters of the CAWIU, which had been transferred from San Jose to Sacramento, were raided by the police. Eighteen members of the union, including Pat Chambers and Caroline Decker, were arrested, charged with vagrancy, and held in jail on $1,000 bonds to await trial.

That fall, Paul Taylor introduced a course in the Economics Department at Berkeley called "'Vigilantes' and the Labor Movement." Focusing on the na-ture of fascism and on manifestations of vigilantism throughout history, the survey began with the Ambuscado in ancient Sparta and ended with the Na-tionals, a group formed in San Francisco during the previous summer.[29] In an article on the general strike and its aftermath, Taylor and a teaching assistant, Norman Leon Gold, reported on the situation that had inspired the course:

> Officials, business men and other conservative citizens have been so effectively agitated, that they are convinced of the immediate necessity, and of the suitability of storm-troop tactics to "save America" and "democratic government, including civil liberties such as freedom of speech, of the press, of assembly and trial by jury." [Thus] creating an hysteria the like of which California has not witnessed since the war, employers and industrial leaders, the press, and officials fostered thereby an attack against "reds" which has spread over the Bay region and be-yond. Labor was importuned to "run subversive influences from its ranks like rats," and some union leaders did physically attack Communists, although not in most of the cases where it was attributed to them. Po-

lice and vigilantes raided communist "lairs," and arrested "reds," characterized by the approving press as "alley spawn." Vigilance committees were rapidly organized; business men, professors, and other staid citizens armed with pick handles and other weapons patrolled streets of the East Bay while more halls were raided and bricks with warnings attached were thrown through the windows of homes. A protecting picket line was thrown around fashionable Piedmont; a librarian was ordered by resolution to submit for destruction a list of books "praising the virtues and advantages of Communism."[30]

One of the books condemned in Oakland was *Red Virtue,* Ella Winter's account of life in the Soviet Union. She herself was vilified on personal as well as political grounds. A satirical portrait of "the divorced wife of Lincoln Steffens" appeared Wrst in the *Pacific Rural Press,* the organ of the Associated Farmers, and was reprinted in the *Carmel Pine Cone,* which a few months earlier had devoted an issue to an affectionate tribute to Steffens.[31] The artists' colony, ordinarily tolerant of diverse opinions, was bitterly divided on the waterfront strike. Winter was as committed to the ILA as she was to the CAWIU. Her single-mindedness in her advocacy of the maritime workers and her confrontational style acted as a lightning rod for the opposition and alarmed some of her associates. When the John Reed Club invited a longshoreman to speak, the hall where they met was invaded by members of the American Legion who had been holding conspicuous drills in the downtown streets of the village.[32] After a local man, a member of the Shipowners Association, was injured on the Embarcadero during the strike, the Association sent down a spy to infiltrate the gatherings of the Steffenses and their circle.[33]

Although she would exact some revenge when she wrote about Carmel in her autobiography many years later, Ella Winter ignored the personal attacks and kept her focus squarely on the issues in her articles for the *Nation* and the *New Republic.* Nor did Steffens retreat or retract. While most of the left-wing vote was swinging to Upton Sinclair and the Democratic-Socialist EPIC slate in the fall election, he wrote a statement in support of the Communist Party candidates for state office. He managed to keep his sense of humor. "We have just come through a White Terror," he reported to his mother-in-law in London.[34] He told someone else that he had summoned "a chief of the Vigilantes and tried to persuade him to send me to the penitentiary."[35]

Steffens exercised his wit, perhaps less appropriately, in discussing the fate of the CAWIU organizers who were actually facing that possibility. At the end of the 1933 strike season, he had canvassed friends and public officials to buy a typewriter for Caroline Decker. He sent out a second mailing after the arrests in the Sacramento office in July. "The charge is vagrancy," he told his correspondents.

> No, don't laugh. They may have been picked up for being so busy. They raised wages, —a little, —last year, but this year the farmers did it voluntarily, all by themselves. At the mere sight of Caroline's agitators coming down the road, the bosses increased the consuming power of their pickers and so beat the pot out of the Revolution and all its workers. But you can close one eye and see that Caroline Decker, her Union, and our typewriter ought to be in jail for life and it's hard that there isn't some law (besides vagrancy) for her and them to have broken. I too can sympathize with the constituted authorities. It's tough to have to hold up our tottering civilization these days and find the straws as well as the bricks.[36]

7

THE TRIAL

The original charge of vagrancy on which the CAWIU organizers were arrested was changed. Fourteen of the union leaders were accused of violating the state's Criminal Syndicalism statute and became the defendants in a trial in Sacramento that got under way in January 1935. As a forum on the issues that had fueled the recent strikes, the trial received a good deal of attention in the press both locally and outside California.

Carey McWilliams had become particularly interested in the union in relationship to the courts. He had reported briefly on the trial of Pat Chambers in Visalia after the cotton pickers' strike and the dismissal of the case after the farmers charged with killing two strikers at Pixley were acquitted.[1] McWilliams's friend Leo Gallagher was the chief defense lawyer for the CAWIU organizers. A Roman Catholic who had once studied for the priesthood, Gallagher had recently been in Germany defending a Communist charged with setting the fire in the Reichstag that had precipitated Hitler's rise to

power. Shortly before the proceedings began in Sacramento, McWilliams offered an admiring profile of Gallagher to the readers of the *Nation*.[2]

During the three months the trial lasted, the *Nation* and the *New Republic* published reports on the proceedings by other writers. The accounts ranged from a partisan indictment by Bruce Minton (Richard Bransten)—"The trial is an experiment in fascist methods"—to Heywood Broun's more temperately worded criticism of the biased coverage he found in the Hearst press and the *Sacramento Bee*.[3] Travers Clement called up the images of Caroline Decker and Jack Warnick when he declared, "Not even the most inflamed imagination could conceive of these intelligent, clear-eyed, good-looking young people as sinister figures."[4]

The union's backers focused on the issue of civil liberties. Noting that one of the defendants was a direct descendant of Matthew Thornton, who signed the Declaration of Independence, spokesmen at a Conference for Labor's Civil Rights objected that "the powers of Government, once initiated *to secure the inalienable rights of man* are today being perverted by treacherous public officials to DENY THE CIVIL RIGHTS OF LABOR."[5] Union advocates also attacked the Criminal Syndicalism law. Challenging its relevance in relation to a group who advocated nonviolence, CAWIU supporters successfully pressured members of the state legislature to introduce a bill to repeal the law.[6]

They were encouraged by a change in the political climate in Northern California. In the wake of the vigilantism that erupted in the summer of 1934, several public figures made statements supporting free speech and, by implication, condemning the actions of the union's foes. Robert Gordon Sproul, the president of the University of California, spoke out in July during the period of the raids on Communist organizations: "With particular respect to communism," he wrote, "it must be said that in and of itself, there is nothing criminal or illegal about it."[7] Eight months later, during the Sacramento trial, Professor A. M. Cathcart of the Stanford Law School told the Commonwealth Club: "If they limit their efforts to change the government to peaceful changes, Californians have an unimpeachable right to be communists if they so desire."[8]

On the list of prominent citizens who approved the repeal of the Criminal Syndicalism law in the spring of 1935 were Sproul, David Starr Jordan (the former president of Stanford), John Francis Neylan, and Chester Rowell. The editor of the *San Francisco Chronicle*, because of his passionate commitment to civil liberties, had been criticized by some readers for being soft on Com-

munism. (In May 1934, he had responded humorously by protesting the omission of his name from Elizabeth Dillings's *The Red Network: A Who's Who and Handbook of Radicalism for Patriots,* "not certainly" because of his "innocence," he stipulated, but on account of his "obscurity";[9] the following year he became "a minor addendum" to the Dillings list.)[10] Joking aside, Rowell was unequivocal about his own position. He supported the repeal of the Criminal Syndicalism law. At the same time, he refused to join the American League Against War and Fascism (which later placed William Randolph Hearst "on trial") because the group did not condemn Communism as well. "The only sound democratic attitude is to be against all three," he insisted.[11]

At the Sacramento trial, the civil liberties issue was raised through the words of Leo Gallagher and the actions of six of the fourteen defendants, including Pat Chambers and Caroline Decker, who were representing themselves in the proceedings. Since they were free on bail, they also spoke outside the courtroom. Jack Warnick and Caroline Decker were invited by a group of students to a meeting in Berkeley. On another occasion, Decker, described by a reporter as "attired chicly in a white satin blouse and black skirt," was the featured speaker at a criminal-syndicalism-repeal rally at the Dreamland Auditorium in San Francisco.[12] Decker and Warnick also expressed themselves freely on another issue on which they held differing opinions. Warnick stood up for one of his fellow defendants, Norman Mini, who was considered by Union hardliners to be a traitor. Mini had resigned from the Communist Party and was represented at the trial by a committee of Socialists, Trotskyites, members of the IWW, and other labor groups. In a letter printed by John D. Barry, the liberal columnist of the *San Francisco News,* Warnick defended Mini against press attacks from the left (the *Western Worker*) and the right (the *San Francisco Examiner*).[13] Decker, on the other hand, challenged Mini on his evaluation of the CAWIU. In an article in the *Nation,* Mini praised the union's record in 1933 but claimed that it had "folded up" after the defeat in the Brentwood apricot strike in June 1934, and during the general strike in San Francisco "could not call one single worker out of the fields to help the longshoremen."[14] In a rebutting letter, Decker set out to correct Mini's "numerous misstatements of facts." She listed figures to prove that the concrete achievement of the CAWIU had been to raise the average farm wage and the weight rate for picking cotton in California from 1932 through 1934. She claimed—correctly—that the pay standards held even after the organizers were arrested.[15]

These dissenting opinions buttressed the arguments of Leo Gallagher, who portrayed the defendants as Americans exercising their constitutional right to organize farm workers. His opponent, the Sacramento district attorney, Neil McAllister, presented the case for a conspiracy by agents of a subversive foreign power. The prosecution read aloud to the jury the literature of the Communist International (Comintern). Russian flags and Young Communist League uniforms were displayed in the courtroom. Gallagher protested that these Communist Party artifacts had no connection with the defendants. He accused McAllister of using scare tactics. "The prosecution is trying to show that the Red flag stands for violence. Actually, the Red flag is a symbol for feeding hungry children and getting employment for the jobless."

More relevant to the case were the files that had been confiscated from the CAWIU headquarters the previous July when the defendants were arrested. The papers included minutes of meetings and conventions and the texts of resolutions and calls to action. Read aloud to the jury, the material sounded dull and perfunctory, rather than inflammatory.[16] However, the letters that were exchanged by Caroline Decker, Ella Winter, Jack Warnick, and Sam Darcy between December 1933 and July 1934 tellingly revealed the real state of the union after the high point of the cotton pickers' strike. Winter wrote in the lighthearted voice of an outside supporter about situations concerning strikes and fundraising, including James Cagney's response to an appeal.[17] The Decker-Warnick correspondence was by comparison harried and agitated. The two organizers seemed to be inundated by ceaseless calls on their time and energy, and by worry over insufficient funds. (The receipts of the CAWIU in dues in December 1933 and January 1934 were $11.25 and $44.88, respectively.)[18] Decker, in responding to requests from Darcy at the district headquarters, sounded irritated and defiant.[19] The overall impression conveyed by these exchanges is of a union and its leaders struggling to survive—belying the picture relayed by the prosecution of an unstoppable juggernaut.

Captain William Hynes of the Los Angeles Police Department's Intelligence Division was paid $3,700 by the Associated Farmers to supply information from his files and to bring former Party members to the witness stand to talk about Communist activities in California.[20] One individual who testified claimed that when Pat Chambers addressed the strikers at Pixley, he threatened to "have the streets of Pixley run red with blood, as were the streets of Harlem [Harlan] Kentucky."[21] A CAWIU partisan, on the other hand, remembered that

Chambers spoke of Harlan, Kentucky, not as a threat, but as a warning of what might happen again.[22] Others remembered him reading aloud a letter from a Labor Department spokesman as the farmers gathered to ambush the strikers.[23]

The defense also called in witnesses; rank-and-file CAWIU members and sympathizers were subpoenaed and brought to Sacramento. W. D. Hamett, who came with several other members of his family, appears to have been subdued by the atmosphere of the trial. He was notably less militant than he had been when addressing the government-appointed panel at the cotton strike hearings in Visalia in October 1933.[24]

Throughout the trial both sides focused on the particular issues on which they had chosen to concentrate. The prosecution asked the jury to "consider the position of the Associated Farmers." Were the farmers of California going to "sit idly by" when confronted by "conspirators" and "propagandists" and "agitators"? By contrast, Pat Chambers in his concluding speech made an appeal for altruism. "You yourselves," he told the jury, "are more or less sheltered." He continued:

> I ask you, irrespective of your decision on this case, to do one thing. Go to the agricultural fields and see for yourselves how miserable the conditions of life are there. You will see children with the terrible imprints of hunger on their faces.
>
> I swore to fight against all organizations that brow-beat the poor. I swore above all that these children would not go hungry. I have seen so much misery, starvation, brutality. I am glad I took part to a small extent in the struggle against them and against the banks that caused them. They now want to force wages back to the same levels as before the strike.
>
> In sentencing us fourteen men and women to jail, you are sounding the opening gun in the attack on the wages of these workers. In releasing us, your service will be to thousands of agricultural workers.[25]

As part of a long summation, Caroline Decker, speaking for all the defendants, returned to the issue of free speech. "If you vote for an acquittal," she told the jury, "you are not voting for communism. You are voting for the right of the American people to say what they please."

The jury took its responsibility seriously, deliberating for sixty-six hours and

casting 118 ballots before reaching a decision. The verdict was announced on April 1, 1935. Six of the defendants were acquitted. Jack Warnick was among them. The other eight, including Chambers and Decker, were judged guilty and sentenced to state prison terms. Chambers was sent to San Quentin. Decker was in the Women's Prison at Tehachapi for almost two years. Her sentence was shortened because she engaged in public service activities, organizing classes and teaching piano to her fellow inmates. She was released on April 26, 1937, shortly before her twenty-fifth birthday. She divorced Jack Warnick and later married Richard Gladstein, the lawyer who succeeded in overturning the criminal-syndicalism convictions under which she was sent to prison. (The 1935 bill to repeal the Criminal Syndicalism law had died in committee as a result of lobbying by the Agriculture Committee of the Chamber of Commerce.)[26]

In the post-trial assessments, it was noted that the Associated Farmers spent nearly fourteen thousand depression dollars on the prosecution of the case.[27] It was also noted that the CAWIU, which in line with Communist policy had repudiated mainstream unions, received in return little support from organized labor. Carey McWilliams quoted a remark made by Paul Scharrenberg, the head of the California Federation: "Only fanatics are willing to live in shacks or tents and get their heads broken in the interests of migratory labor."[28] Paul Taylor, who had observed the national American Federation of Labor (AFL) convention in San Francisco in October 1934, before the trial began, noted a left-led movement toward industrial unionism coupled with an almost total indifference toward organizing farm workers.[29] Some AFL unions had ties to agriculture and its allied industries. In this respect, they were in a position similar to that of the federal government, which excluded farm workers from New Deal labor reforms in exchange for the votes of rural legislators in Congress.

On the attitude of California growers toward non-Communist labor unions, there is conflicting evidence. George West reported that an overture was made to the California Federation as an alternative to the CAWIU, but Philip Bancroft, as a spokesman for the Associated Farmers, told the Commonwealth Club soon after the verdict in Sacramento that "while we farmers sympathize with the aims and most of the actions of the American Federation of Labor, we would regard the unionization of farm labor as absolutely ruinous to us, as well as injurious to the laborers themselves."[30]

The trial had given renewed prominence to the CAWIU, which—as was apparent from the confiscated letters read aloud to the jury—was weakening under the weight of internal as well as external pressures. One of the ironies of the situation was that the prosecution, by introducing false propaganda, inflated the strength of the union in the eyes of the public. There was additional irony in a development that was not generally known: The CAWIU, while under attack by outside foes, was given a coup de grace by the Communist Party. A Comintern directive issued on March 17, 1935, two weeks before the end of the trial, abolished the Trade Union Unity League and its subsidiary unions in favor of the "popular front" in which Party labor organizers were ordered to work within existing unions, including those of the AFL. Although the edict came too late to affect the outcome of the trial, its existence effectively destroyed the defendants' spoken and unspoken claims to autonomy and confirmed the argument of the prosecution that their operation was directed in Moscow.

A number of the CAWIU organizers became active after 1937 in the CIO's United Cannery, Agricultural, Packing and Allied Workers of America (UCAPAWA). Neither Chambers nor Decker went back into the fields. Both broke with the Communist Party, for about the same reasons: they spoke of a lack of "flexibility," of leadership that was undemocratic.[31] Although they subsequently led very different lives—Chambers as an unmarried working-man, Decker as a suburban wife and mother—they kept their identification with farm-labor organizing as a commitment that was acknowledged by later generations of union leaders.[32]

8

LITERARY REPERCUSSIONS

Irving Bernstein, in his book *Turbulent Years,* suggests that the lasting legacy of the CAWIU may have been in the books in which it is featured or at least plays a part.[1] There were a number of them, although only Steinbeck's *In Dubious Battle* has lasting literary value. The others are interesting for different reasons. Union partisans encouraged these after-the-fact interpretations following the CAWIU's demise in 1935.

The Carmel-based *Pacific Weekly* served as a promotional vehicle for Lincoln Steffens and Ella Winter, as well as an outlet for their political and cultural enthusiasms. In it Steffens continued the regular column of observations and opinions that he had started in the *Carmelite.* Winter enlisted their friends to be contributors, as she had done on the earlier publication. Sara Bard Field's name appeared on the masthead. Una Jeffers, who agreed to disagree with Steffens and Winter on political subjects, produced book reviews on literary topics. Marie de L. Welch, who had written simple, moving verses about the cotton pickers' strike and its aftermath, was the poetry editor.[2]

The *Pacific Weekly,* subtitled *A Western Journal of Fact and Opinion,* had been started in December 1934 by a veteran newspaperman, W. K. Bassett, and his wife, Dorothea Castelhoun, a writer of children's books. They had begun their collaboration on the *Carmel Cymbal,* which they described as "a clangorous weekly journal of about 900 total circulation founded [in 1926] in direct competition with the established, sedate, and comfortable Carmel Pine Cone."[3]

Bassett announced that the *Pacific Weekly* was "pledged to a new order, defiantly, irrevocably pledged."[4] Playing the part of a referee, he invited writers representing Socialism, Communism, and other left-of-center viewpoints to argue their positions in the pages of the magazine. For a brief period in April 1935, the paper was removed from the newsstands in Carmel by members of the American Legion, but the attempted censorship had no effect on editorial policy. The debates continued: Steffens ridiculed Joseph Wood Krutch; Haakon Chevalier, a professor of romance languages at the University of California, lambasted Max Eastman; Carey McWilliams, as noted earlier, argued with Upton Sinclair. McWilliams, a frequent contributor, produced articles that covered the entire spectrum of his interests, including "Little Magazines in the West," the Constitution Society of the United States, an orange pickers' strike in Southern California, and the "repatriation" of Filipinos. He wrote sarcastically about the relief policies of the federal government and of the attitude of a liberal Jewish group that, like Chester Rowell, condemned Communism along with fascism.[5]

Bassett asserted his ideological independence from the warring factions he encouraged. He stated his position: "A cementing of the forces which are today striving to destroy the capitalist control of our government can best be served by unlimited presentation of the truth in our economic and social life."[6] In the spring of 1936, however, a power struggle began to simmer. Bassett was challenged by a group among the contributors who wanted the *Pacific Weekly* to follow the Communist Party line.

Bassett was determined that the *PW* would "not be 'just another propaganda magazine.'"[7] In the April 13, 1936, issue he announced a break with Steffens and Winter. Their names disappeared from the masthead, but only for a short period. Bassett was unable to get the backing he needed to carry on independently. At a strategy meeting, the opposition took control. The June 9 issue announced that the ownership had passed to the Carmel Press, Inc.

"'We' have 'seized' the Pacific Weekly," Steffens wrote to Robert Cantwell.[8] Bassett went on with the *Cymbal,* which he edited until 1941. Steffens became at least nominally the new editor-in-chief of the *Pacific Weekly.* He sent out a rambling letter of solicitation for funds, closing it with "Yours, anyhow."[9]

98

Steffens's energy was failing. He entertained the idea of making a return visit to Russia, but his health was too fragile for such a rigorous journey.[10] He spent a good part of each day in bed with his portable typewriter propped up in his lap, writing his column, reviewing books on the Soviet Union, and corresponding with his friends. When his old muckraking associate Fremont Older had a heart attack in October 1934, Steffens had suggested, "Perhaps we can agree on a date and go together."[11]

Older lived a little less than six months.[12] In the final stage of a career that he began as a fiery crusader, he had come to a position of resignation. He wrote, "I used to think if we tried hard enough we could reform the world by next Wednesday at exactly four o'clock. Now I know it will take many millions of Wednesdays to make things any better." He was "not especially interested in whether Capitalism is dead or not, or whether or not Communism is coming. Maybe it matters to those who have reasonable hopes of a stretch of years ahead." He had become skeptical about human nature. "I might become more excited about the situation if I hadn't learned through experience that power is never intelligently used, no matter who acquires it."[13]

Steffens expressed disillusionment of a different kind. Shortly before his seventieth birthday, in the spring of 1936, he wrote to a friend that California "seems like a dumb, respectable, vigilante state to me, ready with the rope and the righteousness."[14] His last writings were characteristically varied. He praised Roosevelt's acceptance speech at the Democratic convention in July: "we vague Democrats foresee his election by a decisive majority."[15] Early the following month he wrote a tribute to the Loyalists in Spain in answer to a request from the *New Masses* to make a statement about the newly erupted civil war.[16] One of his last letters was addressed to his ten-year-old son, Pete, who was visiting relatives on a ranch near Santa Barbara. Recalling his own childhood in and around Sacramento, he advised him: "A boy who can swim and ride a horse can always escape in the night. Or in broad daylight."[17]

Among the tributes that arrived after Steffens's death on August 9, the most eloquent came from members of his profession—who thirty years later would put up a plaque in his honor at the gate of his house.[18] "He was something of

a Socrates among journalists," wrote Allen Griffin, the editor of the *Monterey Peninsula Herald*.[19] The *San Francisco Chronicle* called him "a Tolstoyan and a Christian"—terms that had also been applied to Older—and referred to his career as a muckraker: "In no small way he helped the development of American democracy." These words were probably written by Chester Rowell, who gave his own personal evaluation: "Certainly, of all the communists in the world, he was the least dangerous."[20]

Ella Winter confided her grief to Sara Bard Field, who was one of the few friends who had attended her wedding.[21] Winter found an outlet for her feelings in beginning the project, with the help of Granville Hicks, of collecting and editing Steffens's letters. She also plunged into the more immediate task of planning a November 9 memorial issue of the *Pacific Weekly*. She solicited original works by a number of California writers, including William Saroyan, who had burst onto the national literary scene in 1934 with stories that grew out of his life with Armenian relatives and friends in Fresno. Louis Adamic, relocated in the East, sent a piece entitled "Pittsburgh." Steinbeck's contribution, which he called "Breakfast," was a description of a domestic moment in the life of a migrant farm worker family. He referred to it later as "one of the thousands of working notes" for *The Grapes of Wrath*.[22] Interestingly, the sketch has a trace of a psychological-biological-sexual motif that he had developed more fully in *In Dubious Battle*, where an attraction develops between a young migrant mother and the labor organizer Jim.

Ella Winter was surprised and touched by the offering of Robinson Jeffers, one of seven poets she asked to contribute their work to the memorial issue. In Steffens's honor Jeffers wrote "Silverguenza," which celebrates the Loyalist cause in the Spanish Civil War. "He *is* in the present-day struggling world, whether he wants to be or not," Winter wrote to Sara Bard Field after Una Jeffers brought her the poem.[23] Winter also used the *Pacific Weekly* to publicize the Western Writers Congress, which was in the planning stage at the time of Steffens's death and was later dedicated to his memory. The congress, held in San Francisco on the second weekend in November, was inspired by the American Writers Congress that had met in New York City eighteen months earlier. The original congress, dating from the era before the "popular front," was limited to Communist Party members and "fellow travelers." The San Francisco Congress was by comparison broad-based.

Carey McWilliams, who was in charge of the advance planning, invited

California writers from across the board politically, and up and down the state geographically, to attend or sponsor the proceedings. He canvassed friends in Southern California: Lawrence Clark Powell, Hildegard Flanner, and Jake Zeitlin. He tried, without success, to interest Gertrude Atherton, Kathleen Norris, Cora Baggerly Older (Fremont Older's widow), and George Creel, but Upton Sinclair, who had defeated Creel in the Democratic gubernatorial primary in 1934, agreed to be the keynote speaker. The list of sponsors included Henry Alsberg, the head of the Federal Writers Project, and James Hopper, who headed the Project's Northern California office, as well Sara Bard Field, Miriam Allen de Ford, Janet Lewis, Mabel Dodge Luhan, Mike Quinn, Kenneth Rexroth, Marie de L. Welch, George West, Irving Stone, and Michael Gold.[24]

Henry Chester Tracy asked to have his name removed from the list of sponsors. He did not want to be part of "a movement to proletarianize literature. . . . I don't recognize any Right and Left in literature," he wrote McWilliams. "If there exists a gap, I don't care to widen it."[25] Humphrey Cobb, the author of *Paths of Glory,* a successful, recently published book with an antiwar message, expressed similar views but overcame his reservations and agreed to speak.[26] The *San Francisco Chronicle* reported Robinson Jeffers's statement that he declined to attend because he doubted "that culture can be maintained by conventions and committees." The paper also quoted one of the panelists, Margaret Shedd; in what may have been a gesture of retaliation, Shedd placed Jeffers on a list of "sentimental writers"—along with Hemingway, Faulkner, and Saroyan—who "committed the sin of failing to write about things as they are."[27] Saroyan and Steinbeck had been invited to be sponsors but apparently did not attend.

The congress met at the Scottish Rite Auditorium on November 13, 14, and 15, a weekend when the attention of the public and the press was focused on festivities connected with the opening of the San Francisco–Oakland Bay Bridge. The gathering was "semi-political" and "semi-literary," in the recollection of the poet and novelist Janet Lewis, who came up from Palo Alto and sat next to the San Francisco poet Kenneth Rexroth.[28] According to the *Chronicle,* the emphasis was on opposition to fascism; a slogan was coined, It *Can* Happen Here, a reference to the Sinclair Lewis novel that was currently being serialized in the paper. The reporter recorded Carey McWilliams's statement that it was the "right of writers to take an interest in the preservation of civil lib-

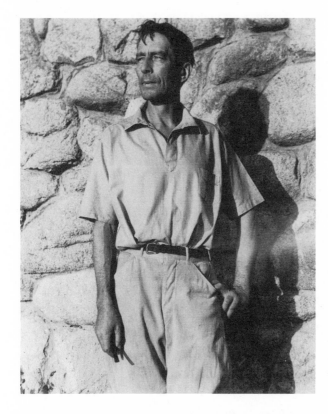

Robinson Jeffers in
the 1930s. Portrait by
Sonya Noskowiak.
Photographic Collec-
tion of the Huntington
Library. Reproduced
by permission of The
Huntington Library,
San Marino, Califor-
nia.

erties," then quoted Charles Erskine Scott Wood's indictment of California as
"the most unconstitutional state in the union" and the message of John D.
Barry, the *San Francisco News* columnist, that writers should heed the call of
labor and "throw off their chains." The delegates listened to a final speech from
Harry Bridges. Some of them went to San Quentin to visit Tom Mooney.[29]

On the last day of the meetings the *Chronicle* reporter, Abe Melinkoff, had
a wonderful time interviewing Dorothy Parker, who had flown up from Hol-
lywood with her husband, Alan Campbell, and another screenwriter and bon
vivant, Donald Ogden Stewart. A witty, good-natured man, a humorist by
profession as well as by inclination, Stewart had developed political convic-
tions in the mid-1930s that led to his becoming the chairman of the Holly-
wood League Against Naziism. He wrote later about his reaction when Ella
Winter rose to speak to the gathering about a letter from Steffens to Harry
Bridges that had recently come to light. Before she was introduced, Stewart
had a mental picture of the widow of a septuagenarian. He "awaited grey hair

and a few sad but brave wrinkles." Instead, he saw before him "a handsome, middle-aged brunette who had the most extraordinary black eyes, alternately luminous and flashing, as she spoke in a charming British voice."[30] Surprised and smitten, he rushed to be introduced. For Ella Winter, a scholarly-looking man with a sense of humor had a familiar appeal. It was the beginning of a new chapter in her life.[31]

The spirit that animated the Western Writers Congress can be discerned in at least one of the works mentioned by Irving Bernstein as representing the literary legacy of the CAWIU.[32] Haakon Chevalier, who with his wife, Barbara, was a leading organizer of the congress, published *For Us the Living* thirteen years later.[33] He dedicated the book to his children as "the testament of my generation, its travails, its passions, its possibilities." There may well be an autobiographical element in the attitude and experiences of his character, Dr. Morgan, a university professor who, in anticipation of the visit of a conservative son, removes copies of the *Nation* and the *New Republic* from his bookshelves. Later, when his home is attacked by vigilantes, the raid has the effect of converting the son to the father's political outlook. The scenes at the university, where the professor encourages a promising young student, are more convincing than a melodramatic plot involving the murder in a San Francisco hotel of the supervisor of a large Central Valley ranch. A sympathetically portrayed strike leader is an innocent suspect in the murder, as is the victim's widow and Morgan's student, whom she later marries before he goes off to fight in the Spanish Civil War. These good (and politically correct) characters are all exonerated when a ranch foreman confesses to the crime. He turns out to be a German émigré with Nazi sympathies who is acting as a spy between management and labor.

The elements of Chevalier's story are only slightly more believable than those in another novel mentioned by Bernstein, *Parched Earth* by Arnold R. Armstrong.[34] A Communist labor organizer is a sympathetic character in this book, which depicts a strike of cannery workers in a company town in a California agricultural valley. There are references to imminent revolutionary changes in the country, but the author relies on generalized symbolism, rather than topical political allusions. The factory and its avaricious, hypocritical owner, along with the self-righteous members of the town's Improvement Association, are swept away in a flood when a dam is destroyed by a half-witted boy who is the unacknowledged illegitimate son of the factory owner. His

mother, a *Californio* descendant, along with her neighbor and ally, who comes from Anglo pioneer stock, are the truth-tellers in this melodramatic tale and have been treated as pariahs by the majority of the town's citizens. It all comes right in the end. As the wicked perish in the flood, the salt-of-the-earth Anglo woman survives to foretell a new day of hope. *Parched Earth* is an example of a proletarian novel that could appeal only to the most credulous readers, those so accepting of its political message that they could overlook the heavy-handed plotting and the stock characters. It is interesting to compare it with *In Dubious Battle,* which broke the mold and was criticized by a publisher's reader, as noted earlier, for its nonconformity with marxist doctrine.

The Palo Alto novelist Charles Norris, like Haakon Chevalier, approached the subject of labor conflicts from an intellectual perspective. Charles did not fit into the naturalistic tradition that had inspired his older and more famous brother, but he followed Frank's lead in writing about contemporary controversies. He tackled such vital issues of his own generation as women's rights, birth control, and the California strikes of the 1930s. Charles, or CeeGee as he was known to intimates, was an intelligent, conscientious man placed in a difficult position. He lacked the natural ability of his brother and the facility of his wife, Kathleen, who turned out a remunerative stream of popular fiction with seeming effortlessness. His real talent seems to have been in business dealings, in promoting and marketing their work, but he felt obliged to follow the family literary tradition. He did this by acting against his natural sociable inclinations, forcing himself into seclusion and following a strict regimen of work—a process that he compared to putting on a hair shirt.[35]

The eleven novels that Charles Norris produced by this process are no more than mediocre as fiction, but they are valuable as social history. His biographer has written that he "was perhaps most praised (even by his detractors) for a fair-minded dedication to the most complex social and political issues of his day."[36] The key word is *fair-minded.* While he was working on *Bricks Without Straw,* his 1938 novel about contemporary ideological controversies, he asked a young relative to write a defense of Communism in a letter that Norris then used verbatim, attributed to one of his characters.[37] He also invited Harry Bridges to have a meal with him at the Bohemian Club, an overture that may have cost him his nomination for the presidency of the club.[38]

These anecdotes help to explain the artistic failure of *Bricks Without Straw* and Norris's last novel, *Flint,* which has as its background the San Francisco

waterfront strikes. (Most of the action of *Flint* takes place in the city, but there is a sympathetic passing reference to an agricultural labor organizer named Pat and to the trial that followed the raids on the office of his union.)[39] Conscientious as he was to get the subject right, to convey the strikers' viewpoint, which he articulated more eloquently than the position of the shipowners, Norris was handicapped by the fact that his protagonist in *Flint* was a habitué of the drawing room and the boardroom. Although this man and his family are doomed by their ties to moribund tradition and untenable values, they, rather than the representatives of the workers, set the tone of the novel. Most of the characters on the labor as well as the management side of the conflict are wooden. The plot, although well crafted, is melodramatic to the point of being unbelievable.

While he was at work on *Flint,* Norris read *The Grapes of Wrath,* an experience that humbled him. In a letter to the book critic Joseph Henry Jackson, he spoke of his own "feeble effort. . . . I'm tackling a much harder job than Steinbeck—with . . . one twentieth of his ability."[40] The heart of the matter was that he lacked Steinbeck's passion. It was a flaw fatal to fiction. Steinbeck could start with a real-life situation, as he did when writing *In Dubious Battle,* and translate it into compelling drama. The reader experiences the events in emotional terms. There is poetic, rather than literal, truth in Steinbeck. Norris, by contrast, never raises the reader's temperature. His plots are contrived. His characters are stereotypes. He was deficient in the skills in which he compared himself to Steinbeck, as he understood only too well. Yet the qualities of accuracy and balance that were liabilities in his work as a writer of fiction made him credible—more credible than Steinbeck—as a social historian. Unfortunately, this was not a role to which he aspired.

Louis Adamic had the workingman's viewpoint that Norris lacked. He also had a simplistic, reckless approach to contemporary issues, in contrast to Norris's conscientious coolness. In *Grandsons,* published in 1935, Adamic covered American labor conflicts involving several generations of a family that had emigrated from Slovenia. The grandfather is killed at the Chicago Haymarket Massacre in 1886. One of his descendants, an organizer for the IWW, is imprisoned for violation of the California Criminal Syndicalism law. On his release from San Quentin he joins an organizing campaign near the town of "El Campo" in the "Empire Valley" and is killed. His cousin Peter, the narrator, is critical of the dead man's widow for trying to extract the maximum politi-

Charles Norris. Courtesy, The Bancroft Library, University of California, Berkeley.

cal profit from his death. Peter is concerned that the couple's little boy is being raised by his mother to be "a great revolutionary, a sort of American Lenin."[41]

Peter rejects the superficial intellectuals (called "infantile leftists" by Lenin himself) and the "hothouse reds" of the Class War Prisoners' Defense Committee as "headline people." Their parading with pro-USSR signs "diffused and balled up the local issues. . . . All the radicals from Los Angeles and San Diego were busy as the devil, mostly trying to fool themselves they were doing something big and important for the working-class."[42] Adamic, having established the credentials of his hero's labor background with a convincing authority, was free to condemn the motives of hangers-on attracted to the trendy radicalism of the era.

In his 1938 nonfiction book *My America,* Adamic elaborated on these ideas in a section titled "Notes on the 'Communists' and Some American Fundamentals." He described the appeal of Communism for young Americans in the early 1930s: "For one who wanted to do something, who wanted to see some-

thing done or happen, there was early in the depression no other party to which to turn, seemingly no other vent by which he could release his pent-up, incoherent sense of rebellion against the forces that had taken away his employment, reduced life to a series of petty bickerings within his family, and threatened to make him in his late 'teens or early twenties an empty, despairing creature." Contemporary reports on Russia by Maurice Hindus, Walter Duranty, and journalists both mainstream and Communist-oriented were influential in this regard, Adamic added.[43] He did not mention Steffens.

Adamic credited the Communists between 1930 and 1935 with "stirring the country to politico-social consciousness and thus, in preparing—unwittingly—the way for the New Deal." This is an interesting hypothesis in the light of the mutual hostility and mistrust between the Communist Party and the Roosevelt administration until 1935. According to Adamic, the Communists' threats of revolution, frightened "naturally conservative, but uninformed middle-class people into supporting, however half-heartedly the New Deal reforms and immense relief expenditures during 1934–1937." Adamic relegated Communists to the "lunatic fringe," however. Although Party members and their supporters included "some of the essentially best, that is, most idealistic individuals in the country . . . [in] their quality as persons [they] never had much chance to project themselves into the movement." The national leadership of the Party "was (and is) largely mediocre, crackpot, exhibitionistic," he insisted. It did not grow "from American roots" but was "an extension of an international movement" being "run arbitrarily by a small inner group in compliance with orders from the Comintern."[44]

The Steinbeck scholar Robert DeMott wrote of Adamic: "Like Steinbeck, he distrusted drawing room theory, and rejected ideology for experience; like Steinbeck, he sought a type of radicalism consonant with the American sensibility and democratic traditions."[45] Evenhanded in his praise and blame, Adamic demonstrated a concern for truth and a consequent disregard for orthodoxy and the penalty for speaking out that are reminiscent of George Orwell. Adamic was by comparison emotional and clumsy, naïve and primitive in his expression—My America was no Homage to Catalonia. But the book represented an idealistic hope, the belief of an immigrant that his adopted country would accept the kind of candid discussion of political and labor issues that was carried on in Europe—including the pros and cons of the movement that promoted the California agricultural strikes of the 1930s.[46]

9

FOLLOWING THE FORGOTTEN AMERICANS

According to the critic William Stott, Louis Adamic's *My America* was the best-selling of the "I've seen America" books of the 1930s, a decade in which chronicles of the road by writers traveling to and through different parts of the country became a popular literary genre.[1] Adamic estimated that he "traveled perhaps 100,000 miles, by train, by automobile, by plane, as well as afoot, pausing here and there to look and listen, to ask questions, to get 'the feel of things.'"[2]

Novelists, journalists, and social scientists followed victims of the Great Depression, the jobless who pulled up stakes and set off trying to find a way to make a fresh start or simply to survive. "The wanderers, male and female, are almost a new race in America,"[3] Sherwood Anderson wrote in a book characteristic of the 1930s. Writers responded to the cultural imperative of the times—that situations involving extraordinary hardship and dislocation could be conveyed most effectively through eyewitness accounts. Anderson's book *Puzzled America* appeared in the same year, 1935, as *Some American People*,

Erskine Caldwell's chronicle of "looking for America at its whistle-stops." After that, according to the critic Vicki Goldberg, writers "flocked across the Midwest, the South, the prairie towns, the back alleys in factory cities, combing the country for clues to its psyche. The need to understand America was so pressing that the roads were clogged with inquiring reporters."[4]

108

The accounts written by people who were themselves undergoing the experience had particular validity. An unemployed insurance agent who set down his impressions of wandering through thirty-two states found the West Coast to be warm enough so that he could sleep in his clothes, but the homeless shelters in California were a mixed blessing. They ranged from a clean, well-equipped Salvation Army dormitory in Santa Barbara to a Volunteers of America facility in San Francisco where he was sent to the "mourners' bench" to be interrogated about his future plans. After months on the road, his patience was exhausted. Writing in the spring of Roosevelt's inauguration, he asked, "How much longer will the Starvation Army, composed as it is of once respectable men, bear eking out a miserable existence in a land of plenty?"[5]

In July 1933, Harry Hopkins, soon after he launched the Federal Emergency Relief Administration, hired the journalist Lorena Hickok for a special assignment: "What I want you to do," he told her, "is to go out around the country and look this thing over. I don't want statistics from you. I don't want the social worker angle. I just want your own reaction as an ordinary citizen. Go talk with preachers and teachers, businessmen, workers, farmers. Go talk with the unemployed, those who are on relief and those who aren't. And when you talk with them don't ever forget that but for the grace of God, you, I, or any of our friends might be in their shoes."[6]

A detailed analysis of the impact of the jobless on California was compiled a few months later by two social workers, William T. Cross (who was recruited to work in the Federal Transient Service, created under the Emergency Relief Act on May 12, 1933) and his wife, Dorothy Embry Cross. They reported that although the movement of people around the country was to some degree random—they went where the freight trains took them—the tide flowing into California was "of flood proportions," reflecting the demographic trend that began in 1849. California represented "the end of the trail."[7] This phrase took on a tragic meaning as the economic opportunities that had flourished since the gold-rush era appeared to be closing down. A mandatory stop in the California journey of the literary critic Edmund Wilson, gathering material for *his*

depression book *The American Jitters,* was a trip to San Diego, which had the highest suicide rate in the nation.[8]

As measures were proposed to stem the tide of new arrivals, estimated to be coming across the border at a rate of 1,200 to 1,500 a day in the fall of 1931, some among the state's six million established residents blamed the boosters who had long promoted expansion and tourism with what one historian called "a constant barrage of come-hither-to-Paradise advertisements and inducements."[9] There was irony in the fact that in Los Angeles, which had earned its own nickname as the "transient capital of America," the Chamber of Commerce sent a delegation to Sacramento to ask Governor James Rolph to station units of the National Guard at border crossings to block the entry of newcomers. A proposal was made to set up concentration camps at Needles and Truckee. Instead, the Republican governor established 250 labor camps, subsidized by state funds and the Hoover administration's Reconstruction Finance Corporation. Over 6,500 men worked in state forestry camps between 1931 and 1933, when the New Deal's Civilian Conservation Corps (CCC) came into the field.[10]

109

These enterprises provided employment for only a fraction of the new arrivals. William Cross in his role with the Federal Transient Service conducted a one-day census of the homeless in forty-eight of the fifty-eight counties in California on September 1, 1933. Of the approximately 110,000 individuals counted, 59 percent were men, 18 percent were boys, and 23 percent were women and girls. A little over half of the total number were classified as transients—i.e., people who had been in the state for less than a year.[11]

The census was preceded by "a field investigation among itinerants traveling by railroad and by highway." One of the researchers hired to work undercover was twenty-five-year-old Melvin Belli, who had just graduated from law school at the University of California's Boalt Hall. With a partner, Belli began work about the first of July by going to the Central Valley and jumping on a freight train. For about six weeks he and his partner rode trains all over the state and slept in Salvation Army shelters, under railroad bridges, and on the ground in hobo jungles while they successfully passed themselves off as transients among the people they were studying. Belli did not take notes. At the end of the assignment, he wrote a report based on the facts and impressions he remembered.[12]

In the temporary settlements Belli found single men and families, includ-

ing babies and nursing mothers. In an interview some sixty years later, he recalled: "There were very few old-timers. Most of them were pretty young. . . . There were very few businessmen or graduates of universities, but there were a lot of common sense people and fairly decent people. . . . We were told to watch out for any signs of revolution, but we didn't see anything like that because there were no leaders who were talking revolution. I didn't hear much complaint about the government except they all wanted a job." Somebody always had a radio, and they would all sit under a railroad bridge and listen to Roosevelt. "There was no organized crime [such as] gangs going out to rob a store." People shared what they found or begged: day-old bread from bakeries, a butt of bacon. "They'd bring it back and have a communal cooking of whatever it was."

Other researchers mentioned the poor physical condition of the people they traveled with, but Belli's impression was that the transients were "getting by healthwise" despite the small quantity and poor quality of the food they were offered at shelters and jails or were able to scrounge for themselves. Through necessity he himself learned how, as well as when and where, to panhandle. On the rare occasions when he shed his identity for a few hours and went to a hotel for a shower and a meal, he felt guilty.

The two things Belli enjoyed most about the job were talking to the people he was observing—mainly about national events, since they resented any prying into their personal lives—and riding the rails. "When a freight train would start out, it would be as if the ground became alive as all these people would rise up." Running to get aboard was very dangerous. He never saw the accidents reported by other investigators, but he once averted one by grabbing the arm of a girl who had lost her balance and was about to go under the wheels. Riding in the boxcars was rough. "When the train was going downhill and they put on the brakes, the car would shudder and almost shake the fillings out of your teeth." They got a smoother ride in the tender behind the engine. It was an unforgettable experience. "The maroon smoke blew overhead and wafted over you in the warm air around Palm Springs and San Berdoo under the full moon. There were all these people huddled there quiet, immersed in the spirit of moving along."

There was only occasional interference from brakemen or other train employees. The investigators got the impression that the railroads, as well as the long-distance buses, were lenient toward free riders. But the police, particu-

larly in Los Angeles, were hostile. Belli remembered that "the sheriff's posses would meet the trains and beat up the people, trying to run them out of the state or run them into jail. . . . Here were people who couldn't get a job herded into jail and fined, not because they didn't want to work, but because they couldn't *get* work."

Pulled off the trains with one group after another, Belli "went to jail all over Southern California. . . . The worst jail was in San Diego. The food was vile. There was mildewed bread, rancid coffee. And the quarters were particularly vile. There was no place to lie down. You'd be standing up. People would be relieving themselves on the floor. Then you'd be herded into court." He had a Sacramento telephone number to call if he ran into trouble, but he never used it.

In the courts the usual charge was vagrancy, "which was a crime then." Those arrested "did not understand the alleged rights that were read to them or what was going to be done to them . . . although usually they were given a suspended sentence or simply checked out." In the San Diego courtroom, Belli was released to stand trial in six months. When he returned on the specified date in December to defend himself as a practicing attorney, he had the satisfaction of getting "the biggest award that had ever been given up to that time [for false arrest on a vagrancy charge] by a jury down there."[13]

In their report, which incorporated the findings of Belli and other researchers, William and Dorothy Cross noted: "As the floating population along the highway and railroads was observed during the summer and fall of 1933, it constituted not so much an itinerant labor group as a moving mendicant population." The authors estimated that "perhaps ten to fifteen per cent of the total" were pre-depression hobos. An additional 25 percent to 30 percent had *become* hobos: "The skilled appear to be pushing the unskilled into casual labor or into the discard."

The federal government was prepared to intervene. "The handout-and-godspeed method, sanctioned by pioneer tradition, was to be ended. . . . no 'passing-on' will be tolerated except by a reference center to a treatment center within the state." As a supplement to the CCC camps, the Federal Transient Service planned to create a chain of shelters offering food, clothing, bathing facilities, and medical care in exchange for one to three hours of work a day by each registrant. The five major shelters in the northern part of the state were to be located in San Francisco, Oakland, Sacramento, Stockton, and San Jose.[14]

While describing and planning for out-of-work city dwellers, the Crosses reported the presence of a separate group of "crop-followers" and "westward-moving migrants."[15] If impoverished newcomers in general were the victims of misperception, these migrants were doubly handicapped because they were cast into a prescribed role by individuals and institutions, including the press, involved in the recent and continuing farm labor warfare in the state. The controversy they provoked took some of the same form as that surrounding the urban transients but was far more emotional.

In 1933 these "crop-followers" and "westward-moving migrants" did not excite much notice, but the following year their number increased in the wake of a natural disaster that presented another challenge to the New Deal. In 1934 a huge stretch of farmland from the Rio Grande to the Canadian border was baked by record heat and ravaged by scouring winds after months of no rain. The winter and spring wheat crop that year was the smallest since 1893. Corn stood in stunted rows. Cotton plants withered. By late July cattle were dying by the thousands in Oklahoma, where temperatures reached 117 degrees. The federal government responded with an emergency program to dig wells and transport water to save livestock, while a million and a half people went on relief.

In June, Paul Taylor, on his first New Deal assignment, visited a corner of the area that was soon to be called "the dust bowl." The opportunity came at a transitional moment in his research. He was in Washington, D.C., studying self-help cooperatives for the resident unemployed, organizations that were becoming less relevant as the programs of the Roosevelt administration began to make an impact. A friend he encountered in the FERA offices proposed that he join an inspection tour to the northwest quarter of North Dakota as a dollar-a-year man.[16] As a graduate of the University of Wisconsin, which emphasized the contribution of social sciences to government, Taylor was primed to serve in the New Deal. He was particularly interested in the projected agricultural reforms of the Resettlement Administration under Rexford Guy Tugwell, some of which were about to be initiated in response to the drought.

Taylor was invited to report in any way he wanted on what he saw firsthand. From the scene he wrote a succinct summary of impressions and conclusions that seems to have been a composite of his own observations and those of other members of the group.[17] In enumerating the problems encountered by

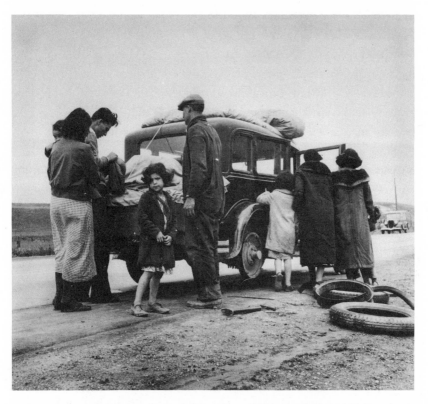

A Mexican migrant family stops for roadside repairs in California, February 1936. Dorothea Lange photograph, U.S. Farm Security Administration, Library of Congress.

people in the area, he mentioned "communist agitation." This was a reference to the Farm Holiday Association movement, which had gained some momentum among stricken farmers in the Midwest and engaged the interest of the novelist and reporter Josephine Herbst, a contemporary of Taylor's from his hometown of Sioux City, Iowa. Taylor indicated his opinion of its significance by comparing it with "the grasshopper menace."

In his report Taylor focused on questions of climate and topography, writing with an authority that suggests he had consulted with an agronomist on the inspection team or had been influenced by the writings of John Wesley Powell. Taylor noted that the drought "had borne very unequally on different portions of the broad region affected." Its impact on the eastern part of the area he surveyed was temporary, he thought, and could be relieved by such measures as building dams and terracing fields, and by introducing "subsistence

homesteads"—measures that were being proposed by the Resettlement Administration. But in the western part of the region—the area designated by Powell as beyond the one hundredth meridian—the effects of light, fluctuating, and "possibly declining rainfall" seemed to be permanent. Taylor concluded that a "balanced" agriculture suited to his native Iowa was not feasible in the Great Plains. He proposed that the land in this area be purchased for grazing, an idea that has continued to be promoted over the years.[18]

Taylor suggested that families who were unable to survive on the arid land be helped by the government to transfer to better farming areas within the state or in other states. He did not anticipate the fact that rural families in distress would not wait for the government to resettle them but would head west on their own initiative. Lorena Hickok, who was in the drought area in the same period, reported to Harry Hopkins on the covered-wagon loads of displaced Minnesota farmers "who were just roaming about the country like gypsies."[19] "After the drifting dust clouds drift the people," Taylor wrote a year later. "Over the concrete ribbons of highway which lead out in every direction come the refugees."[20] He noted that the uprooted tended to travel along a horizontal line.[21] Nebraskans and Dakotans who went to Oregon and Washington, states that had been homesteaded by people from the northern plains, were assimilated more easily than the people from Oklahoma, Texas, Arkansas, and Missouri who traveled across the Southwest into California, where, in the words of William and Dorothy Cross, "desirable free or cheap land for homesteading has been practically non-existent."[22]

As Taylor noted, in the 1920s there had been an influx of people like the Hamett clan from the south central states who arrived when cotton was introduced in the San Joaquin Valley. Some of the group changed occupations or moved to other areas, while those who stayed brought their traditions and culture to the cotton-growing region of California. In the 1930s the new arrivals seemed more numerous because of the public's perception of them as a destitute group that was, moreover, taking the place of the departing Mexicans in the farm labor wars. As the newcomers crossed the state border in vehicles laden with their children and all their household possessions, they were conspicuous. So it was that observers like the photographer Dorothea Lange, who worked with Paul Taylor to bring public attention to their situation, got the impression of people arriving in "a deluge."[23]

10

PAUL TAYLOR FINDS A PHOTOGRAPHER

Dorothea Lange isolated the experience that led her into documentary photography. One morning in the early years of the depression, she was standing near the south window of her San Francisco studio. Looking out, she noticed a young workman coming up the street. She assumed that he was unemployed because he appeared indecisive and hesitant about where to go, what direction to take, at an hour when he would have been at his job if he had one. She seemed to read his history in his posture and gait. Watching him, she felt an impulse to take her camera into the streets. The decision was not so sudden as it seemed. As she recalled the circumstances, she was weary of personal and professional constraints and wanted to attempt something new in her work. She felt she needed a challenge outside her accustomed field of portrait photography; at the same time, she was fearful about the difficulties involved.[1]

Lange was better prepared for the experience than she perhaps realized, since the most satisfying moments of her childhood had been those that she spent walking around the streets of New York City. She commuted to school

by ferry from Hoboken, New Jersey, where she was born in 1895, of German parentage. After school, while she waited for her mother to finish her working day, Dorothea wandered everywhere, absorbing impressions, experiencing a communion with her surroundings that was "like making all parts of the world your natural element." She felt invisible. "I knew how to keep an expression of face that would draw no attention, so no one would look at me."[2] Although she had a decided limp, a legacy from a bout of polio when she was seven, and was conscious of it around other people, she carried into adulthood a sense of knowing how to be an unnoticed observer.[3]

"I became a sort of solitary through those years," Lange said later.[4] She chafed at the confinement of school, the rigidity of the curriculum. On occasions when she could tolerate it no longer, she left the building without telling anyone. One day she walked from 108th Street clear down to the Battery at the foot of Manhattan Island. She felt no compunction. It was her business to look at pictures, at people, and at ordinary sights: when she saw a line of washing hung out near the Hackensack Meadows, she thought it was beautiful. She was going to be a photographer, she announced, when the family discussed her future. The elders insisted she take teachers' training so that she would "have something to fall back on."[5] Still commuting, she enrolled at a teachers' college in New York but spent every spare moment after 3 P.M. and on weekends hanging around photographers' studios.

She knew what she wanted. Her aplomb impressed other people and got her into a class taught by the noted experimenter Clarence White at Columbia University. She was taken on as an apprentice by another well-known photographer, Arnold Genthe, who specialized in portraits of celebrities. Working in off hours at his Fifth Avenue studio, she made proofs, retouched negatives, and, occasionally filling in as a receptionist, intercepted the telephone calls of his clients, including appeals from importunate women. Lange decided that Genthe, "an unconscionable old goat who seduced everyone who came in the place"[6] (though he did not succeed with her), had a lover's talent for bringing out the best in women with his camera. Genthe had lived in California—for a time in Carmel. He had been shaken out of his niche on the West Coast by the San Francisco earthquake of 1906, but not before leaving an important historical legacy, pictures of the people of pre-earthquake Chinatown as well as of the rubble-strewn streets of the damaged city.

Lange's future husband, the western artist Maynard Dixon, also fled to New

York after the earthquake, but only temporarily. They met in San Francisco, where she settled more or less by accident in 1918. In the face of intense family opposition, she and a girlfriend, a Western Union clerk, decided to pool their cash of $140, leave home, and travel around the world, confident that they could support themselves when their money ran out. That happened sooner than they expected: they were robbed in San Francisco and had to go to work. Dorothea got a job in a photofinishing store, where she met Roi Partridge, the husband of the photographer Imogen Cunningham. With her drive, style, and good looks, Lange soon won a place for herself in the local art scene and found a backer to help her open a studio of her own at a good address, 540 Sutter Street. She was young, under twenty-five, but her experiences in New York with Genthe and in the studio of Aram Kazanjian, where she had learned the business end of the trade, prepared her for independent success. In her reception room she created a simple but dramatic setting where she entertained artist friends as well as customers—many of whom were wealthy, civic-minded patrons of the arts. She understood the nuances of reputation and fees. She had the cream of the trade. She was the person to whom you went if you could afford it. Her specialty was studies of families, particularly mothers and children. She tried to please people, but without flattery, to portray them honestly. "I didn't do anything phenomenal," she said later. "I wasn't trying to."[7]

Her methods separated her from her colleagues, including Willard Van Dyke, Edward Weston, Ansel Adams, and Imogen Cunningham, who formed the f.64 Group, in which they experimented with the high resolution and maximum depth of field obtained by using the smallest aperture—f stop 64—of their cameras' lenses. The resulting prints, in which a small part of an object might fill the paper while the nature of the whole was unrecognizable, produced a sometimes surreal effect very different from the recognizably human moods and relationships portrayed by Lange. She was not invited to join f.64, an oversight that her husband Maynard Dixon offered to protest by sending the members a closeup shot of a portion of his nude body. But in any case, artistic experimentation did not fit Lange's notion of photography as a trade and of herself as a "tradesman." Her insistence that she was an artisan, rather than an artist, stemmed from the fact that she earned her living by photography until her marriage, after which she continued to contribute to the family income with her commissions.

Maynard Dixon was twenty-one years older than Lange. When she married him in 1920, he was renowned both as a gifted artist working in the tradition of Frederic Remington and as a "San Francisco figure," a tall, lean, ruggedly handsome man who wore cowboy boots under his painting smock and decorated his studio with Indian and western artifacts. He had a versatile talent. He executed murals, illustrated books and magazines, and designed billboards to subsidize his sketching trips to the Southwest and his painting.

Lange contributed her own dramatic flair to Dixon's reputation as a Montgomery Street legend. To their inner circle of friends, as well as to patrons who expected artists to be bohemians, they were a memorable couple. Her response to him was to match his pace and accept him on his own level. She knew he was a born artist with "remarkable facility and an extraordinary visual memory. . . . That very narrow, flexible hand of his could put anything he wanted it to on a piece of paper." But she criticized herself later for not acting on her intuition that he was capable of more. "Had I been really participating I could have encouraged him to dip his brush in his own heart's blood."[8]

Lange was ambivalent about her own work. She said later, "All the years that I lived with him, which were fifteen years, I continued to reserve a small portion of my life . . . out of some sense that I had to—and that was my photographic area."[9] Her words sound defensive. On the expeditions they made to Arizona and New Mexico—to recharge Dixon's artistic batteries—he sketched while she kept the domestic machinery running smoothly. On a trip to Taos in 1931 she noticed a man driving past every morning in a Ford. Learning that he was the photographer Paul Strand, she was amazed, for "it was the first time I had observed a person in my own trade who took his work that way. He had private purposes he was pursuing. . . . I didn't until then really know about photographers who went off by themselves."[10] Her working hours had been limited to her studio and the homes of clients. The rest of her time was devoted to Dixon and their two sons, Daniel Rhodes, born in 1925, and John Goodness, born in 1928. In her retrospective view, she and the little boys were a closely knit unit slightly removed from the profane, charming, irrepressible husband and father, inventor of romps and jokes and holiday traditions.

The Dixons' lightheartedness was dampened by the Great Depression. Art commissions declined. As an economy measure after their return from Taos, they gave up their home, sent the boys to boarding school, and began living

in their separate studios. Lange was upset by the dislocation of the family. The impulse to take her camera into the street was in part a response to an emotional void. She explained that "if the boys hadn't been taken from me by circumstances I might have said to myself, 'I *would* do this, but I can't because. . . .' as so many women say to themselves over and over again, which is why men have the advantage. I was driven by the fact that I was under personal turmoil to do something." She may have been influenced by the recent memory of Paul Strand, "the sober, serious man driving with a purpose down the road."[11]

Lange made her first street pictures "jostling about in groups of tormented, depressed and angry men. . . . At that time I was afraid of what was behind me—not in front of me. . . . Really it's my camera I was so afraid about. I thought someone might grab it from the back and take it away or hit me, from the back."[12] The first time she went out, her brother Martin accompanied her. She found, however, that "you quickly forget yourself in your desire to do something that needs to be done. And people know that you are not taking anything away from them."[13]

When she went out to photograph a breadline, she told herself the impulse was an indulgence made possible and paid for by her studio work. "I assigned myself the task of photographing the [1934] May Day demonstrations at Civic Center . . . by the unemployed, and I said to myself, 'I can't afford to do this and I shouldn't, but I want to. But . . . I've got to set limits on how much. I've got to photograph it, develop it, print it, get it out of my system, in twenty-four hours. I can't let it spill over.'"[14]

Her first street pictures had the same quality as her studio portraits. She tended to select one individual in a crowd, someone whose face or body told a story. She caught people in the isolation of despair: a workman seated on a box beside his overturned wheelbarrow, his head down on his arms; an elderly man in a breadline, turning his back on his fellows; a well-dressed figure in hat, overcoat, and shined shoes, sleeping on a public bench. These are anonymous human beings; their self-absorption made them unaware of the camera, with the result that the pictures have a powerful impact on the viewer.

Caught up in the urgency of the period, when nearly one-fifth of the population of California was on relief, Lange became committed to recording public scenes. In the summer of 1934 she was vacationing at Fallen Leaf Lake in

the Sierra Nevada with Dixon and the boys when the San Francisco general strike began. She tried unsuccessfully to interest herself in photographing plants, as Imogen Cunningham had done when her children were small, but the turmoil in the city drew her back. Her pictures were different from the action shots the newspaper photographers were taking. Her recording of men with fists upraised and of a speaker at a microphone, caught in midshout, are studies of faces. Gone is the frozen despair she found in the streets the year before. These strike supporters are joyous in their militancy. Her portrait of a contemplative policeman, standing at ease with his hands folded over his paunch, is essentially a character study. Maynard Dixon also recorded the waterfront strike, in a dramatic painting of workers with fists out that he titled *Scabs*.[15]

When Lange hung one of her street photographs on her studio wall, her clients asked, "Yes, but what are you going to do with it?"[16] She hadn't the slightest idea. But a few colleagues were becoming aware of the direction of her work. In the late summer of 1934, Willard Van Dyke arranged an exhibit of her street scenes of the past two years at his Brockhurst Gallery in Oakland.

Her pictures caught the eye of Paul Taylor, who had been interested in photography for twenty-five years. As a Marine Corps officer heading for the Western front in 1918, he had brought along a Kodak in his kit. The pictures of battlefields and French villages that he took after the Armistice were dark and unsatisfactory, but he had an instinct for finding significant scenes. By the time he began his Mexican immigration studies in the late 1920s, he had learned to handle a Rolleiflex camera well enough that he could use it as a research tool—"a form of short-hand note-taking," in the words of Richard Steven Street, who analyzed Taylor's photography.[17] Taylor's purpose was utilitarian. His distinction was that he focused on subjects overlooked by his contemporaries. His studies of early farm workers in California have the historical interest of Arnold Genthe's Chinatown portraits, although they are not artistic.[18]

When Taylor was visiting Jane Addams's Hull House in Chicago in 1929, he met Paul Kellogg of Pittsburgh, who with his brother edited *Survey*, a magazine that had exposed the environmental impact of the steel industry and addressed other social and economic problems.[19] Every fourth issue was illustrated and, as *Survey Graphic*, provided a showcase for the work of the photographer-reformer Lewis Hine and other artists.

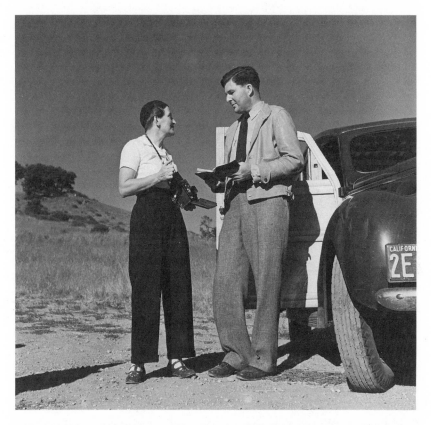

Dorothea Lange and Paul Taylor at work, 1939. Photo by Imogen Cunningham, copyright ©
Imogen Cunningham Trust. Reproduced with permission of the Imogen Cunningham Trust.

Kellogg was interested in Taylor's immigration study. He visited him in the
field in Dimmit County, Texas, and invited him to join a roster of authors that
included Lincoln Steffens, Ida Tarbell, William Allen White, Charles A. Beard,
and Dorothy Thompson. After submitting an article on the impact of the
depression on the open border between the United States and Mexico, Tay-
lor sent to *Survey Graphic* "Mexicans North of the Rio Grande," a spirited
abstract from his multivolume monographs, illustrated with six of his own
photographs and five portrait studies by Ansel Adams, who was then unknown
to him. Their collaboration formed part of a memorable issue on Hispanic
Americans, which also contained artwork by Diego Rivera, José Clemente
Orozco, and Georgia O'Keeffe and writings by D. H. Lawrence, Mary Aus-
tin, and J. Frank Dobie.[20]

When Taylor saw Dorothea Lange's pictures for the first time, he was impressed by "her eye for the essence of a situation."[21] He had just sent Kellogg an article on the San Francisco waterfront strike and its aftermath. Through Willard Van Dyke he telephoned her to see if he could use one of her pictures, a closeup of an orator, as a frontispiece for his article. She agreed. Paul Kellogg paid her $15 for the print, which appeared over the caption "Workers, Unite!"

Taylor and Lange met not long afterward through Van Dyke, who organized a field trip to an Oroville lumber camp where people were working under the Unemployment Exchange Association, a self-help cooperative through which goods and services were traded. In a July 1934 article in *Survey Graphic* written with Clark Kerr, Taylor had praised self-help cooperatives—the subject of Kerr's doctoral dissertation in progress—as a democratic bulwark against political extremes on the left or right. Also in the party that drove north in Taylor's station wagon were two other photographers, Imogen Cunningham and Mary Jeannette Edwards, and an anthropologist, Preston Holder. The statements made by Taylor and Lange about the trip point up the difference in their viewpoints. "My own interest," said Taylor, "was in encouraging the photographing of a social phenomenon; the interest of the others was in finding opportunity to photograph people in social situations without fear that their motives would be misunderstood and their approaches resisted."[22]

Lange remembered "that whole business of being up there as something very sad and dreary and doomed . . . they were so very much on the bottom that they lacked everything to do with. There was nothing to hand."[23] Nevertheless, she began taking pictures, not posing people, but catching them off guard when they had forgotten about her presence. "I have this gray coat that I put on, and I just disappear," she told Willard Van Dyke. He had interviewed her about her methods for an article in *Camera Craft*, the first critical evaluation of her work, that appeared in the same month as the trip to Oroville: "For her, making a shot is an adventure that begins with no planned itinerary. She feels that setting out with a preconceived idea of what she wants to photograph actually minimizes her chance for success. Her method is to eradicate from her mind before she starts, all ideas which she might hold regarding the situation—her mind like an unexposed film."[24]

Taylor remembered her on this trip walking up to a lumberman who was

resting on an axe and taking his picture from behind. She in turn studied the professor, who worked with quiet concentration. "I remember Paul sitting there in their community house—an abandoned sawmill, so it had that atmosphere—interviewing and speaking to these people. I had never heard a social scientist conduct an interview. . . . And I was very interested in the way he got broad answers to questions without people really realizing how much they were telling him. Everybody else went to bed while he was still sitting there in that cold, miserable place talking with those people. They didn't know they were being interviewed, although he wrote and wrote."[25]

Not long afterward, Taylor thought of Lange when he accepted an assignment from the Division of Rural Rehabilitation of the California Emergency Relief Administration to look into the need for housing for drought refugees from the Great Plains and south central states who were coming to the West Coast. Richard Steven Street noted that Taylor, in his Mexican studies, had "encountered a human drama of such depth and magnitude that it strained his ability to capture it in notes, interviews, and statistics. Only in the visual documents he was compiling did Taylor see the kind of information which could alone convey . . . the *situation*." [26] Once again he thought he could present a stronger case if he had pictures of the people and the situations he would be describing. He had to argue his point with Laurence Hewes of the Rural Rehabilitation staff, who finally agreed to put Lange on the agency payroll in a slot reserved for a clerk-typist.

Maynard Dixon accompanied the group on their first trip, in February of 1935, to a pea pickers' camp at Nipomo, in San Luis Obispo County, about 200 miles south of San Francisco. Taylor instructed his research associate Edward Rowell: "This is the first time we've had a photographer out in the field and I don't know how she will be received. Your instructions are to see that nothing untoward happens. I don't want anything to disturb the relations between ourselves as a team and those pea-pickers. Carry her camera. She'll need somebody to do that. Just quietly stay with her and see that nothing goes awry." To Dorothea, he said: "This is your first day in the field. If you don't make a single photograph the first day, that's all right with me." In retrospect he realized that he need not have worried: "Well, she made 'em all right. Made them the first day. And made good ones that we put into the report. She had no trouble. As up at the U.X.T. in the mountains [the Oroville lumber camp],

she just quietly walked up to them with her camera. No problem in her relations with the pea-pickers at all. It went on that way, always."[27] About the work she was doing, Lange said later:

124

> It's a very difficult thing to be exposed to the new and strange worlds that you know nothing about, and find your way. That's a big job. It's hard without relying on past performances and finding your own little rut, which comforts you. It's a hard thing to be lost. You force yourself to watch and wait. You accept all the discomfort and the disharmony. Being out of your depth is a very uncomfortable thing. . . . It may be very hot. It may be painfully cold. It may be sandy and windy and you say, 'What am I doing here? What drives me to do this hard thing?' You ask yourself that question. You could be so comfortable, doing other things, somewhere else. . . .
>
> Oh, the end of the day was a great relief, always. 'That's behind me.' But at the moment when you're thoroughly involved, when you're doing it, it's the greatest real satisfaction . . . at the moment when you say, 'I think maybe . . . I think that was all right . . . maybe that will be it.' And you know when you're working fairly well. You have a stretch. But as I say, every day as it passes you say, after it's done, 'It's over. I did the best I could. I didn't do very well but I did the best I could. . . . There's nothing on the film. I'm sure there's nothing on it, nothing worth recording. . . .' Photography for the people who play around with it is very exhilarating and a lot of fun. If you take it seriously, it's very difficult.[28]

Lange defined documentary photography as "buttressed by written material and by all manner of things which kept it unified and solid."[29] Taylor and his assistants would get information by asking people, "How far is it to the next town? What's the work going on there? Where do people come from who do this work?" The professor was continually taking notes, snatching free moments to jot down memoranda. On a later trip she remembered him standing at a desk at a hotel writing steadily while a state official who was accompanying them exclaimed, "You see how methodical he is? . . . He leaves nothing to chance." He forgot everything but his work. Lange and the others "discovered that this man didn't know anything about what people require in the way of food and drink and lodging." She remembered "how amused I was that we started at six o'clock in the morning and he never thought that any-

body should have anything to eat." However, it seemed wrong to her to spend $1.75 for dinner after being with people who didn't earn that much in a whole day. And she was startled when one member of the research team commented on a gas station attendant who had answered their questions: "He was a good informant." She thought, "What language! What kind of people are these?"[30] Perhaps this was the service station employee who showed them a woman's gold wedding band that a migrant family had exchanged for a tankful of gas.

In late February, Taylor, Lange, and Irving Wood, a Wisconsin classmate of Taylor's who was also working in the Division of Rural Rehabilitation, went to the Coachella Valley, where they joined a state farming official, Harvey M. Coverley. On March 1, Coverley and Lange visited a number of labor camps where people were living "under squalid and unsanitary conditions," according to Coverley's report.[31] They found dirt floors, houses made of mesquite poles tied together with baling wire, roofs thatched with palm leaves, windows covered with burlap, no plumbing. At a camp near Indio they talked to families who migrated north following the crops in the summer. Their average earnings were $1.50 for a ten-hour day. In one place they heard that the doctor who was the district health officer refused to deliver babies in the improvised huts of farm workers. Coverley's report concluded that sanitary camps were needed.

The regional representative of the Rural Rehabilitation Division, Lowry Nelson, and his wife accompanied Taylor's group to the Imperial Valley on a late March–early April trip. They went to a checkpoint on the Arizona-California border where travelers crossed the Colorado River. Taylor later described the scene:

> At Fort Yuma the bridge over the Colorado marks the southeastern portal to California. Across the bridge move shiny cars of tourists, huge trucks, an occasional horse and wagon, or a Yuma Indian on horseback. And at intervals in the other traffic appear slow-moving and conspicuous cars loaded with refugees.
>
> The refugees travel in old automobiles and light trucks, some of them home-made, and frequently with trailers behind. All their worldly possessions are piled on the car and covered with old canvas or ragged bedding, with perhaps bedsprings atop, a small iron cook-stove on the running board, a battered trunk, lantern, and galvanized iron washtub tied on behind. Children, aunts, grandmothers and a dog are jammed into

the car, stretching its capacity incredibly. A neighbor boy sprawls on top of the loaded trailer.

Most of the people were "white Americans of old stock." He saw "long, lanky Oklahomans with small heads, blue eyes, an Abe Lincoln cut to the thighs, and surrounded by tow-headed children; bronzed Texans with a drawl, clear-cut features, and an aggressive spirit; a few Mexicans, mestizos with many children; occasionally Negroes."[32]

When Taylor was collecting information for his immigration studies, he paid a gas station attendant at Tehachapi Pass to count Mexican families traveling in both directions. He now asked border guards to keep records of the incoming dust bowl migrants; they were categorized as parties "in need of manual employment" entering with out-of-state license plates. During a four-month period in 1935, 3,500 men, women, and children were counted at one border station, of whom one-third came from Texas, Oklahoma, and Arizona.[33] Taylor assembled his statistics several months before the Los Angeles Police Department initiated a check at sixteen entry points along the state border to turn back families "with no visible means of support." The so-called "bum blockade" operated for two months in February and March of 1936 before it was ruled unconstitutional.[34] Some of the border guards Taylor talked to thought the migrants came to California for the high relief payments. He collected quotations from the families that contradicted this impression.

On the trip to the Imperial Valley, Dorothea Lange began jotting down in a spiral-bound notebook what people said when she was taking their pictures. Some of the entries are Taylor's. The jottings were made hastily, interspersed with information about camera shots, itinerary, expenses of the road. They reveal the extent to which people unburdened themselves to sympathetic listeners:

> Seems funny to me we got so much of everything, including good men with good bodies, and we can't make a living. It's an unfair deal. I can't figger what it's all about.
>
> Good God only knows why we come here, xept he's in a movin' mood—
>
> Yes mam Born and raised in the state of Texas—farmed all my natural life—ain't nothing there to stay for—nothin to eat—sumpin radically wrong.

Sharecropper family came Sept. '34 "We haven't had to have no help
yet. . . . Lots of em have but we haven't."

Now all I've got left is my Ford car and I'm figuring to sell that for
$10 . . . can't get enough to buy the license.[35]

In late May, Lange and Taylor were in the Marysville area, visiting some of
the approximately one hundred families living in a Hooverville near the river.
An older woman reported that a city official had threatened "to burn our shack
down. Them was his very words. How can we go when we ain't got no place
to go?" Someone else said: "A man'll do any damn thing to get hold of a dol-
lar so he can stay in one place." Back in the Imperial Valley in June, Lange
noted the following: "I was raised to help myself—we wasn't raised to ask for
help," and "I'm whipped but i ain't complainin'."[36]

In his plea for the erection of camps for the migrants Taylor described their
living conditions as "unsanitary, and low in the extreme; they are utterly un-
fit surroundings in which to raise American citizens." His report closed with
a declaration: THIS PROJECT MEETS A NEED CLEARLY AND PUBLICLY RECOG-
NIZED BY FEDERAL AND STATE AUTHORITIES, AND BY CIVIC BODIES IN
CALIFORNIA. IT IS AN IMPORTANT STEP TOWARD BETTER INDUSTRIAL RELA-
TIONS IN A STRIFE-TORN FIELD, AND TOWARD TRAINING OF TENS OF THOU-
SANDS OF MEN, WOMEN, AND CHILDREN IN BETTER STANDARDS OF
AMERICAN CITIZENSHIP.[37]

Taylor may have adopted this tone, which sounds offensively paternalistic,
because he was conscious of the public hostility to the migrants—a feeling
soon to be reflected in a California Assembly bill demanding the exclusion of
"all paupers, vagabonds, and indigent persons."[38] He was also aware of the in-
tense opposition of growers to the idea of a camp program run by a New Deal
agency. He had to counteract their assumption that the government camps
would become hotbeds of labor organizing. On other occasions when he was
searching for words to express the gravity of the problem, he sounded ponder-
ous; he spoke of "the process of social erosion and a subsequent shifting of
human sands" (using a geological metaphor as he did in the first paragraph of
his monograph on the cotton pickers' strike).[39] He sincerely believed that
better housing and living conditions would lessen labor strife, and that this was
a good thing, as he believed that the federal government had a responsibility
to its citizens. In his public utterances he stated this point with succinct elo-

quence: "The trek of drought and depression refugees to California is the result of a national catastrophe. The succor of its victims is a national responsibility."[40]

128

The report on the need for a camp program was successful, partly because Dorothea Lange's pictures made the impact that Taylor had calculated they would. He later described what happened: "After the photographs [accompanying the report] were passed around the table, the commission voted $200,000 to initiate the program. The question was not raised again, why a photographer?"[41] There were some delays in getting the program funded, but Lowry Nelson, who had accompanied the investigative team to the Imperial Valley and looked at the situation firsthand, broke the impasse to make the money available. By the early summer of 1935, building began on the first of a chain of government camps that were to play a significant role in the lives of the dust bowl migrants and the literature about them.

This development was crucial in the professional and personal relationship of Paul Taylor and Dorothea Lange. It brought her work to the attention of government leaders. Laurence Hewes, who joined the Resettlement Administration in Washington, showed the illustrated report to his chief, Rexford Tugwell, as well as to Henry Wallace and Harold Ickes. As Hewes remembered the circumstances, the New Deal administrators, who were preoccupied with the agricultural problems of the South, didn't show a great deal of interest in the dust bowl migrants (not recognizing their connection with the region, perhaps). But Hewes or one of his associates sent Lange's pictures to Roy Stryker, whom Tugwell had brought down from Columbia University to be chief of the Resettlement Administration's History Division, a photographic unit that was recording the impact of the depression on Americans and the New Deal response to it.[42] Soon after Stryker was alerted by Hewes, he got in touch with Lange and asked her to join his group of photographers, which would include Ben Shahn (better known as a painter), Arthur Rothstein, Carl Mydans, Walker Evans, Russell Lee, Marion Post, and Jack Delano.

Meanwhile, Taylor used Lange's photographs to illustrate his articles in *Survey Graphic* and got her to submit an illustrated article of her own, "Pea Picker's Child," in which she told the stories of people they encountered on their research travels. It is evident that her emotional response to these scenes affected his own writing, which became more subjective.

The interchange was personal as well as professional. It was signaled by Taylor's beautiful camera portraits of Lange in 1935. In several, she is sitting on the roof of a car with her own camera; in a closeup shot he caught her in profile with a soft, secret smile, the portrait of a woman in love.

Under the circumstances, their relationship seemed foreordained. Field work and research had been the focal point of Taylor's life for a number of years. His professional interests had separated him, emotionally as well as physically, from his Berkeley connections and weakened his ties to his wife and three children. From the time Lange took her camera into the streets, she began moving away from her marriage to Maynard Dixon. The admiration and assistance of Taylor, a man her own age, encouraged her transformation from studio portraitist to documentary photographer. As Taylor's partner in an important enterprise, she had forged a connection with the contemporary world while she began to tap the reservoir of her own talent. The attraction between them grew out of a feeling of reciprocity; each enhanced what was vital to the other. "Attraction and accomplishment met," Taylor said later.

The feeling was powerful enough to outweigh the negative factors involved; the confusion connected with the dissolution of two fifteen-year marriages, the pain inflicted on their discarded partners, the dislocation brought to their five children, the distress of family and friends. As a man of conventional demeanor, Paul Taylor was conscious of the social repercussions of divorce in that era. Questioned about the situation many years later, he commented simply: "It wasn't altogether easy."[43]

They were married on December 6, 1935, in Albuquerque, New Mexico, and went on with their work without a break. As often as he could get away from Berkeley during breaks in his teaching schedule, Taylor accompanied Lange on her photographic assignments for the Resettlement Administration and later the Farm Security Administration (FSA), for which she was paid five dollars a day plus expenses. For several summers in the mid-1930s he was also on the federal payroll, reporting to the Department of Social Security on an investigation of the feasibility of extending benefits to farm workers. He and Lange coordinated their schedules in order to travel around the country together.

Several of the other photographers on Roy Stryker's team were accompanied by their spouses. Russell Lee's wife, Jean, went with him during most of

his thousands of miles of travel. At night she transcribed his notes while he developed his film in the bathrooms of tourist cabins where they stopped.[44]

Arthur Rothstein, the first photographer hired by Stryker, carried a sleeping bag, a water bag, an axe, and a shovel in his car, plus all his photographic supplies, including chemicals. He often slept outdoors. When he accumulated enough exposed film, he would find a hotel room with a bath attached, seal up the bathroom, turn it into a darkroom, and develop his negatives to send to Stryker.[45] Marion Post, the only other woman on the team, who was hired after Lange, also had to handle all the contingencies of travel on her own. There is a memorable picture of her lying on the ground changing a tire, assisted by a man who is using a fence post as a jack. She looks young and fragile but so purposeful that she seems capable of accomplishing the task by sheer will power. Presumably the picture was taken by one of the passersby who helped her. One can imagine that it impressed Stryker, who was an encouraging father figure, as well as an exacting taskmaster, to some of the younger photographers.[46]

Lange recalled Stryker's saying that he could tell, from the pictures they sent in, when the photographers were tired—which they were more often than not. She remembered "staying out too long, working too hard, you were working

Paul Taylor and Dorothea Lange in their Berkeley home, early 1960s. Courtesy of Helen Dixon.

130

in all kinds of weather and working all kinds of hours and there weren't any Saturdays or Sundays; it was dust and heat, bad beds, bad food and lots of travel. I mean nobody thought anything of working all day and traveling most of the night and waking the next day, and you had to be out early before the sun was too high and in the heat of the day you were traveling to the next place. You had to write up your notes at night."[47]

Roy Stryker required his photographers to do research on the places and conditions they were recording, preferably before they set out with their cameras. In the summer of 1937 he considered farm tenancy to be "the biggest issue before the R.A." Lange dutifully read Arthur Raper's *A Preface to Peasantry* as she headed to the southern states, although in general she preferred to do the reading after she finished her assignments. "It is often very interesting," she said, "to find out later how right your instincts were if you followed all the influences that were brought to bear on you while you were working in a region."[48] With Taylor along to give her the benefit of his expertise and to stimulate her with his own discoveries, she could afford to be flexible.

On the road Taylor acted as a front man by striking up conversations with the people she photographed. He then wrote down what they said. When he was not with her, she sometimes brought along a stenographer. If she had no record keeper, she worked out her own method of keeping track of the pictures and the words. Ron Partridge, Imogen Cunningham's son, who sometimes accompanied Lange as a photographer's assistant on her California assignments, remembered that she interrupted the filming from time to time to run out the car to jot down notes. Once she set down an excerpt from a sermon she overheard through a church window.[49]

In most instances, her notes are written in a kind of shorthand, as in this excerpt from a trip to the Imperial Valley:

Feb. 22 — Carrots 14 ¢ a crate, 48 bunches in a crate, sorted, graded, tied including tag couple [earn] 70 ¢ in 1/2 day. . . .

They sleep in the rows — for 60 ¢ a day.

Fellers, such as me Farmers, such as me, right down on our knees. Got no more chance than a one-legged man at a foot race They're aimin' at keepin fellas *sich as me* right down on our knees, aimin at makin slaves of us.[50]

132

Despite the haste and confusion that was a condition of working outdoors, Lange and Taylor were scrupulous about matching words to the people who spoke them. One quotation might pertain to a number of film exposures that were made at the same time and place. With this qualification, it could be said that the words matched the pictures. Lange was upset about the way this standard was ignored in a feature on her work that appeared in *U.S. Camera;* the captions were so mixed up that the ones pertaining to her dust bowl travels were used under her San Francisco street pictures.[51]

Taylor once said of Lange, "Her ear was as good as her eye," implying that she had the ability to be selective.[52] He had the same kind of ear. Neither of them took down everything they heard. Nor did they use everything they recorded. Taylor chose arresting quotations from the notebook to enliven his articles and talks. Since he was addressing a number of different groups in the mid-1930s, when he was constantly writing and speaking as a migrant advocate, he often repeated material that was effective. Certain anecdotes and homilies were polished by frequent use until they became a part of the folklore of the dust bowl migration. Two of his favorites were a request for directions to a California town made by an Oklahoma mother in the Imperial Valley—"Where is Tranquility?"—and another plaintive refrain: "It seems like God has forsaken us—back there in Arkansas."

Taylor relayed the capsule autobiography of a fruit picker in the Sacramento Valley: "1927—made $7,000 as a cotton farmer in Texas; 1928—broke even; 1929—went in the hole; 1930—deeper; 1931—lost everything; 1932—hit the road; 1935—serving the farmers of California as a 'fruit tramp.'" Another man's story of coming down in the world ran as follows: "My father was a track foreman at $1.25 a day, but we lived in a house and everybody knew us. This rancher has us for two or three weeks, and he's through with me. He knows me till he's through with me." A third man made the observation: "Livin' a bum's life soon makes a bum out of you. You get started and you can't stop."

Taylor had a long collection of quotations to counteract the notion that the migrants were freeloaders:

We haven't had to have no help yet. Lots of 'em have, but we haven't.
Relief? I wouldn't have it no way it was fixed.
All I want is a chance to make an honest living.

When a person's able to work, what's the use of begging? We ain't that kind of people.

Taylor used quotations that corroborated his own views. He quoted a tenant farmer from Oklahoma complaining about the situation in the Imperial Valley: "The monied men got all the land gobbled up." Another individual said, "We got enough trouble without going Communist."[53]

The critic William Stott thinks that the quotations used as captions for Lange's RA/FSA pictures have "an exaggerated folk pungency."[54] Stott admires Lange's work as a government photographer but thinks she idealized the migrants. Pare Lorentz, the film maker, noted, "You do not find in her portrait gallery the bindle-stiffs, the tramps, the unfortunate, aimless dregs of a country. Her people stand up straight and look you in the eye. They have the simple dignity of people who have leaned against the wind, and worked in the sun, and owned their own land."[55] It's true that although some of the adults in her pictures have tousled hair and torn clothes, and their children have dirty faces, these details are incidental to the overall positive impression they make on the viewer. Her people are almost without exception appealing. Those in her most famous pictures are so powerfully compelling that they have a glamour of their own.

Writing in the early 1950s about her working methods, Lange espoused stringent standards of integrity and realism.[56] "First—hands off," she admonished. "What I photograph I do not molest or tamper with or arrange." (This statement may have been a reference to the practice of occasionally posing subjects and manipulating background as done by Margaret Bourke-White in her book *You Have Seen Their Faces* or to the criticism of Lange's RA/FSA colleague Arthur Rothstein, who was called down for photographing the skull of a cow in two different locations.)[57] Her purpose was also to convey "a sense of place" and "a sense of time." These precepts seem puzzling when applied to the work she was doing in the 1930s, and indeed throughout her career, which seems more impressionistic than literal. She endowed her subjects with her personal vision even when she was carrying out assignments she would not have chosen voluntarily. Stryker's aim was to compile a record of rural life in America, focusing on current problems in the agricultural economy and the solutions offered under the New Deal. For this second category he required

pictures of dams, buildings, and housing projects. Lange did not have Margaret Bourke-White's love of architecture, or the feeling for machinery and industrial processes that was evident in Bourke-White's *Fortune* magazine illustrations. Lange would not have gone up in an airplane to photograph a dust storm, as Bourke-White did.[58]

134

Lange looked at a landscape in terms of the people who lived in it. A photograph she took in Childress County, Texas, in June 1938, shows an abandoned farmhouse surrounded by freshly plowed tractor furrows clear to the door. There are no human beings in sight. The picture tells the story of what happened to them. It is an example of how a work of graphic art can convey a message in shorthand. In this one arresting image, she summed up a situation that Steinbeck described at length in the opening chapters of *The Grapes of Wrath*, and that Paul Taylor analyzed painstakingly with words and graphs in his scholarly articles.

Lange had an eye for symbolism. She turned her camera on a homemade sign tacked up in a gas station: "This is your country. Don't let the big fellows take it away from you." She may not have posed people or moved them around, but she took advantage of opportune moments such as when she found some hitchhiking migrants standing in front of a billboard that urged: "Next time take the train." In the same spirit, Marion Post, working at the end of the decade, took pictures of affluent winter vacationers luxuriating in Miami Beach and interspersed a picture of uniformed maids caring for a white baby in Mississippi with a shot of a bare-bones FSA day care center for black children in Florida.

Lange's interest was psychological, rather than sociological. When she went in November 1936 to the government camp sometimes called "Weed Patch," near Arvin in Kern County, she took some very appealing pictures as she followed the director, Tom Collins, on his rounds among the residents. Collins, John Steinbeck's friend and informant on the migrants in the government camps, is wearing white pants, as he does in Steinbeck's fictional portrait of him in *The Grapes of Wrath*. Steinbeck would write that Ma Joad felt reassured when she noticed that the director's pants had worn seams. Lange captured Collins's unpretentiousness and his rapport with people in a different way. In one photograph she shows him hunkered down on a level with some of the children. He is drawing on the ground with a stick—a common practice among the migrants, as Steinbeck and others observed.[59] Lange made her ex-

posures on a clear, sunny winter day. In one particularly well-composed shot, the brightness of Collins's clothes is reflected in a snowy sheet hung out by a young woman camper, and in her brilliant smile.

Since Lange was, first and foremost, a portrait photographer, she had to learn to meet problems she encountered outside the controlled environment of a studio. At times she achieved the effect she wanted by cropping, eliminating extraneous background details from the negative. In several instances she changed the picture radically by removing a figure from the foreground. The original photograph called *Ditched, Stalled, and Stranded* shows a couple sitting in their broken-down vehicle. They are appealing individuals who register their plight with different degrees of emotion. The husband looks anguished; the wife appears merely worried. Lange achieved a more powerful image by cutting out the figure of the woman and enlarging the harrowed face of the man.

135

Tractored Out, Childress County, Texas, 1938, by Dorothea Lange. Copyright © Dorothea Lange Collection, The Oakland Museum of California, The City of Oakland. Gift of Paul S. Taylor. Reproduced with the permission of the Oakland Museum.

136

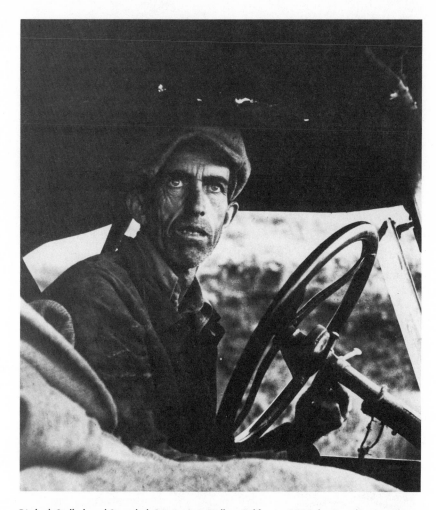

Ditched, Stalled, and Stranded, San Joaquin Valley, California, 1935, by Dorothea Lange. Copyright © Dorothea Lange Collection, The Oakland Museum of California, The City of Oakland. Gift of Paul S. Taylor. Reproduced with the permission of The Oakland Museum.

In another photograph, called *Migrant Family* or *Desperation,* a young wife in a flour-sack dress nursing a sickly looking little boy is a background figure. Her husband, a much larger presence in the foreground, dominates the picture. Lying prone with his head propped on one hand, he looks as if he is completely worn out and has given up all exertion. His other hand is caked with dirt. The image recalls Steinbeck's description in his 1936 newspaper se-

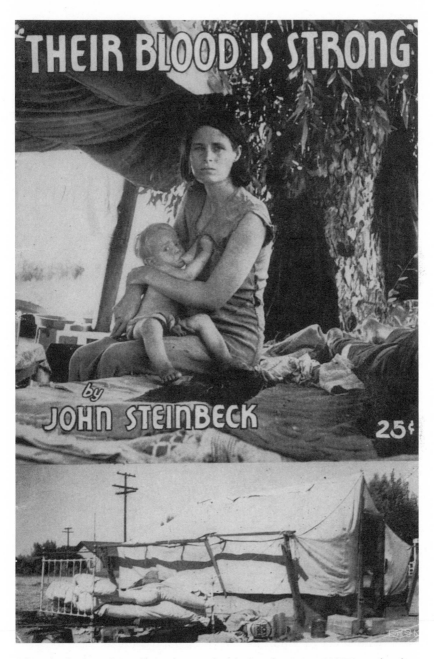

"Their Blood Is Strong" pamphlet, with cover photo by Dorothea Lange, 1938. Reproduced with the permission of the Labor Archives and Research Center, San Francisco State University.

ries, "The Harvest Gypsies," of the cumulative demoralizing effect of migrant life, as well as a phrase that appears without a reference in a jotting in Lange's field notes: "conscious retrogression." A similar photograph of the mother and child, with the disturbing image of the father removed, was used as a cover for *Their Blood Is Strong*, the 1938 pamphlet version of Steinbeck's articles. This version is a better-proportioned picture but lacks the "bullet-hard impact" of the original, which was closer to Steinbeck's text.[60]

Lange created her most famous picture, *Migrant Mother*, by cropping one among a set of photographs that she had taken hastily and used for a humanitarian purpose. The circumstances were somewhat similar to those that produced another famous picture of the 1930s, Arthur Rothstein's image of the father and two boys in a dust storm in Cimarron County, Oklahoma. Rothstein had spent an afternoon with the Coble family on their farm, which was almost buried in sand. As he later described the situation, "Toward the end of the day the wind began to pick up and the sand began to blow and under those conditions it was very difficult to stay outdoors . . . I said goodbye to them . . . and I had started for my car. . . . I turned around to get a last look. I had my camera in my hand, and I saw them, their heads bent, pressing into the wind, with the sand blowing and the little boy with his hand up. I saw that scene and I just raised the camera and took the picture. . . . There was only one negative, one frame."[61]

Although Lange took more than one picture of her subject, *Migrant Mother* also evolved from a lucky shot. On a rainy afternoon in March 1936, Lange was driving toward San Francisco on Highway 101. In Nipomo she passed a sign for a pea pickers' camp not far from the site of her first photographic expedition with Paul Taylor a year earlier. She had completed the work she had set out to do. She was alone. She was tired. So she drove on for twenty miles. Then, without having made a conscious decision, she turned around and "like a homing pigeon" drove back to the camp.[62] She walked up to the improvised tent, a tarpaulin propped up by poles, belonging to a mother with three children. She somehow got the impression, which turned out to be inaccurate, that the family had sold the tires from their car to buy food for the children.[63] Dorothea took a few pictures, moving closer and closer to the figures, but she spent such a short time with the woman that she did not learn her name. She did, however, get enough information about the plight of the 2,500 men, women, and children stranded in the camp when the pea crop failed to real-

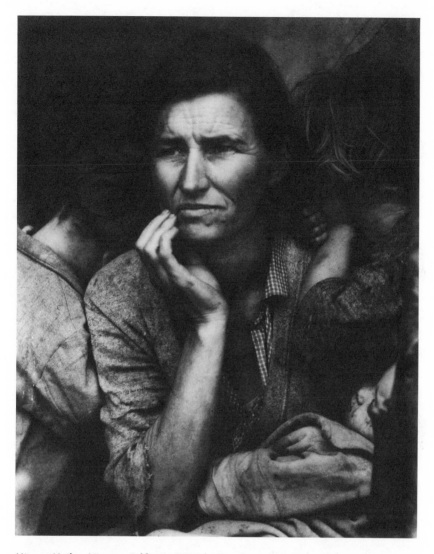

Migrant Mother, Nipomo, California, 1936, by Dorothea Lange. Copyright © Dorothea Lange Collection, The Oakland Museum of California, The City of Oakland. Gift of Paul S. Taylor. Reproduced with the permission of the Oakland Museum.

ize that she had walked into an emergency situation. She drove home, developed the film and made prints, and dashed with the story and pictures to the office of the *San Francisco News*. As the editors telephoned federal relief officials to rush food to the camp, George West credited the rescue "to the chance visit of a government photographer."[64] Lange was not identified by name.

The *News* reproduced a distance shot of the family in their cluttered tent, and one of the children at closer range. This picture lacked the artistry of the most frequently reproduced version of *Migrant Mother,* in which the faces of the two older children are hidden against their mother and the baby is lying asleep in her lap, focusing the viewer's attention on the distant, burning gaze of the woman. The central figure has the symmetry, but not the softness, of a Raphael madonna. The picture that appeared in the *News* was by comparison cluttered and crude, but it inspired an editorial writer to declare that he found in the woman's "fine, strong face the tragedy of lives lived in squalor and fear, in terms that mock the American dream of security and independence and opportunity in which every child has been taught to believe."[65]

11

THE ROAD TO *THE GRAPES OF WRATH*

John Steinbeck and Carey McWilliams literally and figuratively followed many of the roads traveled by Paul Taylor and Dorothea Lange. Predictably, their reactions to the situations they encountered were similar, but not identical. If their progress had been charted on a map, the tracks left by each of them would have been distinctive.

In the early summer of 1935, not long after Taylor and Lange submitted their report petitioning the government to build camps for the migrants, Carey McWilliams made a brief field trip to the Central Valley. He was not concerned with the migrant problem—he seemed to be hardly aware of it—but with farm labor issues in general following the demise of the CAWIU. He was accompanied by Herbert Klein, a graduate of Stanford who was working as a freelance writer in Southern California. Klein's political views had been influenced by his experiences as a foreign correspondent in Germany during Hitler's rise to power. He was interested in comparing the California agricul-

tural system from a Marxist perspective with that of the European countries he had known.[1]

McWilliams was attuned to echoes of the recent battles of the CAWIU. In Sacramento he went over the transcripts of the Criminal Syndicalism trial that had ended two months earlier. He and Klein talked to Leo Gallagher, the defense counsel, and went to San Quentin to see two of the convicted defendants, Pat Chambers and Norman Mini. The two writers also sought out individuals representing different viewpoints in the state's farm labor controversies. In Fresno they met with members of the American Workers Party and with S. Parker Frisselle of the Associated Farmers. In San Francisco they had an enlightening talk on unemployment relief with Nathan Gregory Silvermaster, director of the research division of the California Emergency Relief Administration, just before Silvermaster transferred to the national headquarters in Washington, D.C.

En route home to Los Angeles, McWilliams and Klein stopped in Carmel at the office of the *Pacific Weekly.* Some ten months later, the *PW* published their observations in a series of articles entitled "Factories in the Fields."[2] (Klein wrote under a pseudonym, although he used his own name in an overview account the two wrote for the *Nation,* in which they exposed the strikebreaking activities of the Associated Farmers.)[3] In the longer series, Klein's influence is evident in the quotations from Lenin as well as in the terminology of protest and outrage. McWilliams did not customarily use this vocabulary, although Greg Critser, who has closely examined his activities in this period, has noted that his contact with the experiences of friends and fellow ACLU lawyers who were defending strike leaders "introduced an emotional component into McWilliams's reportage of farm labor strife. Increasingly his use of the term 'farmer fascism' became unqualified."[4]

McWilliams and Klein did extensive research on federal benefits to California agriculturalists; according to their calculations, growers in the state had received $9 million in subsidies under the U.S. Department of Agriculture's Triple-A program, inaugurated in the spring of 1933 to compensate the producers of a number of surplus commodities, including cotton, for cutting back their acreage in order to raise prices.[5] Later research has documented the substantial amounts paid by the government to the largest cotton growers in the state. The AAA program, under which the price of cotton almost tripled in 1933, had the effect of driving out small, marginal farmers.[6]

Klein and McWilliams had heard rumors about the construction of the Resettlement Administration camps for dust bowl refugees but, without investigating further, interpreted the project to be one of the "schemes of dominance" of the "farm-industrialists."[7] McWilliams later corrected this impression when he visited the offices of the RA's Region IX (covering Arizona, California, Nevada, and Utah), although he continued to have a different view of the agency than Paul Taylor.

Taylor was interested in the RA's conservation and reclamation projects, cooperative farms, and "subsistence homesteads" as strategies to stabilize marginal farmers on the land or assist them when they relocated to other areas of the country. He saw the RA as a government organization addressing problems of rural poverty that were ignored or exacerbated by the policies of the USDA. When sharecroppers and tenants from the south central states lost their livelihood as a result of the AAA's crop-reduction program and joined the migrant stream, the RA was their advocate, as the USDA was the spokesman for landowning farmers. There was a federal agency for each constituency, although the money allocated to each of them reflected the difference in their influence and power.

McWilliams looked at the picture in terms of overall government policy as reflected by the discrepancy in funding. His position was similar to the one expressed recently by the historian Charles Wollenberg, who wrote of the situation in the 1930s: "While California growers obtained federal price supports for some products, legally enforced marketing orders for others, and massive government expenditures for irrigation projects, migrant laborers received a small, poorly funded camp program that never got beyond the 'demonstration' stage."[8]

McWilliams's views would be reinforced by his later public role. As head of the Division of Immigration and Housing in the Culbert Olson administration from 1939 to 1942, he was responsible for overseeing more than 5,000 labor camps in the state. The Resettlement Administration and its successor agency, the Farm Security Administration (FSA), built no more than sixteen permanent and nine mobile camps in California and Arizona in the 1930s.[9] The federal effort was significant chiefly as a symbol of New Deal involvement and as an expression of democratic—some would say Democratic—principles.

Even this modest achievement required strenuous lobbying. Following the recommendation of the Taylor-Lange report, George West of the *San Francisco*

News promoted the erection of the first two camps, at opposite ends of the Central Valley, before the end of the year 1935. The camps were built with the approval and assistance of the communities nearby. The City Council in Marysville—where Taylor and Lange had documented the problem of the homeless congregating in the dry bed of the Yuba River—appropriated $3,000 for the facility, which opened in mid-October. The Kern County Board of Supervisors, which regularly heard reports on the health hazards posed by unregulated squatter settlements, voted to spend $8,000 to secure a lease on a tract of land near Arvin and agreed to furnish water, electricity, and firewood, and to provide medical care to the residents of the government facility.[10]

Despite these indications that the camps were needed, the RA encountered considerable opposition before, during, and after they went up. Some people in the surrounding communities resented having a colony of destitute outsiders planted in their midst. Political conservatives objected to the chief of the sponsoring agency, Rexford Tugwell, who as a member of FDR's "brain trust" had a reputation as a radical utopian theorist of the New Deal. Many growers who were under the giant USDA umbrella mistrusted the independent RA, although it was by comparison a pygmy.

Some members of the agricultural community believed that the supporters of the migrants were in favor of farm labor strikes. A statement by the head of the California Federation of Labor at the dedication of the Marysville camp reinforced this idea: Paul Scharrenberg, who had once spoken of the CAWIU organizers as "fanatics" and dismissed their cause, now welcomed the opportunity the camp provided for the unionization of agricultural labor, "a task which had been considered impossible in the past."[11] In point of fact, federal regulations prohibited the camps from becoming headquarters for a union, but they could be—and they were—used to start locals. A Region IX official described the policy as recognizing "the right of workers to organize and bargain collectively through representatives of their own choice, regardless of whether or not they live in a camp."[12] This policy did not reassure employers who were fearful of a resurgence of strikes. They continued to voice their objections.

In February 1936, after the first two federal camps had been running for several months, George West wrote about "powerful influences" that threatened to stop the RA program "dead in its tracks."[13] He continued to look for ways to influence the situation. After the publication of *In Dubious Battle* in

March, he got the idea of recruiting Steinbeck, whom he had met at the Steffenses' home in Carmel, to investigate the migrant situation in the state and to publicize the camp program. The assignment was significant because it set Steinbeck on the path that led him over a period of three years to *The Grapes of Wrath.*

145

It would be interesting to know whether West discerned a political partisan in Steinbeck. He might have wondered whether the reaction of the public to *In Dubious Battle* was driving the author out of his neutral corner. The novel's subject was so timely and so volatile that some readers considered reporting on it at all tantamount to taking a position. In any case, West avoided controversy by introducing Steinbeck in the *San Francisco News* as "the author of *Tortilla Flat* and other books."[14]

Steinbeck began his journalistic assignment after completing the short novel *Of Mice and Men.* He plunged into a busy round of public contacts after a period of solitary absorption. West sent him to the San Francisco headquarters of the RA's Region IX, which was run by a liberal administrator, Jonathan Garst. Steinbeck was directed to the Information Division, headed by Frederick Soule, and was turned loose in the files under the guidance of Soule and his assistant, Helen Horn, an energetic young woman with strong partisan convictions. Horn and Soule showed Steinbeck material on the history of California agriculture that seemed to strike him with the force of a revelation. The information, in combination with the observations he made on a field trip to see the migrants, had a marked effect on him. It changed his perspective on the farm labor system he had known and taken for granted when he was growing up in the Salinas Valley. Thus, whether his conversion to the farm labor cause resulted primarily from his firsthand exposure to human suffering or from the influence of Horn, Soule, and others—or from both sources—the fact is that his learning experience came through government representatives who had a humane, if bureaucratic, involvement in the problem, rather than through union informants with a revolutionary agenda.

Steinbeck was accompanied on the trip by Eric H. Thomsen, the Region IX director in charge of the management of migrant camps. Thomsen was an unusual man, a social critic who acted on his convictions. He had given up a successful career as the head of two steamship lines, one in his native Denmark, the other in New York, to attend Union Theological Seminary and become a Congregational minister. He had been the religious and educational

director of the Tennessee Valley Authority before he joined the RA in the summer of 1936. An undoctrinaire thinker with the instincts of a reformer, he proved to be a stimulating guide for Steinbeck.[15]

Thomsen and Steinbeck drove to the RA camp near Arvin, in Kern County. It had been in operation for about seven months.[16] Sometimes called "Weed Patch" after a small settlement outside the gates,[17] the twenty-acre tract had been divided into twelve blocks with eight tent sites in each, accommodating ninety-six families altogether. Although spartan, the camp appeared to be an oasis of order and cleanliness. This impression was reinforced when Steinbeck was taken to some ditchbank settlements not far away, where he was shocked by the sight of men, women, and children living in squalor. The Hoovervilles near Oildale and Taft were particularly horrifying.[18] Steinbeck would convey his vivid sense of the contrast between the ditchbank and the government camp in *The Grapes of Wrath*.

Steinbeck also used an incident that occurred soon after his arrival at Arvin when enemies of the federal program tried to disrupt the Saturday night dance. Had they succeeded, local law-enforcement officials would have been called onto the scene to invalidate the authority of the RA.[19] As a reminder of the hostility surrounding the government project, this threat may well have fired Steinbeck's political consciousness.

Before returning to San Francisco a few days later, Thomsen put Steinbeck into the hands of the camp manager, Tom Collins, who guided him on this and a subsequent visit to Arvin. Collins would, in fact, be Steinbeck's chief source of information on the migrants, first for his *News* articles and later, in 1937 and 1938, when he was gathering additional material for *The Grapes of Wrath*.

When Steinbeck met him, Collins was the star of the RA camp program in California, the indispensable manager who made it work. He was given the assignment of opening successive new camps as they were built, including one in Brawley, in the Imperial Valley, where he was sent out in advance to calm the furious opposition in the community. With his talent for public relations, he seems to have come onto the scene at precisely the right moment. Yet little was known about his previous career beyond the fact that he had organized a public school program on Guam and subsequently ran a private institution for disturbed boys in California. Through determined digging and some good luck, Steinbeck's 1984 biographer, Jackson Benson, was able to fill in some of

the missing details in the life of this unusual man who played a key role in the creation of a great American novel.[20]

There is still some uncertainty about Collins's birthdate, but he was probably about forty at the time of his first meeting with Steinbeck, who was then thirty-four. Collins looked much older than the husky writer, judging by the photographs that Dorothea Lange took of him, which match a word portrait by Steinbeck that appears in a foreword to a fictionalized memoir by Collins of their experiences together.[21] On walking into the camp office, Steinbeck saw "a little man in a damp, frayed white suit" sitting at a table with a crowd of people around him. "He had a small moustache, his greying black hair stood up on his head like the quills of a frightened porcupine, and his large, dark eyes [were] tired beyond sleepiness, the kind of tired that won't let you sleep even if you have the time and a bed."

Steinbeck went on to picture the manager's hands-on ministrations to the people. It was nighttime and raining. The bad weather had increased tensions in the camp and demands on the manager. He was constantly interrupted. He ran out to talk with "families and neighbors who always visited with sick people" and who had to be persuaded to stay away from an isolation unit where children with measles were quarantined. Then he was called out to deal with a fracas caused by a new female resident who was standing on a toilet in a sanitary unit. She was "besieged by a furious group of women" who had only recently learned themselves about the use of indoor plumbing. After he was summoned to quiet several more arguments among the people, the camp settled down for the night, except for the crying of a baby. Following the sound, Collins found a weary mother so fast asleep that she didn't hear the wail of the hungry child who had slipped from her breast. He reattached the nursing baby to her nipple without awakening the mother.

Although Steinbeck may have embellished some of these incidents, Collins *was* constantly on call. Another visitor who followed him around the camp for a couple of days said he had a twenty-four-hour job.[22] Collins's reports from Arvin describe his dealing with problems more sophisticated than the ones Steinbeck described. He acted as an ombudsman for the campers in work situations. When some pickers suspected they were being shortchanged on a grower's scales, he put them in touch with the Department of Weights and Measures. He instructed the parents of children who were cheated of their full wages on how to file a complaint with a state labor commissioner in Bakers-

147

field. (This happened before the passage of the Fair Labor Standards Act, although the ban on child labor did not cover agricultural employment and, in any case, would have been ignored by families who depended on the work of every able pair of hands.) Collins was sensitive to the campers' feelings as well as their rights. Although he gladly passed along most of the job offers that came into his office, he was wary when townspeople who were not ready to accept the women campers as neighbors wanted to hire them as household helpers.[23]

As the first camp manager, Collins put into practice the belief of the RA staff that there were practical as well as psychological benefits in the creation of a democratic community. Because of limits set on the building program as a result of public opposition, the agency decided to concentrate on creating "demonstration camps." The rationale was that the migrants, by participating in the activities of the camp, contributing their labor to its upkeep, and serving on its governing council, would recover their emotional equilibrium and prepare themselves for life in the society outside. The democracy-in-microcosm principle was not invariably successful. (The historian Walter Stein has expressed serious reservations about both the concept and its application on a day-to-day basis among people with a strongly individual orientation.)[24] Yet the idea seems to have been working at Arvin when Steinbeck visited. A longtime resident named Sherman Easton, a man who impressed Steinbeck and others, reported—only half jokingly—that Collins, after setting the wheels in motion, was able to sit back and let the council run the camp.[25]

Another part of Collins's job was to develop good public relations in the neighborhood. He arranged baseball games with employees of the DiGiorgio Ranch and spoke to civic groups in Bakersfield. He was also called upon to entertain traveling VIPs, including Secretary of Agriculture Henry Wallace and Isador Lubin from the U.S. Department of Labor,[26] as well as social scientists, artists, photographers such as Lange and Horace Bristol, reporters, and writers. (No other writer stayed as long or received as much attention as Steinbeck.) Local delegations were constantly touring the camp, which was maintained meticulously to disarm critics. Behind the facade of goodwill, Collins, mindful of the enemy outside the gate, also kept a shrewd watch on the actions of nearby grower-employers. He reported, for example, that the Associated Farmers threatened to outbid the government when the RA wanted to take

over the lease of the camp property from the Kern County Board of Supervisors. "We are, of course, neutral but vigilant," he insisted, although he occasionally relieved his feelings in communications to the San Francisco office.[27]

Collins had won some celebrity within the RA for his camp reports. Fred Soule of the Information Division said they were "the most closely read of all the material that comes into this office."[28] Soule gave copies to George West, Carey McWilliams, and others. Collins's reports were a great resource for Steinbeck, who took copies home with him after the visit to Arvin. Steinbeck used Collins's anecdotes and stories in his newspaper articles and, later, when he was writing *The Grapes of Wrath.* Jackson Benson has noted that Collins's philosophy and outlook were reflected in Steinbeck's work and that "bits and pieces of Collins's 'color' are sprinkled here and there in the novel."[29]

Collins's reports are a rich compendium of facts, opinions, and stories, interspersed with fascinating nuggets of migrant lore. Yet at times he sounded a little too conscious of his own importance as an intermediary, and very occasionally he revealed a paternalistic attitude, as when he described how he taught the campers lessons in personal hygiene without hurting their feelings.[30] Clearly this tone did not carry over into his face-to-face exchanges with people who had the reputation of being suspicious of outsiders and quick to resent being patronized. Collins followed an instinctual code of manners like his counterpart, Jim Rawley, in *The Grapes of Wrath,* who wins Ma Joad's acceptance by asking for a cup of her coffee. Collins developed the useful practice of dropping in on families for a meal and a chat to find out what was on their minds. He recorded the approval of the campers at Marysville for Paul Taylor's September 1935 Commonwealth Club address on the migrant situation in California, which was broadcast by radio.[31] A year later he reported the enthusiasm of Arvin residents for Steinbeck's *San Francisco News* articles—but their dislike of the title the paper gave to the series, "The Harvest Gypsies." When Steinbeck heard about their objection, he wrote them an apology.[32]

There was a delay before these articles were published, which Steinbeck attributed to their controversial nature. During the interval he fired off a summary of impressions from his field research to the *Nation,* as McWilliams and Klein had done a year earlier. Steinbeck's piece, entitled "Dubious Battle in California," was his first public statement on the state's farm labor problems.[33] It boils with passionate indignation. "The Harvest Gypsies," published in the

News in the issues of October 5–10 and October 12, was equally vehement. Steinbeck, Ella Winter commented approvingly in a *Pacific Weekly* review, "writes with a pen as sharp as a copper etching."[34]

The series provided the RA and the *San Francisco News* with a good deal of ammunition. George West used Steinbeck's statements—which were a recapitulation of information that he himself and the Region IX staff had supplied—as the subject for editorials. While the interest in the subject was strong, he announced that the camps at Marysville and Arvin would be doubled in size and that eight new camps would be constructed. After the series ended, he published enthusiastic letters from readers.[35]

In this period when they were working independently, with little, if any, knowledge of one another's activities, Steinbeck, McWilliams, and Taylor used similar terminology. Describing the large-scale agriculture of California, Taylor referred to "open-air food factories" at about the same time that McWilliams coined the phrase "Factories in the Fields."[36] Steinbeck spoke about "a system of agriculture so industrialized that the man who plants a crop does not often see, let alone harvest, the fruit of his planting."[37] Taylor described the state's farm workers as "a semi-industrialized rural proletariat."[38] Steinbeck declared that if "our agriculture requires the creation and maintenance at any cost of a peon class, then it is submitted that California agriculture is economically unsound under a democracy."[39]

Although Steinbeck in his articles promoted reforms—such as the creation of an agricultural labor relations board—based on the premise that the migrants were farm workers, he and Taylor tried to enlist support by calling attention to the migrants' background as displaced farmers. "They are the descendants of men who crossed into the middle west, who won their lands by fighting, who cultivated the prairies and stayed with them until they went back into desert," Steinbeck wrote. He underscored the point: "Since the greatest number of the white American migrants are former farm owners, renters or laborers, it follows that their training and ambition have never been removed from agriculture." (This statement was inaccurate even though a federal agricultural agency sponsored the camp program; as James Gregory has shown, fewer than half of the migrants had worked in agriculture before they came to California.)[40] Steinbeck, following the RA agenda, suggested "that lands be leased; or where it is possible, that state and Federal lands be set aside as subsistence farms for migrants."[41] From *his* field research, Taylor had learned that

150

this blueprint, which he also favored in theory, was not always successful in reality. On a visit to an RA project in Casa Grande, Arizona, he discovered that the strongly individualistic residents were not enthusiastic about either the philosophy or the practice of communal enterprise.[42]

Gerald Haslam has defined the paradox represented by the dust bowl migrants: they were "white people doing traditionally non-white work."[43] Their presence brought a new perspective to the California farm labor scene. Race was an unspoken factor even when it was not specifically mentioned. Taylor, Steinbeck, and McWilliams were all familiar with the history of the successive groups of mainly dark-skinned immigrants who had worked in the California fields from the time of the gold rush. Steinbeck's commentary seems to have racist overtones, but his own position is clear; when he contrasted "foreign 'cheap labor'" with "white/American labor,"[44] he was thinking in terms of union organizing. McWilliams also commented on the advantage represented by citizens who could not be deported. He predicted—too optimistically, as it turned out—that the dust bowl refugees would bring "a day of reckoning . . . for the California farm industrialists."[45]

None of the three writers directly addressed the question of whether the federal government gave favorable treatment to the migrants because they were white Americans. Paul Taylor's view of the camp program was that it was part of the national effort to rescue farm families who had been displaced from their land. He did, however, become involved in the issue of racial segregation in the camps. There were a few blacks among the dust bowl migrants, as there had been blacks among the cotton pickers from the time the crop was introduced in California.[46] In 1936, Tom Collins turned away some black workers who were brought to Arvin by a neighboring landowner. He had a legitimate excuse; the camp was full. But the request caused him to review policy guidelines. A federal facility must be open to everyone, he wrote Eric Thomsen. He intended to let it be known publicly that "we do not discriminate—color—race or creed." Yet since the all-white camp council had recommended that Negroes, Mexicans, and Filipinos be placed in a separate unit, he added, "We shall hold [section] #6 for that purpose, unofficially."[47]

Collins's successor estimated that the Arvin population was "98 percent native white"—a figure that matches the ratio of whites to other races in Kern County during the depression decade.[48] But in 1937, Paul Taylor notified the Region IX staff that "the impression is abroad that the camp at Arvin is not

for Mexicans and that the managers in the past have not wanted them. It seems Mexicans may not make use of the Brawley camp for a similar reason, built largely upon rumor."[49] Discrimination at Arvin was ended by a new manager, Fred Ross, who later in his life became a mentor to César Chavez.

152 Ross ignored the protests of Anglos and assigned Mexican farm workers to the general quarters.[50]

The similarity in the ideas of Steinbeck and Taylor can be attributed to the fact that they did their preliminary investigations under the aegis of liberal New Deal agencies. Taylor had the advantage of his scholarly training and background, as well as continuous exposure to new information and impressions he acquired on the trips he took with Dorothea Lange. Through traveling all over the country, he brought a national perspective to the problems of the migrants in California. Steinbeck's knowledge of the situation was by comparison superficial. After he wrote *The Grapes of Wrath,* he conveyed the impression that he had done research in Oklahoma, the locale of the first ten chapters of the novel. He and Carol drove through a section of Oklahoma on Route 66 on their way home from the East Coast in the late summer of 1937, but they rushed along trying to get home and did not stop for research.[51] Taylor, by contrast, acquired firsthand knowledge of the different geographical and agricultural areas of the state in his travels with Lange.

When Steinbeck selected a home for his fictional family, the Joads, he chose Sallisaw, near the Arkansas border, more or less at random. It was a plausible choice. Eastern Oklahoma was the area of the state that produced the heaviest migration in the 1930s.[52] Dorothea Lange, traveling with Paul Taylor, passed through Sallisaw in 1936 and took a picture of "stricken farmers, idle in town during the great drought"—men in gingham shirts and bib overalls hunkered down on the sidewalk in front of a store.[53] Sallisaw citizens interviewed by a reporter in 1986 said that people left the land when their crops "burned up." Yet according to the recollections of the survivors, local people had not been forcibly driven from their homes by tractors sent out by managers of the banks, as Steinbeck depicted the situation.[54] That happened farther west, in the dust bowl area of the state.

In 1937, as mentioned earlier, Taylor spent some time investigating the impact of mechanization in the Texas Panhandle region. He continued his research in Childress County, Texas, the following summer. He put his findings into a report for a professional journal that attracted enough attention to

be quoted in the Texas press.[55] It was on one of these trips that Lange took her unforgettable pictures of abandoned houses surrounded by tractor furrows. Steinbeck saw her photographs at the FSA office in San Francisco and perhaps also in Washington, D.C. Some of her images seem to have worked their way into his word pictures in the interchapters of *The Grapes of Wrath* and out again into the film montages in the motion picture made from the novel.

It is clear that Steinbeck shared a good deal of common ground with Taylor and Lange, but they did not have the influence on him that was claimed by the art critic Carol Schloss, who wrote that "it was knowledge of their field work that spurred him to make first-hand investigations of his own."[56] During the trial-and-error period that preceded *The Grapes of Wrath,* Steinbeck's field trips with Tom Collins had far more significance. When he was in Washington, D.C., in the summer of 1937, he visited the FSA office and asked for help with his research for a novel he was working on. In October, after he returned to California, he bought an old bakery wagon and drove to the migrant camp at Gridley, where Tom Collins was the manager. He took Collins with him as a guide to the various crop areas of the Central Valley. They worked in the fields, passing themselves off as laborers. Jackson Benson noted that since Collins was on the FSA payroll, the government was "in a sense, subsidizing Steinbeck's research."[57]

Before and after this trip, Steinbeck was working on a book on the migrants, into which he distilled his travel impressions. He called it "The Oklahomans." Benson called it "a first draft" of *The Grapes of Wrath.*[58] In the rainy winter of early 1938, Steinbeck returned to the Central Valley with Collins and the photographer Horace Bristol to observe what was happening and offer what help they could to migrant families who were caught in the flooded areas around Visalia. The experience left Steinbeck exhausted and filled with rage at what seemed to be the callousness of local officials. "A nice revolutionary feeling is the concomitant of this suffering," he told Pare Lorentz.[59] He poured out his anger in letters and into a vitriolic novel about the Associated Farmers to which he gave the working title "L'Affaire Lettuceburg," presumably referring to the 1936 lettuce packers' strike in his hometown. He completed a 70,000-word manuscript in May of that year, but in Benson's words, "the grossness of his attack sickened him," and he burned it.[60]

Steinbeck turned almost immediately to writing *The Grapes of Wrath*. He began the novel on May 31 and completed it on October 26. In the diary that

he kept during those five months, he traced his progress and his mood swings, which ranged from quiet satisfaction to fatigue to occasional euphoria. The diary's editor, Robert DeMott, comments that "in the act of composition, *The Grapes of Wrath* was an intuited whole."[61] Having conceived the novel in its entirety, Steinbeck set himself the task of transcribing it in daily installments. He made very few changes after his wife typed the chapters.

The work was accomplished in the midst of disruptions, some accidental, others self-inflicted. On more than one occasion Steinbeck broke his discipline to enjoy parties that were followed by hangovers and remorse. Toward the end he worried about wearing himself out and losing his momentum. After he and Carol sent off the manuscript late in the year, he collapsed from exhaustion.

It is appropriate that a novel inspired by so many journeys is itself the narrative of an epochal journey. Robert DeMott writes: "Steinbeck's rendering of the graphic enticements of Route 66—'the path of a people in flight'—from Middle America to the West defined the national urge for mobility, motion, and blind striving."[62] The story begins within a small compass and gains momentum as the Joad family travels from Oklahoma to California, from self-centeredness to concern for others, from insularity to consciousness of the forces that govern their lives. This is no pilgrimage of saints. The Joads and their preacher Casy are blunt, earthy, and occasionally blasphemous. Steinbeck fought the attempts of his editors to tone down their language, perhaps knowing instinctively that if he was accused of sentimentality, the profanity would be a useful antidote.

For this characteristic, as well as for its political relevance, *The Grapes of Wrath* attracted attention well before it was published on April 14, 1939. It went almost immediately to the top of the best-seller list, where it remained for most of the rest of the year.[63]

12

VOICES FROM THE BATTLEMENTS

Until late in the decade in which Steinbeck became famous, the national magazine coverage of California labor conflicts was lopsided. At a time when Paul Taylor was addressing a little group of liberals who subscribed to *Survey Graphic* and Ella Winter and Carey McWilliams were preaching to a small company of the converted who read the *Nation* and the *New Republic,* the country's mass-circulation weeklies and monthlies presented the position of West Coast growers and industrialists on a regular basis. Liberal and left-wing critics had long targeted the *Saturday Evening Post,* a Curtis publication under George Horace Lorimer, for its unvarying support of the employers' side in labor disputes.[1] The *Post* devoted a good deal of attention to the strikes involving Harry Bridges's International Longshoremen's and Warehousemen's Union.[2]

California's agricultural conflicts were more frequently covered in another Curtis publication, *Country Gentleman,* often under the byline of Frank J. Taylor, a freelance writer based in the San Francisco Bay Area. Taylor was both

versatile and prolific. He reportedly logged more than 25,000 miles a year in research travel, mostly around the West Coast.[3] Although he was known as an authority on aviation, horticulture, and agriculture, he wrote on a great variety of subjects for major magazines, including the *Post's* rival, *Collier's*. The 156 *Reader's Digest* regularly planted his articles in other publications in order to reprint them in slightly condensed form. The *Digest's* editor, DeWitt Wallace, who shared the anti-union, anti-Communist views of Lorimer and his successors, searched for ways to convey those views in positive terms. One of Taylor's *Digest* articles, about a cooperative for the unemployed, originally appeared in the *New Republic;* another, about a public-spirited Santa Barbara woman, in *Survey Graphic;* and yet another, entitled "Getting Along with Eighteen Unions," in the *Christian Century.*[4]

The eclectic approach appealed to Frank Taylor, who valued his professional ties with journalists of various ideological persuasions. Late in his life he met regularly with two Stanford alumni, former *New Republic* editor Bruce Bliven and R. L. Duffus of the *New York Times* when they lived on or near the campus in their retirement years. They were joined occasionally by William Chenery, who had moved to Big Sur when he stepped down as publisher of *Collier's.* Taylor had attended Stanford after Bliven and Duffus and had left before Steinbeck entered as a freshman. He had interrupted his studies to organize an American Field Service ambulance unit during the war in Europe and had remained overseas as a foreign correspondent for the United Press, writing from Germany, Austria, Czechoslovakia, Hungary, and Russia. He had been imprisoned briefly by the Soviets after writing a dispatch about the revolutionary government that was not in the enthusiastic vein favored by Lincoln Steffens.[5] After returning home to marry his high school sweetheart, Taylor worked in journalism, advertising, and public relations on the East and West Coasts before starting his magazine-writing career from a home in the hills above Los Altos, California. By producing thirty to forty articles a year, he supported his family in this chancy occupation through a combination of professional skill, hard work, and good connections. He also acted as a liaison between West Coast entrepreneurs and East Coast editors.

Within the same two-week period in September 1936, Frank Taylor and Steinbeck published articles that revealed the disparity in their viewpoints. Fourteen days after Steinbeck made his first public statement in the *Nation* denouncing the Associated Farmers, a story by Taylor on the Salinas lettuce

Frank Taylor interviewing a grower. *Sigma Chi Magazine* photo, courtesy of Robert W. Taylor.

packers' strike appeared in *Collier's.*[6] The strike had taken place too recently for Steinbeck to have mentioned it in his article, but it must have made a lasting impression on him, since he called his aborted vigilante novel "L'Affaire Lettuceburg." During the strike he had written a friend an alarmist account: "There are riots in Salinas and killings in the streets of that dear little town where I was born."[7] He may have been referring to an incident in which a strikebreaker was mistakenly shot by an overly zealous guard.[8]

Taylor did not mention killings, but he described the tear-gassing of the strikers by motorcycle police acting on orders from the chief of the Highway Patrol. He reported the excesses of Colonel Harry Sanborn, publisher of the *American Citizen* ("a weekly devoted to the exposure of communistic activities on the Pacific Coast"), who "had been brought hastily and secretly into Salinas by plane to act as coordinator" of the law enforcement groups and who was relieved of his duties after he threw out newspaper reporters who tried to interview him. Salinas was a strong union city whose citizens were "labor-minded," Taylor stated. He gave this objective picture of the adversaries and

the strike issues in a second article he wrote for a business magazine.[9] His summary was geared to his readers. "The situation is vital to the whole country," he stated, "for the reason that Salinas is to the lettuce market what Wall Street is to the financial world."

158

Frank Taylor was a sincere admirer of the technological achievements of California agriculture. He once called it "the greatest agricultural empire the world has ever known."[10] In his 1930s articles he called attention to the impact of the state's $600-million harvest on the rest of the country—noting, for example, the fact that almost half the perishable fruits and vegetables consumed in the United States were grown in California.[11] There is an echo of Paul Taylor and Carey McWilliams in Frank Taylor's statement: "Farming has ceased to be a simple, serene mode of living and has evolved into an outdoor factory deal with all the attendant industrial grief."[12] But he came to a different conclusion than they did: "Farming in California is expensive agriculture," he insisted, "beset even in times of industrial tranquillity by unusual hazards such as long-haul freight rates, danger by spoiling, cost of packing, whimsies of the market. The strike menace is one more hazard than California agriculture can bear."[13]

When Steinbeck was under fire after writing *The Grapes of Wrath,* he referred to Frank Taylor as "the propaganda front of the Associated Farmers."[14] Two years earlier, before Taylor and Steinbeck found themselves in an adversarial position, Taylor had stated the case for the AF in an article for *Country Gentleman.*[15] Writing as always in a quiet, persuasive, reasonable tone, he presented statements that answered the accusations of critics. In contradiction to what was said about them, the growers, he insisted, wanted to pay fair wages; California farm wages were in fact the highest in the nation. Growers were also concerned about workers' housing—he cited 6,000 new units built by AF members. He quoted the AF president, Walter Garrison, on the attitude of the organization toward unions: "We are in favor of collective bargaining, but we are opposed to the closed shop, to violent picketing and to the hiring hall." Taylor mentioned the involvement of the waterfront unions in the 1936 Salinas lettuce packers' strike and in the strike the following year in the asparagus fields near Stockton. He referred to the "march inland" financed by John L. Lewis's two-year-old Congress of Industrial Organizations (CIO). When a delay in the harvest could wipe out the profits of a whole year, growers were not going to stand by quietly without a protest.

Taylor addressed the question of violence. Although the AF had been accused of vigilante tactics, the organization took the position that the use of guns was restricted to the various sheriffs' departments with which agreements had been worked out. Taylor quoted the statement of a leader that the AF had never spent a dime on firearms or gas bombs. Farmer volunteers were "armed with a pick handle about twenty inches long."

Although no one answered Taylor's statements immediately, a number of them were partially or fully refuted by the testimony of witnesses or through subpoenaed documents introduced at the 1939–1940 investigation of the Associated Farmers by the La Follette Committee of the U.S. Senate. A Stanford economist pointed out the fact that the relatively high wages paid by California growers had to be judged in the context of the workers' total annual income, which involved the question of whether the work offered was steady or sporadic.[16] Revealing situations that Taylor had not mentioned, the La Follette hearings brought to light evidence that the civil liberties of farm workers had been violated by county-enacted antipicketing ordinances and by methods of intimidation such as registering, photographing, and fingerprinting workers as a requirement for employment, as well as by espionage and precautionary arrests. An *Oakland Tribune* reporter described an incident reminiscent of a scene in *The Grapes of Wrath:* Arriving in the town of Winters on June 22, 1937, he and the people with him were stopped by sheriff's deputies and asked if they were looking for work or could explain their presence in the area. They were told that if they did not leave or accept work, "they would be faced with being jailed."[17] Other witnesses gave evidence about the types of coercion— tear gas and, on occasion, firearms—used by cooperating law enforcement officials to disperse strikers. It was revealed that several hundred dollars had been spent on tear gas at a ranch owned by an AF leader.[18]

Frank Taylor was usually moderate, but he sounded doctrinaire in an article defending H. C. Merritt Jr., the owner of the Tagus Ranch, where Pat Chambers had led a brief, successful strike among peach pickers in August 1933. Taylor summed up the strike: "A few years ago, at the height of the harvest, radical labor organizers, making a drive on all California farming, descended on Tagus Ranch, dragged fruit pickers from their ladders, and temporarily tied up operations. The trouble was quickly over. Two of the terrorists are still in jail. That was the ranch's one taste of labor trouble."[19]

Taylor presented Merritt's position on the company store, a subject that was

picked up by Steinbeck and featured in *The Grapes of Wrath.* According to Taylor, "The Merritts manage to lose a cent or two on every dollar of sales— purposely, just to keep it clear that they make money only out of farming and not out of the store—or the restaurant that serves 15–25-cent meals, or the garage, or the filling station." Cotton was grown on the Tagus Ranch to provide work in the fall and winter months for two hundred year-round workers even though—Merritt claimed—"We don't make a nickel out of cotton." The grower did not want his workers to live in squatter camps or in government camps "where they may be worked upon by radical labor 'agitators.'" He offered housing on the ranch with electricity and firewood included for three dollars a month. He had constructed a schoolhouse, which was leased to the county for fifty cents a year, where hot chocolate was served to the children every morning.

Steinbeck was getting a different interpretation from Tom Collins's Arvin reports. Collins expressed the opinion that there was "a danger of feudalism" in a situation in which workers stayed permanently in employer-run camps.[20] As for company stores, Collins discovered near Arvin, in his own backyard, what he called a "racket" in which workers went in debt to a grower's brother.[21] He also noted that a number of growers issued orders on local stores instead of paying workers in cash. The store owner expected the worker to buy something "in order to get his money and the worker is usually too timid to refuse."[22] At the Tagus Ranch, in lieu of wages, workers received chits that could be exchanged for groceries at the ranch store, but for this service ten cents was deducted from every dollar they earned.[23]

Taylor praised Frank Palomares, "scion of one of the early Southern California Spanish families," who as head of the San Joaquin Agricultural Labor Bureau was "the West's foremost agricultural labor expert." By setting a scale of wages that "all employers are supposed to pay, no more, no less," the bureau had "reduced the temptation" for workers "to jump from job to job in the middle of the grape, peach, fig or cotton picking."[24] Labor partisans, on the other hand, accused Palomares of holding wages at the level specified by the growers.[25] Collins described a Chamber of Commerce meeting in Bakersfield at which Palomares warned of the danger of Communism as he "lashed out in bellicose fashion at the Resettlement Administration for establishing migrant camps."[26]

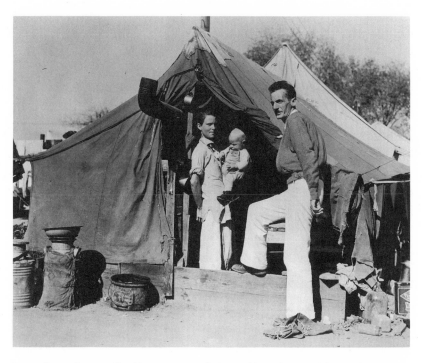

Tom Collins and migrant family, Arvin Camp, Shafter, California, 1935. Photo by Dorothea Lange. Copyright © Dorothea Lange Collection, The Oakland Museum of California, The City of Oakland. Gift of Paul S. Taylor. Reproduced with the permission of the Oakland Museum.

Collins lashed out himself against the Associated Farmers. In a report written at about the time Steinbeck first visited the Arvin camp, he shot off a statement more impassioned than cogent on behalf of its residents: "Little do they know that about them stalks the ghostly dirge of the machine gun in the hands of the mental aborigines of selfishness and greed."[27] Eric Thomsen, who brought Steinbeck to Arvin, was less intemperate but more sweeping in his indictment of the AF, which had attacked his publicly stated position on the migrants and labor organizing.[28] After he left his job when the camp program was taken over by the Farm Security Administration under the USDA, he wrote a friend that "the Secretary of Agriculture [Henry Wallace] confidentially informed the region [Region IX] that they [the USDA] were under such intense fire that 'while we had done a swell job,' they would need to compromise the program for the sake of political backing of other programs of more than lo-

cal significance." Thomsen added a postscript: "A year later they discovered that the need was national rather than local and that the heat was on whether or not they dealt with the need; be it said in justice to the politicos that they did then tackle it with a vengeance and did a good job."[29]

162

The discovery of the need for renewed action was in all likelihood connected with the floods in the San Joaquin Valley in February and March of 1938. When the Farm Security Administration offered financial aid to nonresident flood victims, the director of the State Relief Administration declined on the grounds that the money would attract more migrants.[30] Steinbeck blamed the Associated Farmers for "sabotaging" the efforts of the federal government.[31]

The emergency drew him into a new round of personal involvement and publicity writing. On one of his trips to the flooded area around Visalia, he was accompanied by the photographer Horace Bristol, who had a commission to do a story for *Life*.[32] Bristol, who had worked briefly with Dorothea Lange before joining the *Life* staff, had gone with Steinbeck on earlier trips to the Central Valley with the idea that they might collaborate on a book.

Although Steinbeck acknowledged that he was now famous enough to command attention on the national scene, he had an uneasy relationship with mass-circulation magazines. Bristol thought that another Luce publication, *Fortune* (which in 1936 had assigned James Agee and Walker Evans to do a feature on tenant farmers in the South), would be interested in an article, but Steinbeck told Elizabeth Otis that he turned down an offer: "I don't like the audience."[33] (He may have been wrong in his judgment. In April 1939, the month *The Grapes of Wrath* was published, the editors of *Fortune* cataloged the more notorious features of the California farm labor scene—"tear gas, finks, goon squads, propaganda, bribery, espionage"—which were later documented by the La Follette Committee.)[34] Steinbeck was also adamant in refusing to make any changes in the material he sent to *Life*. In the end, the magazine did not use his article; the following year, *Life* reproduced Bristol's pictures with captions by Steinbeck that included quotations from *The Grapes of Wrath*.[35]

By this time the situation was out of Steinbeck's hands. His saga of the uprooting and migration of an Oklahoma family had been appropriated by the American public. A reporter for *Publishers Weekly*, writing a year after the book's publication, noted that the commentary "was not confined to the literary pages. By the fall of 1939 [the novel] had figured in so many news sto-

ries and editorials that the press of the country was using the words 'Joad' and 'Okie' without explaining them."[36] In 1939 and into 1940 it was the most talked-about book in the country. Mrs. Roosevelt gave it her public stamp of approval.[37] East Coast reviewers were almost unanimous in their praise.

"And how they eat it up," exclaimed a contributor to the AF's *Pacific Rural Press,* "those emotion-hunters, intelligenzia [*sic*], pinks, reds, and cocktail cuddlers."[38] Very few people were neutral about the book. They loved it or, in the case of the outraged chauvinists in Oklahoma and California who were insulted by Steinbeck's portrayal of them, they hated it. A writer in *Collier's* commented that "certain alarmed interests in California" would gladly have paid $300,000 to "place the book and the book rights in a heavy safe and row out on the Pacific Ocean and dump the whole thing overboard."[39] Opposition was most vocal in Kern County, where four months after its publication the Associated Farmers persuaded the Board of Supervisors to ban *The Grapes of Wrath* from county libraries.[40] This step was announced as the beginning of a statewide campaign, but other counties proved to be resistant to such coercion. A librarian in Fresno County made a stand for civil liberties by stating that, in her opinion, readers "might take the book or leave it."[41]

It was in the midst of this furor that the *Reader's Digest* asked Frank Taylor to investigate what was going on.[42] As he recalled the situation later, "Mr. [DeWitt] Wallace assigned me to trace the travels of the Joad family. . . . His idea was that 'The Grapes of Wrath' although fiction was being read as fact and he thought Reader's Digest readers would be interested in a reportorial job on the Joads or their real-life counterparts."[43] Taylor did some thorough research, even traveling to Washington and Oregon to discover why the migrants had assimilated more easily in the Northwest.[44]

His report on what was going on in California was a persuasively low-key presentation of what many critics were saying in more strident tones. He made some valid points, buttressed by factual evidence, in trying to explain why many people in the state were, as he put it, "wrathy about 'The Grapes of Wrath.'" Discussing the resentment of longtime residents of the San Joaquin Valley toward Steinbeck's portrayal of their callous neglect of the migrants, Taylor documented increased tax expenditures at the county level for the benefit of these newcomers. The unfairness of being judged negligent when in fact they were enduring an economic burden had also been mentioned in a story

in the *New York Times*.[45] (Kevin Starr, in a corroborating view, cites archival evidence for "increased tax revenues spent on relief and public services in the southern San Joaquin." He adds: "It can be argued, in fact, that California maintained the most generous local and state relief program in the United States between 1935 and 1941.")[46]

Taylor brought up the controversial question of high relief payments as a lure in attracting the migrants to California. James Gregory concedes that there may have been some truth in this assertion, which was consistently downplayed by migrant advocates. Other factors were the relatively high cotton-picking wage and per capita income in the state.[47]

Taylor also disputed Steinbeck's portrayal of the migrants as being recruited through handbills. Although acknowledging that two labor contractors did distribute handbills, he claimed that they subsequently lost their licenses. (One of the placards preserved from that period called for pea pickers in Lompoc, near Nipomo where Dorothea Lange photographed her *Migrant Mother,* an area that annually suffered from a surplus of workers.)[48] Steinbeck may have been influenced by an item in one of Tom Collins's reports about two prominent landowners near the Arvin camp who "made it a practice to circularize Oklahoma and parts of Texas encouraging cotton pickers to come to Arvin, Mountain View, and Weed Patch districts under the promise that work was plentiful and wages good. The first to come are hired, then fired as others arrive. The oversupply forced down the cost of labor."[49]

Collins might not in fact have been talking about handbills, but about the growers' ads that appeared in newspapers in Oklahoma and other migrant states. Carey McWilliams collected these advertisements. Dorothea Lange and Paul Taylor included samples in their book *An American Exodus.*[50] The solicitation seems to have originated with Arizona cotton growers and their agents. Labor recruiters from Arizona estimated that they were responsible for bringing 42 percent of the migrants from Texas and 29 percent of those from Oklahoma into their state, which was a way station on the road to California.[51]

The central point of Frank Taylor's commentary on *The Grapes of Wrath* was that the migrants were not suffering in the way Steinbeck pictured the situation because the federal government, through the Farm Security Administration, was helping them. His argument is largely invalidated by the fact that he and Steinbeck were reporting on different times. Without giving any political background, Taylor described the FSA grant program, which helped migrants

survive until they qualified for state aid, and the Agricultural Workers Health and Medical Association, which assisted over twenty thousand people in its first ten months of operation. Both programs were launched in 1938 *after* stonewalling by state officials during the disastrous floods in the San Joaquin Valley brought intervention from Washington. Steinbeck, however, set *The Grapes of Wrath* in the period *before* the federal government stepped in; the novel ends with the flood. It is interesting that the government camp, where the Joads find peace in addition to modern plumbing, served as a common denominator for Steinbeck and Frank Taylor—who in this instance wrote like a publicist for the FSA.

The *Reader's Digest* continued to be mindful of Steinbeck's popularity. In August 1940 the magazine excerpted an episode entitled "Two for a Penny" from an interchapter of *The Grapes of Wrath*. Introduced as "A typical roadside stand, and a touch of humble, yet magnificent kindness," the piece described the response of a diner's proprietors and their truck-driver customers to a migrant family who come in to buy bread. The *Digest's* editors presented the episode as a heartwarming vignette, an example of simple American generosity. They did so by cutting from Steinbeck's original version the woman proprietor's description of some wealthy tourists as "shit-heels"—in one stroke of the blue pencil removing both the profanity and the social message.[52]

Unlike *Reader's Digest,* the Curtis magazines took no notice of public interest in their totally uncompromising reporting of California farm labor controversies. On the eve of the publication of Steinbeck's novel, Garet Garrett, who had been friendly with Steffens in Carmel, contributed a grower-inspired article to the *Saturday Evening Post* in which he referred to the misdeeds of the CAWIU and the successor union, the CIO's UCAPAWA.[53] A year later Ben Hibbs, writing in *Country Gentleman,* described the Associated Farmers' favorite health officer, Dr. Lee A. Stone, sitting at a booth at the Madera County Fair with a sign that read: "Madera County Health Unit boasts 2600 Cabins in Grower Labor Camps. TO HELL with 'The Grapes of Wrath' and 'Factories in the Field.'"[54]

13

"SOMETHING MUST BE DONE, AND DONE SOON!"

When Carey McWilliams's *Factories in the Field* appeared in July 1939, three months after *The Grapes of Wrath*, it was hailed by enthusiastic reviewers as the documentation of the novel. The connection was reflected in sales. As *The Grapes of Wrath* held first place on the best-seller lists across the country for the rest of the year, *Factories in the Field* went through four reprintings in three months.[1]

Since the authors were considered to be connected through the Steinbeck Committee to Aid Agricultural Organization (to which Steinbeck lent his name and McWilliams his executive talents), spokesmen for California growers suggested that a double-barreled attack had been planned deliberately.[2] Anticipating such criticism, McWilliams had noted in his introduction that his manuscript had been forwarded to his publisher (Little, Brown) "prior to the time that Mr. John Steinbeck's [novel] was published." He had not known that Steinbeck was writing *The Grapes of Wrath*.[3] Although he quoted a statement from "The Harvest Gypsies" in his chapter on the Associated Farmers

(as well as an excerpt from a Paul Taylor article in another section),[4] he and Steinbeck had never discussed their work or even met each other.

Steinbeck became aware of McWilliams's project soon after he finished his own. Shortly after he mailed his manuscript to Viking in December 1938, he read *Factories in the Field* in serial form in the *People's World*.[5] He was sufficiently impressed to volunteer a statement through his literary agents for McWilliams's publisher to use as a blurb when *Factories in the Field* came out some months later. Steinbeck recommended the book as "a complete and documented study of California agriculture, past and present." He added: "It should be read by those people who are confused by the liars and lobbyists who have covered this situation for years."[6] The statement appeared on the book jacket of later editions.

Referring to the articles he had written in 1935 with Herbert Klein, McWilliams made the point that *Factories in the Field* was "based upon entirely new research." The book reflected his wide-ranging interests and included evidence of his early enthusiasm for literature. He opened it with a poem, "The Nomad Harvesters," by Marie de L. Welch and in later sections referred to Henry George, Josiah Royce, and Frank Norris, as well as to a 1930s novelist with the possibly pseudonymous name of A. Van Coenen Torchiana. Leading the reader through a colorful and illuminating survey of earlier land-labor relationships in California, McWilliams combined a historian's balanced view of the past with a courtroom prosecutor's approach to contemporary issues. He prepared the ground for the closing arguments of his case by contrasting the vast nineteenth-century Central Valley landholdings of Miller and Lux with the Kaweah Cooperative Colony developed by the Socialist labor leader Burnette K. Haskell (in an area that later became a part of the Sequoia National Park). Toward the end of the book, in his discussion of the contemporary situation, McWilliams recommended "a collective agriculture to replace the present monopolistically owned and controlled system"—a statement that was seized upon by his political enemies and waved before the public like a red flag. A historian of a later generation, Walter Stein, explained McWilliams's position by comparing him to the New Deal theoretician Rexford Tugwell: "Both sought to apply the collective principle to achieve better use of land and people within a liberal capitalist economy."[7]

Whether or not McWilliams accepted this interpretation, he, like Tugwell, was given an opportunity to test his ideas through government service. If the

system could not be replaced, he could try to reform it as head of the Division of Immigration and Housing under Culbert Olson. The problems that had beset the agency during previous Republican administrations were described by Paul Taylor (who was also given an appointment by Olson, to the State Board of Agriculture). Taylor told members of the Commonwealth Club that the Division of Immigration and Housing was doing "yeoman's work" in "struggling against the obstacles of public apathy, inadequate staffs, resistance of employers unwilling or unable to do better, reluctance of local officials to apply penalties to their neighbors for violation of state camp sanitation laws."[8] In a later speech Taylor told members of the club that the agency was "crippled."[9]

McWilliams lost no time in trying to turn things around. He stepped on the toes of growers by increasing the number of labor-camp inspections and imposing more stringent standards. His most controversial action was in holding—in conjunction with the State Relief Administration—wage hearings in which he changed a practice that had forced recipients of state aid off the relief rolls to take jobs at wages established by growers. At McWilliams's hearings the wage-relief formula was set at a figure higher than the growers were offering. The change created an uproar; McWilliams remarked later that he was accused of "attempting, single-handed, to 'sovietize' California agriculture."[10]

Steinbeck commented on the reaction of the opposition to "our new liberal governor [who] is trying to make some changes."[11] He had played a part in the campaign by giving his permission for "The Harvest Gypsies" to be reissued by the Simon J. Lubin Society, a lobbying group that promoted the interests of small farmers and farm workers in opposition to the Associated Farmers. The society was run by Helen Hosmer, née Horn, who had left the FSA Region IX staff with the blessing and some private financial help from Jonathan Garst and Fred Soule.[12] In the fall of 1938 she joined the successful effort to help elect Culbert Olson, damage the U.S. senatorial campaign of the Associated Farmers leader Philip Bancroft, and defeat the AF's antilabor initiative on the November ballot. Shortly before the election she persuaded Steinbeck to write an epilogue to his 1936 newspaper series. She changed the title to "Their Blood Is Strong," added a cover photograph by Dorothea Lange, and published the material as a 25-cent pamphlet.[13]

Among farm labor advocates there was rejoicing over the victory of Olson,

the first Democrat to be elected governor of California in the twentieth century, but they were frustrated when the gains won in the election were blocked or reversed in the legislature. Programs initiated by newly appointed radical staff members of the Department of Relief were dismantled. Both the assembly and the senate passed a bill to abolish the Division of Immigration and Housing. Only a veto by the governor saved McWilliams's job.

McWilliams wrote later that *The Grapes of Wrath*, by "appearing at this particular time"—two and a half months after Olson took office—"had the effect of a match being tossed into a powder keg."[14] He and Steinbeck were targeted at a December 1939 meeting of the Pacific Coast branch of the Associated Farmers. An AF representative from Lodi warned of a drive by Communists to seize control of California farms "as advocated by Carey McWilliams."[15] McWilliams publicly denied an accusation that he had "tried to create unrest and dissension among agricultural workers," but he took some pride in being called "California's number one agricultural pest, worse than Pear Blight or boll weevil" and in reporting that the AF "had raised a special fund of $15,000 to conduct a smear campaign against the two books and their authors."[16] When Steinbeck was blamed for "grossly libeling migrants from the dust bowl states by representing them as vulgar, lawless, and immoral," McWilliams pointed out that the charge of immorality and religious blasphemy, the centerpiece of the attack on the novel in Kern County, was a smokescreen for opposition to issues that *Factories in the Field* also raised.[17]

McWilliams seized an opportunity to expose a novel by Ruth Comfort Mitchell as the Associated Farmers' answer to *The Grapes of Wrath*. Mitchell, who lived in Los Gatos within a few miles of Steinbeck's new home, was the wife of the Republican state senator Sanborn Young, a leader in support of Proposition 1, the antipicketing initiative that was defeated by the voters who elected Olson. McWilliams took note of the fact that the day after *The Grapes of Wrath* was suppressed in the Kern County public libraries, Mitchell presided over a San Francisco luncheon meeting of Pro America, a Republican women's club, "where one [AF] spokesman after another told the crowd . . . that there was not one shred of truth, not one fragment of fact, in anything that Mr. Steinbeck and I had said about California's farm labor problem."[18] Mitchell, a contributor to women's magazines and the author of more than half a dozen novels with a West Coast background, had complained that "California, once

the mecca of empire builders, had become a bird refuge for cuckoos, scolding jays, and sharp-billed butcher birds."[19]

The cruel butcher birds are a symbol in *Of Human Kindness,* Mitchell's 1940 novel about the depression-era struggles of a Central Valley farm family.[20] She described the Banners as "kindly American people trying to get along despite harassment."[21] The difficulty comes in the form of strikes fomented by Communist labor organizers. The Banners have the traditional values of their pioneer forebears. They are people of the land who find themselves confronted by new challenges. They overcome their prejudice against migrants when their daughter marries a new arrival from Oklahoma; they try to help their neighbors to get along with workers who are destructive of their property. Mary Banner, the heroine, brings food, water, gas money, and milk, "the milk of human kindness," to migrants squatting on her land and directs them to the nearest Farm Security Administration camp—yet another favorable reference to the government program by a writer who was accused of being a spokesperson for California growers.

Mitchell put the accent on the positive. The world of her fiction is "perpetually optimistic," in the words of a critic.[22] It is also a world of *noblesse oblige,* of caste and class. Mitchell denied that she had set out to answer Steinbeck.[23] Yet there are incidents in her novel, notably a scene in which a Communist organizer excites a crowd by displaying the corpse of a fallen comrade, that are reminiscent of *In Dubious Battle,* and a vignette of a nursing mother who has lost her milk reads like a parody of the last scene in *The Grapes of Wrath.*

Of Human Kindness was a target ready-made for McWilliams's satire. In his review he mentioned Mitchell's connection with the Associated Farmers, her distaste for "trade-union organizers, Okies, liberal schoolteachers," her portrayal of "her own people, the farmers, the townspeople, the first citizens" as "sociological saints." He suggested that the final verdict on the books had been rendered by the La Follette Committee, which supported Steinbeck.[24]

Standing outside the warfare of the California writers, the British émigré Aldous Huxley offered an independent view of the migrant and farm labor controversy in his 1939 novel *After Many a Summer Dies the Swan.* It was based on a real-life experience that was his introduction to the physical and social landscape of Southern California. In 1937, as he and his wife and son drove

through the outskirts of San Bernardino en route from Taos to Los Angeles, they were overwhelmed by the stench of decayed oranges. Through the car windows they saw migrant workers gazing bitterly at mounds of rotting fruit piled by the side of the road. In the background were huge haciendas.[25] In recreating the episode in his novel, Huxley placed the workers at the foot of a hill below the estate of an industrial magnate, a character modeled on William Randolph Hearst. The setting is true to formula, almost too true to be credible, but the sequel is politically unorthodox: Huxley's migrant father, a cardboard figure called "the man from Kansas," is revealed to be as scheming and avaricious as the rich man who lives above him.[26]

171

Steinbeck chose to distance himself from the battle of the books. (One of his last partisan actions, undertaken shortly after he mailed off the manuscript of *The Grapes of Wrath,* was to publicize a Christmas party at the FSA camp in Shafter where the actress and migrant advocate Helen Gahagan Douglas brought some prominent Hollywood people to lead the festivities and give presents to the children.)[27] Carey McWilliams was in a better position to confront the opposition. His life and his work had become integrated. When he joined the Olson administration, he had resigned from his firm and given up the practice of law. He had also divorced his first wife and embarked on an enduring marriage to a novelist, Iris Dornfeld. He was, moreover, temperamentally suited to controversy and enjoyed the public arena.

Steinbeck, by contrast, disliked publicity under any circumstances and was particularly averse to it at this time. From the high point of the novel's completion, he descended into a period of fatigue and illness when he had little tolerance for the interference of editors and publicists and abhorred the intrusion of strangers. He wanted to turn in other directions. He went to Chicago to join Pare Lorentz, who was making a film, *The Fight for Life,* about the work of Dr. Paul de Kruif in trying to lower infant mortality. Steinbeck made a sea voyage to Mexico with Carol and his biologist friend Ed Ricketts. There was a manic quality about his restlessness. In this period he was frequently drawn to Hollywood, where he was becoming infatuated with a young actress, Gwyndolyn Conger. Success had brought disturbing changes, such as the loss of anonymity and an awareness that longtime associations, including his marriage, were being irrevocably affected. He was also troubled by the fact that writing about poor people was making him a rich man, a situation that Kevin Starr has called "one of the enduring paradoxes of American literary history."[28]

Steinbeck's general malaise heightened his anxiety about his political foes in California. He had first crossed swords with the Associated Farmers in 1936 when he took a stand in the *Nation* and was answered by a spokesman for the organization.[29] As the opposition to him grew in proportion to his fame, he debated strategies to meet it.[30] Even before the publication of *The Grapes of Wrath,* he became concerned about covering his tracks.[31] He expressed fear of physical attack.[32]

Steinbeck, who always avoided public appearances, was relieved not to have to testify before the La Follette Committee, although he had sent material to Washington before the committee decided to hold hearings on the West Coast.[33] Unwittingly, he and McWilliams became involved in the ongoing warfare between the La Follette Committee of the Senate and its "investigative counterweight," the House of Representatives' Dies Committee on Un-American Activities.[34] In Washington, members of each committee tried to block the appropriations of the other. In California, where the committees held nearly simultaneous hearings in late 1939 and early 1940, information was supplied to one by the Simon J. Lubin Society and to the other by the Associated Farmers—groups that were also spying on each other.

Steinbeck mentioned having "placed certain informations [*sic*] in the hands of J. Edgar Hoover in case I take a nose dive."[35] He discovered, however, that the FBI was accumulating material on *him* that had been sent by the Dies Committee. He complained to Attorney General Francis Biddle, who forwarded his message to Hoover. The FBI director replied that Steinbeck "is not being and never has been investigated by this Bureau," a statement patently false, since materials released under the Freedom of Information Act demonstrate that the FBI had been keeping track of Steinbeck's activities since 1936, specifically his sponsorship of the Western Writers Congress and his contribution to the Steffens memorial issue of the *Pacific Weekly.* Included in his files was a letter from Ella Winter rebuking him for his attitude toward a waterfront strike in San Diego.[36] (Although it was not in the record, he was later criticized by Winter for opposing the Soviet invasion of Finland, just as he was taken to task by "the party line left" in general for supporting a U.S. defense buildup at the end of the decade.)[37] Steinbeck was in an unwinnable position. In the 1950s the FBI opened a file entitled "Instances Wherein America's Enemies Have Used or Attempted to Use Steinbeck's Writings and Reputation to Further Their Causes." The official reason given for doing so was that "because

many of Steinbeck's writings portrayed an extremely sordid and poverty-stricken side of American life, they were used . . . by the Nazis and Soviets as propaganda against America."[38]

Ella Winter, on whom the Dies Committee had been gathering information, announced her intention of attending the La Follette Committee hearings, and later wrote a report on them for the *New Masses*.[39] Carey McWilliams, who spent much time preparing material and testifying—in January 1940, in Los Angeles—before the La Follette Committee, had previously been identified by the Dies Committee as "a radical."[40] James Cagney was called before the Dies Committee to explain his friendship with Lincoln Steffens but was exonerated when he said that Steffens's "viewpoint was so contradictory . . . that you could not arrive at any conclusion regarding the man."[41] Paul Taylor, who was active in the San Francisco hearings of the La Follette Committee, believed that he was investigated by the FBI.[42]

In his role as advocate for Steinbeck, McWilliams went on the radio to defend *The Grapes of Wrath* against the charge by the Associated Farmers' Philip Bancroft that the novel was "highly sensational and utterly inaccurate." McWilliams and Bancroft appeared together before the Commonwealth Club of San Francisco and the Friday Morning Club of Los Angeles. On March 7, 1940, on the "Town Meeting of the Air" in New York City, they engaged in a particularly acrimonious debate in which Rexford Tugwell and Hugh Bennett, chief of the federal Soil Conservation Service, took part.[43]

The excitement over *The Grapes of Wrath* had resurged with the release of the Twentieth-Century Fox motion-picture version on February 27, 1940 (Steinbeck's thirty-eighth birthday). The producer, Darryl F. Zanuck, had worked in an atmosphere of secrecy and tension.[44] The Hays Office, the government agency monitoring the film industry, had issued a warning about Communist propaganda. Several thousand people had written letters to the studio, many condemning the enterprise, others protesting that Hollywood would whitewash the truth. Zanuck had undertaken the project with a sense of mission. He and the screenwriter, Nunnally Johnson, the director, John Ford, and the actors who played the leading roles—everyone, in fact, connected with the film—took great pains to produce a cinematic translation that was faithful to the spirit and atmosphere of the novel.[45] Before Zanuck began shooting the script, he sent investigators to the Central Valley to see if conditions were as Steinbeck described them. Satisfied, he sent a second film unit

traveling down Route 66 from Oklahoma to take footage that was used as backdrop when the movie was shot on the Fox lot. At Steinbeck's suggestion, Zanuck hired Tom Collins as a consultant on props, settings, and costumes, and to recruit migrants from the FSA camps as extras.[46]

 Steinbeck had read and approved Nunnally Johnson's script, although it lacked a final scene because Zanuck had not made up his mind how to end the film. Even if the public had been amenable, the Hays Office would never have sanctioned a film version of the novel's last episode, in which the Joads' daughter Rosasharn (Rose of Sharon), after giving birth to a stillborn child, suckles a starving man, a stranger encountered during the flood. Steinbeck had insisted on keeping the scene in the novel against the advice of his editors. It was essential, he thought, to the message he was trying to convey: "If there is a symbol it is a survival symbol."[47] (It was incorporated fifty years later by the Steppenwolf Company of Chicago into a stage version of the novel.)[48] Zanuck originally planned to end the film with Tom Joad's eloquent speech to his mother about his mission as an organizer, which begins, "Well, maybe . . . a fella ain't got a soul of his own, but on'y a piece of a big one." As spoken by Henry Fonda to Jane Darwell, the speech was a high point of the film. After John Ford had finished shooting, however, Zanuck viewed the rushes and decided the movie should end on a more positive note. He added a scene showing Ma and Pa Joad driving to what they hope will be a more promising future, with Ma saying, in words taken from the middle of the novel, "We're the people. We'll survive." Although many fans of the novel complained about this bland, almost saccharine ending, it didn't seem to bother Steinbeck. Perhaps he was thinking of the powerful cinematic images that brought his interchapters to life when, after going to Hollywood to see a preview in mid-December 1939, he wrote, "Zanuck has more than kept his word. He has a hard, straight picture. . . . It has a hard truthful ring."[49] When Zanuck arranged a premiere showing in New York soon afterward, the film drew such rave reviews that he reversed his original decision that he would not show it in California.

 Steinbeck was out of the state, as he explained in a note of regret, when Eleanor Roosevelt came west a short time later, in April 1940, to get her own impression of the background of *The Grapes of Wrath*.[50] After the book was published, the president had been quoted as saying, "Something must be done and done soon."[51] The first lady had spoken on several public occasions on the

migrant issue in relation to the novel. Her tour of the southern San Joaquin Valley was arranged by Helen Gahagan Douglas after Douglas consulted with Paul Taylor, who had become her adviser on the California farm labor issues that launched her political career.[52] Douglas and her husband, the actor Melvyn Douglas, flew with Mrs. Roosevelt and her secretary, Malvina Thompson, from Los Angeles to Bakersfield, where they were met by Laurence Hewes, who had succeeded Jonathan Garst as head of the FSA's Region IX. En route by automobile to a government camp, the party stopped to visit a ditchbank settlement, "a cluster of makeshift shacks, constructed of old boards, tar paper and tin cans pounded flat."[53] Almost immediately a crowd of people came up and surrounded the first lady. She became so absorbed in talking to them that, against the warning of bystanders, she went into a tent where the children had a contagious rash. Before she left the area, she rebuked the camp manager for allowing a water faucet to be attached to a privy.[54] At the immaculate FSA camp in Visalia, a "highly-scrubbed blue jean and calico-clad committee" was waiting for the group. It was a replay of Steinbeck's experience four years earlier. And in answer to a skeptical question from a reporter, Mrs. Roosevelt made an emphatic and impassioned reply: "I never believed," she said, "that *The Grapes of Wrath* was an exaggeration."

According to Carey McWilliams, her words had a significant political impact. Congress was debating a resolution to create a committee to investigate the interstate migration of destitute citizens and to study their social and economic needs. Representatives from Oklahoma and California who opposed the creation of the committee had denounced Steinbeck's novel. After Mrs. Roosevelt's statement was circulated in the press, Congress in May 1940 "quickly passed" the resolution to create the Tolan Committee on Interstate Migration, named for its chairman, Representative John Tolan of Oakland. The committee held hearings on the migrant problem in the south central states and on the West Coast.[55]

After all the uproar, the government's review of the problems came too late to be effective. The Tolan Committee documented the background of *Edwards v. California,* a case involving individuals indicted in Marysville, in the upper Sacramento Valley, under the Indigent Act. Passed by the California legislature in 1933 and revised in 1937, the act made it a punishable offense to bring destitute people into California. A 1941 Supreme Court decision struck down the law and established the principle of the free movement of people across

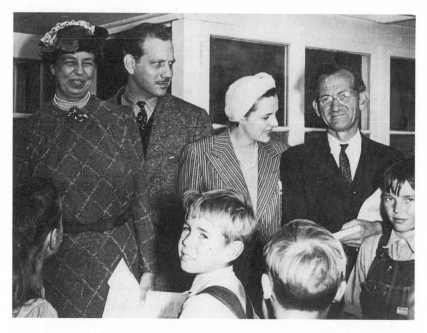

Eleanor Roosevelt, Melvyn Douglas, and Helen Gahagan Douglas with residents of the Farm Security Administration camp in Visalia, 1940. Helen Gahagan Douglas Collection, Carl Albert Center Congressional Archives, University of Oklahoma. Reproduced with the permission of the Carl Albert Center Congressional Archives.

state borders.[56] By this time, however, not many people were paying attention. The nation was gearing for war. Chairman Tolan himself had introduced in Congress what was described as the first regulatory statute to deal with the migrant problem, a bill to regulate labor contractors and private employment agencies engaged in interstate commerce. A hearing on the bill was held in November 1941, but it never passed onto the floor for a vote.[57]

On December 2, 1941, five days before the Japanese attack on Pearl Harbor, Paul Taylor testified before Tolan's committee. The committee's function and even its name had been changed to reflect changed priorities; it was now the Select Committee Investigation of National Defense Migration. The problem of the migrants' livelihood—the subject of the original survey—was being solved by the employment opportunities opening up in California shipyards and airplane-manufacturing plants. In early 1942 the agenda of the committee changed again: the lawmakers began hearings on the impending evacuation of Japanese Americans from the West Coast.

International events also affected the outcome of the La Follette Committee investigations. In the words of the author of a book about it, the committee "took for its central theme 'the existence of the National Labor Relations Act, the reaction of employee or employer organizations to its application, and their long struggle to realize or frustrate the benefits which it promised.'"[58] The fact that the hearings focused on farm workers, who were not covered by the NLRB, was an acknowledgment of the special situation that had been called to the attention of Congress by local writers—according to the historian Jerold S. Auerbach, "the warnings of Steinbeck and McWilliams provided the final thrust necessary to bring the committee to California."[59] Paul Taylor, a classmate of La Follette's at the University of Wisconsin, was influential on a personal level.[60]

McWilliams said later that the La Follette Committee was not eager to come to the West Coast.[61] There is evidence that the general public was more interested in the hearings of the Dies Committee. What, then, was accomplished by the twenty-eight days of the La Follette hearings held in San Francisco and Los Angeles, the testimony of approximately four hundred witnesses, and the revelations contained in hundreds of subpoenaed documents of the Associated Farmers, documents Steinbeck had suggested would send some of the association's members to jail?[62] For one thing, the attention put an end to the plans of the AF to expand into other states.[63] The organization was still on the scene in Kern County and other farm areas of California in the post–World War II period.[64] But Ernesto Galarza, a leading organizer for the AFL's National Farm Labor Union in the late 1940s and early 1950s, observed that the growers who held economic and political power in the region relied on other methods to combat strikes—for example, the importation of *braceros* from Mexico.[65]

The main achievement of the La Follette hearings was the exposure of organized violence. A proposal to empower farm workers by giving them the protections accorded to industrial workers under the New Deal had been set forth by Governor Olson.[66] It was later endorsed by Senator La Follette in a speech in the United States Senate, but with a war on, few of his colleagues were listening. "Hitler knocked us out of the ring," the head of the California investigation told Paul Taylor.[67]

14

AFTERMATH

The outbreak of war in Europe adversely affected the reception and sales of Dorothea Lange and Paul Taylor's summation of their work in the 1930s, *An American Exodus.* Appearing several months after *The Grapes of Wrath* and *Factories in the Field,* the book suffered from a liability of timing that was shared by another—and perhaps the greatest—of the photo-text collaborations of the depression decade, *Let Us Now Praise Famous Men,* by James Agee and Walker Evans.[1] Margaret Bourke-White, who had developed her career as a photographer for *Life* and *Fortune,* and the novelist Erskine Caldwell had earlier combined their talents to expose depression-era problems. Their ground-breaking book *You Have Seen Their Faces* appeared at the optimum time—in 1937—to capture public interest. Lange and Taylor were aware of their success but had reservations about their methods. As noted earlier, Lange rejected Bourke-White's technique of arranging people and objects to create an effective image. (The extent of her own manipulation was to remove

someone's thumb from the print of *Migrant Mother*.)[2] Taylor criticized Caldwell's practice of putting his own words in the mouths of his subjects. "I don't say he didn't do it skillfully, but there was a difference between us," Taylor said later.[3] As if to emphasize this difference, he and Lange used authentic quotations from migrants, run together like an inscription on a public monument, for the endpapers of their book.

179

Taylor and Lange had interviewed Caldwell and Bourke-White. After the publication of *The Grapes of Wrath*, they called on Steinbeck at his home in Los Gatos to ask him to write a preface for *An American Exodus*. Steinbeck, besieged with requests and feeling pressured at this particular time, declined.[4] He preferred to volunteer endorsements, as he did for *Factories in the Field*. He wrote a fan letter to Woody Guthrie and later complied with a request from him for an introduction to a book of songs.[5] Guthrie wrote a song called "Tom Joad" after seeing the movie version of *The Grapes of Wrath*.[6]

Steinbeck's refusal of Taylor and Lange's request was not ill intentioned. He simply didn't know them very well. Only a few of Lange's contemporaries had singled out her work. (One who did was Steinbeck's friend Pare Lorentz, who borrowed her talents and some of her material: when he was beginning work on the film *The Plow That Broke the Plains*, he took captions from the 1935 Taylor-Lange camp report and had them spoken aloud over sequences filmed outside a migrant tent camp.)[7] Lange was most frequently identified simply as a member of Roy Stryker's team.

The reception of *An American Exodus* was disappointing even though the book attracted a mention from Eleanor Roosevelt, who met Lange and Taylor after her visit to the migrant camp in April 1940.[8] It also received some favorable reviews—and one that was lukewarm: Carey McWilliams wrote that Paul Taylor's text was "quiet, scholarly, dispassionate, unassailably accurate" and "not really essential."[9] McWilliams's reservations were understandable, but his analysis was off the mark. Taylor's historical material was an integral part of the book and brought to life dramatic changes in agriculture from the time of the Civil War to the Great Depression: the collapse of the plantation system in the South; an 1893 land race in Oklahoma; hoe culture and mule-drawn plows giving way to tractors. Taylor recognized the significance of scenes that were rapidly disappearing from the American rural landscape—or beginning to dominate it. He knew the things to look for. Dorothea Lange with her cam-

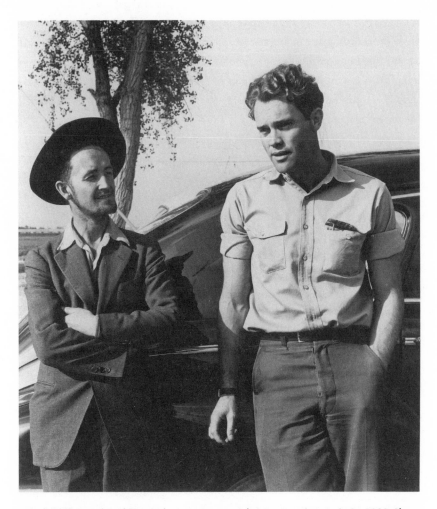

Woody Guthrie and Fred Ross at the Farm Security Administration camp in Arvin, 1939. Photo by Seema Weatherwax, copyright © Seema Weatherwax. The Seema Weatherwax Archive, Special Collections, Stanford University Libraries. Reproduced with the permission of Seema Weatherwax and the Stanford University Libraries.

era revealed the quintessential nature of these things. The problem with the book was this disparity of tone. The formal words of the social scientist were overwhelmed by the dramatic images of the artist.

It might be expected that a combination of photographs with imaginative, as distinguished from scholarly, writing would produce a closer stylistic integration. That did not always happen, however. Both Sherwood Anderson and

Archibald MacLeish wrote impressionistic narratives that were paired with the work of Stryker's photographers, but in both instances the result was unsatisfactory, seeming to be a contrivance of editors, rather than a true marriage of text and pictures.[10] *You Have Seen Their Faces,* a far more effective book, reflected the personal and professional ties that bound Caldwell and Bourke-White at the time it appeared. Finally, there was *Let Us Now Praise Famous Men,* the most memorable example of the genre produced in this period, in which Walker Evans's sober photographs provide the counterpoint to James Agee's vaulting prose. In the ratio of pictures to text, as well as in the tone, the impression on the reader is almost the opposite of that given by *An American Exodus.*

181

The subjective impulse that Paul Taylor reined in when he was writing the text for his book with Lange burst forth two years later in the most personal and passionately expressed article he ever wrote. "Nonstatistical Notes from the Field" appeared in January 1942 in a relatively obscure scholarly journal.[11] Taylor began by challenging the standards followed by many mainstream economists. Answering the statisticians who "demand numbers" and "love averages," he declared: "My method in the field is to observe, then to select. . . . Maybe I'm not interested for the moment in averages. Maybe I'm looking for trends, and don't want to cancel out the very item where I see the 'future' foreshadowed by 'history,' by averaging it with another where the 'future' has not yet struck."

The essay that followed this credo is a poetic evocation of the area of the country where Taylor had first observed the impact of the drought. As he and Lange investigated the changes that had come to the region with the return of normal rainfall, his writing measured the distance he had traveled from technical analysis to subjective interpretation. Returning to a place he had visited on the observation trip for the Federal Emergency Relief Administration, he pulled out his mimeographed report, a photograph showing a "grove and buildings covered by drifting soil," and a map with areas shaded to mark grasshopper devastation and wind erosion. The essay describes the scene: "Now, six years later, we are standing on this same spot. Gleaming stubble of wheat rings closely what was the home acre. Underneath a cover of tickleweed is the soft and swelling line of soil drifts that choked to death the trees of the windbreak.

Weeds and mounds mark the foundations of buildings. A lone tree in leaf shows perhaps where the well was put down—a spring of life on the grave of defeat of a farm family."

In what had been the northern edge of the dust bowl, Taylor and Lange found bumper crops but relatively few residents: "Everywhere wheat and the signs of the emptiness of people." Some abandoned farmhouses had been moved into town. In one community wheat was growing right up to the door of an empty church. "'Where are the members?' we asked. 'They all dried out.'" A farmer who had hung on during the lean years was storing his wheat in other vacant buildings in town. Taylor asked the survivors he met, "Will farmers and townsmen come back now that there's wheat and rain?" and was told, "No, they're not well enough fixed to come back. There's nothing for them."

In central South Dakota, on the former Rosebud Indian reservation, which had been opened to homesteaders beginning in 1909, Taylor visited a county that had lost one-third of its farmers from 1930 to 1940. In the county seat he was told, "We've lost a lot of good men. They got discouraged and sold out. The state rural credit got the farms, sold the improvements off the place, leased the land to the big operators. The Triple A wheat benefit goes with the land; they ought to limit the farmer's benefit to his own ten-year average." But there was another side of the story, and Taylor also heard that "if it weren't for the triple A benefits there just wouldn't be a town here at all." This led him to comment: "When you're in the field, don't expect people to agree on the triple A or on anything else. When they don't, maybe one of them is wrong. More often, each is giving you another side of the truth, which has many. Accounts seldom divide simply into the true and the false."

Statistics, Taylor believed, could not fully describe such a complicated reality. He explained why he preferred a less formal approach: "The results I get from observation stimulate my own thoughts more than many columns of figures; they have opened issues of significance; they fortify me in one of the ways of work I like most." When he interviewed a gas-station attendant, always a favorite source of information, he got an inkling of what was going to happen in that part of the country. "Nine combines came by here today," he was told; "120 went through here last season. They travel on rubber from Texas, Oklahoma, and Kansas, and work to North Dakota and Montana." Taylor insisted: "I have nothing against statistics." But his judgment was that

"by the time you statisticians know the numbers, what I'm trying to tell you about in advance will be history, and you'll be too late."

A sense of urgency, a hallmark of 1930s reporting, was particularly strong in Taylor. He was ever mindful of the connection between his articles and speeches and the purposes for which they were designed: the creation of the government camps, the investigations by congressional committees, the education of the public. At the same time, he took note of contradictions and discrepancies. He was too scrupulous an investigator to be a simple propagandist. He returned to the dust bowl to satisfy his own curiosity, to find out what happened when the weather returned to normal. By then, not many other people were interested.[12]

Unlike Paul Taylor, John Steinbeck had separated himself emotionally from the scenes that inspired his work. Yet *The Grapes of Wrath* continued to exert a powerful symbolism that influenced situations in California after the author and some of the other people connected with them had moved on to other concerns.

In writing the novel, Steinbeck had signified his conversion to the cause of farm workers by creating a labor leader who was both a man of the people and a secular saint. The lay preacher Casy has the dedication, the eloquence, and the evangelical faith of the 1933 cotton strike leader W. D. Hamett, but he is defined and set apart by his spiritual quest. As he travels westward with the Joads, he is engaged in a journey of self-discovery. In separating from the past, renouncing his earlier self-indulgent life of religious ecstasy and fornication, he emerges as a Christ-like figure without pretense or personal ambition, dedicated to serving his fellow men through labor organizing. His martyrdom inspires Tom Joad, the hero of the novel, to follow the same path of selflessness.

Casy's story is in contrast to that of the real-life labor leader Hamett, who combined an innate independence and shrewd self-interest, and who juggled commitment to the cause with responsibility to his family. Although he continued to try to improve his wages and working conditions by allying himself with a later radical ad hoc labor group, he eventually dissociated himself—perhaps because of expediency—from the organizers of the CAWIU.[13]

Although *In Dubious Battle*—in which Hamett was the likely model for the rank-and-file leader London—Steinbeck portrayed the ambiguities of farm la-

bor strife more truthfully, in *The Grapes of Wrath*, with its combination of rage and compassion, he projected a far more powerful message. Yet the strength of the book—its universality—is also its weakness. Steinbeck was bold, if overly ambitious, in combining a saga of the physical and spiritual journey of a family with a documentary study of a segment of society in a particular period of history.

Steinbeck broke the mold by avoiding ideological stereotypes. He confounded Marxist doctrine by using Christian symbolism, then defied organized religion by challenging conventional precepts of sin and redemption. In exposing the inequities of the capitalist system, he was concerned not so much with material influences on society as with the spiritual dimension in the lives of individuals. The historian Robert McElvaine summed it up: "The quality of owning freezes you forever into 'I,' and cuts you off forever from the 'we.'"[14] *The Grapes of Wrath* is an angry book, but it is also hopeful. Steinbeck delivers an unequivocal judgment on vested power and wealth along with a statement of faith: in the face of the fury of nature, the rejection of men, the absence of creature comforts, the threatened loss of life itself, altruistic human impulses are born. Although many of the migrants rejected his portrayal, he immortalized them by making them the bearers of this message.

Not surprisingly, *The Grapes of Wrath* was used in another farm labor organizing effort. UCAPAWA, the successor to the CAWIU, was considered to be less successful. Chartered by the CIO in 1937 and headed by Donald Henderson, a former student of Rexford Tugwell's, the new union faced formidable obstacles in its California operation. In the canneries, well-entrenched AFL rivals waged jurisdictional battles; in the fields, destitute migrants flooded the labor market. As a result, organization was erratic. There was a pattern of new locals being formed and then dissolved.[15] Some of the newly arriving workers opposed the union. James Gregory quotes migrants, some of whom were influenced by their farm backgrounds, who sided with the employers.[16] Yet the participants in the UCAPAWA cotton pickers' strike of 1939 had the militancy Hamett had demonstrated six years earlier, when the picking wage offered was twenty cents lower.

The FSA camps became centers for strike activity stimulated by visiting UCAPAWA organizers and entertainers. Two who made a circuit of the camps were Will Geer, who had played the role of Jeeter Lester in *Tobacco Road,* and Woody Guthrie, who was well known to the camp residents through his Los

Angeles radio program, *The Oklahoma and Woody Show.* Woody put his po-
litical views into his own parodies of well-known ballads. In early October
1939, he came to the Arvin camp with a caravan of celebrities from Hollywood
and brought down the house with his own version of "Greenback Dollar,"
which began: "I ain't gonna pick your 80 cent cotton, / Ain't gonna starve
myself that way."[17]

185

The camp director, Fred Ross, was an active promoter of the festivities and
the strike. He encouraged Woody to write a piece for the Arvin newspaper, the
Tow Sack Tatler.[18] The partisanship of FSA personnel was criticized, however,
by the new director of Region IX, Laurence Hewes, who thought that *The
Grapes of Wrath* and *Factories in the Field* were having a bad influence on his
staff. Hewes took the position that "the government wasn't involved and
wouldn't take sides" in the strike.[19] He was critical of UCAPAWA's Communist
leadership, as well as of some of its tactics. With the concurrence of Helen
Gahagan Douglas, who succeeded Carey McWilliams as head of the Steinbeck
Committee to Aid Agricultural Organization, Hewes vetoed a union proposal
that would have denied federal services to migrants who refused to join the
strike.[20]

Anxious to allay hostility in communities near the camps, Hewes made
some personnel changes. He brought in a number of older men trained in
agriculture and "transferred some of the more obstreperous juniors to positions
remote from the powder keg of the San Joaquin [Valley]."[21] (Whether it was
coincidental or not, Fred Ross spent the later part of his career with the FSA
in one of the district offices.) Hewes advised "law enforcement agencies that
they were free to come and go on official duties in all camps," and he issued
a directive that "residents must accept bona fide offers of employment or leave
our camps"—revoking two of the cardinal principles that, implemented by
Tom Collins, had impressed Steinbeck. Hewes commented that after he tight-
ened the rules, "in one or two camps professional agitators with bad records
moved out."[22] One former camper claimed that labor activists were *kept* out.[23]
In assessing the differences from the earlier period, it should be noted that the
Garst administration's rules regarding labor organizing were created for a hy-
pothetical situation during a period of relatively little union activity. Hewes
made his changes during an upsurge of radical union activity that the Garst
team had not experienced.[24]

By this time, Tom Collins's career in the agency was on the wane. After his

assignment as adviser on the film version of *The Grapes of Wrath,* he lost touch with Steinbeck. Their association had kindled Collins's ambition to be a writer, an ambition that Steinbeck had encouraged but that, ironically, destroyed Collins's usefulness in his original job as camp director. The critic Carol Schloss sees the matter differently. She claims that Steinbeck caused Collins's downfall by persuading him to go undercover in order to help gather information for Steinbeck's book. Collins's deception in pretending to be a migrant cost him the trust of the people in the camps.[25] In a memoir he wrote about his travels with Steinbeck, Collins tells of being labeled "a Judas" by members of a camp council.[26]

Whether Collins was a victim of Steinbeck's exploitation or of his own misplaced ambitions, his experience with the novelist adversely affected his role in government service. A colleague at Brawley remembered the sad, ludicrous sight of Collins making a "Hollywood entrance" when he gave a talk about his movie "career."[27] Other associates recalled him in his later years with the agency as a teller of farfetched tales, some of them borrowed, few of them believable.[28] He was kept on the payroll with lesser assignments until he left Region IX in 1941.[29] Steinbeck had dedicated *The Grapes of Wrath* "To CAROL, who willed this book. To TOM, who lived it." The Steinbecks' marriage also unraveled after the publication of the novel. They were divorced in 1942.

The furor in California—and Oklahoma—distracted attention from the effect of *The Grapes of Wrath* on the rest of the country. "Only those who were on the scene at the time," wrote the critic and novelist Harvey Swados, "can understand the impact that this book made upon a public hungering for good news about the oppressed and exploited. For hundreds of thousands of Americans, *The Grapes of Wrath* . . . seemed to sum up the tragic but enriching experience of the whole decade."[30]

The novel exerted a continuing fascination that set artists and writers traveling down Route 66. After reading it soon after it came out in 1939, Lange's colleague Russell Lee went to Oklahoma "to pick up . . . the shots that are so graphically told." In the words of the critic David Peeler, "Throughout his search, Lee was sustained by the belief that he should photograph Oklahoma, not as it was, but as Steinbeck thought it should be."[31] It took Lee over a month to find a family that resembled Steinbeck's characters. He took a pic-

ture of Elmer Thomas, a fifty-one-year-old former cotton farmer from Muskogee, and Thomas's wife, Edna, in front of a Model-T truck loaded with their household possessions, all ready to start with their four children on their second trip to California. Their first trip had originated in Webbers Falls, sixteen miles from the Joads' town of Sallisaw. They had returned home when their shack in McFarland, in the San Joaquin Valley, burned to the ground. They had recouped their losses and were starting out again.

To commemorate the fiftieth anniversary of the publication of *The Grapes of Wrath*, John Fischer, a writer on the *San Jose Mercury News*, located the Thomas family and published the story of their subsequent experiences.[32] On their first trip to California, in the mid-1930s, they had followed the harvests up and down the West Coast. The children remembered people calling them "Okie trash." When they returned in 1939, jobs outside agriculture were opening up. Elmer Thomas was hired by the Southern Pacific Railroad to repair track. Edna cooked for the crew. Elmer also worked for the WPA and on another government project, the building of the Hoover Dam. One son joined the CCC. Another wandered the country as a cook and jack-of-all-trades. A third drove a moving van, then became a cab driver, and later started a scrap-metal business. The only daughter, the youngest child, worked in a Woolworth store days and as a carhop at night. The family that had held together during hard times in the depression split up later—Edna and Elmer were divorced in the post–World War II years—although they both continued to live in Bakersfield. The reporter discovered that the town of McFarland, "where the Thomases first found a start," was "dying. What the threat of poverty was to the Okies, the threat of pesticides" had "become to the Mexican farm migrants who replaced them." The downtown was mostly boarded up, "the residents having left after 13 children of farm workers contracted cancer," which proved fatal for nine of them.

Studs Terkel, in his introduction to the fiftieth-anniversary edition of *The Grapes of Wrath*, noted the persistence of problems afflicting Americans at the low end of the economic spectrum—and the indifference of people at the top. Writing at the end of the 1980s, an era "distinguished by a mean-spiritedness that has trickled down from high places," he said that "victims are defined as 'losers.'. . . Since there is obviously no room for 'losers' at the top, there is no bottom for them either. The Joads would undoubtedly fall into that dark recess; as millions of our dispossessed fall today."[33]

Others believe that the Joads have moved into the sunshine. James Gregory noted that journalists returning to the scene to find out what happened to the Okies "usually reported that America's losers had become winners."[34] This was the impression conveyed by a reporter-photographer team from the *Stockton Record*, Richard Hanner and Calixtro Romias, who in 1986 recapitulated the fictional journey from Sallisaw to Stockton.[35] At first they encountered problems in trying to match the novel to history. In Oklahoma, the governor repeated the old complaints that Steinbeck got the geography wrong and caricatured the people by making them talk and act like hillbillies. Then they discovered that Route 66, "the mother road, the road of flight," which ran 2,500 miles between Chicago and Santa Monica, had all but disappeared, "supplanted by a huge sterilized speedway called Interstate 40." They followed the old road whenever they could find it and talked to old-timers along the way who remembered it during the 1930s.

Crossing the Tehachapis south of Bakersfield, they turned north on Highway 99 to find the Arvin camp. It was filled with Spanish-speaking families who rented apartments (equipped with bathrooms, kitchens, and telephones) from the state for $3.50 to $4 a day in the harvest season. In nearby communities they found former south-central-states migrants who remembered the FSA camp as a sharing place, a happy place, as Steinbeck pictured it. "Those people had been through so much, when they had a chance to help, they did." "Everybody knew each other and watched out for each other."

This spirit characterized life in Stockton's "Okieville," a three-square-mile unincorporated area separated from the city by Highway 99. For its 7,000 residents, Okieville was a cultural sanctuary where "decent people helped each other survive in an alien world." One person said, "If we had a crust of bread, half of it belonged to somebody else, if he needed it." It was an area of churches. Traditions such as "coon dog trials" and "coon sacking" were transplanted from home. According to one resident, "It wasn't Saturday night unless you got drunk and got into a fight."

In the 1960s and 1970s, the prosperous former migrants moved out, replaced by a group described as "white trash," who were on welfare, some of them involved in drugs. There was racial tension with blacks and Hispanics at the high school. The Ku Klux Klan held rallies in Okieville, which at one time was considered a dangerous place for blacks. By the late 1980s, this kind

of trouble was subsiding, however. The area was becoming part of the larger community.

The migrants and their descendants are now scattered throughout the state, although in Kern County and the city of Bakersfield their cultural imprint, especially in a taste for country music, is particularly strong. The traditions that have been described by the writers and literary scholars James Houston and Gerald Haslam (a native of Oildale) and analyzed by the historian James Gregory were surveyed in an oral history project at California State University–Bakersfield. Many of those interviewed did not like *The Grapes of Wrath.* It is ironic, but it should not be surprising, that the novel, a cherished symbol for liberals, is not entirely popular with the descendants of the people it portrays—descendants who tend to be traditional and conservative even though they register as Democrats.[36]

189

A *Washington Post* reporter, Dan Morgan, has written a history of a migrant family that shatters all the clichés. Under the spell of *The Grapes of Wrath,* he too went to Sallisaw and discovered a clan that had migrated to California in 1934. His 1992 book *Rising in the West* is an oral history of three generations "from the Great Depression through the Reagan years," a journey from farm labor to careers in business, sports management, real estate, and politics. One of the sons, who was born in a tank house on a cotton ranch in the San Joaquin Valley, acquires a vineyard and arranges to hire nonunion labor. A member of the next generation learns idealism in the Peace Corps and works for the Dukakis campaign. The younger members of the clan marry people who are not Anglo Protestants. Some of them become active players on the upper-middle-class field of graduate schools, expensive cars, and European vacations. They are plagued by the problems of the 1980s, including divorce, but family and religion continue to be important influences in their lives.[37]

The Grapes of Wrath and Dorothea Lange's photograph *Migrant Mother* are frequently paired as symbols of an era. Lange did not learn the name of the thirty-two-year-old woman when she photographed her at the pea pickers' camp near Nipomo. Many years later Flora Thompson and two of her daughters showed up at the Oakland Museum, the chief repository of Lange's work outside the Library of Congress. When Thompson was dying of cancer in 1983 at the home of a son in Scotts Valley, Santa Cruz County, her family solicited

funds for her care by inviting news photographers and reporters to tell her story.[38] The family has continued to demonstrate an ambivalent attitude toward the photograph and its impact on their lives. They feel that Lange, in her haste to take her pictures, neglected to inquire about their true circumstances, with the result that Flora Thompson mistakenly became a symbol of destitution. Yet they are also proud of the connection. When she was buried over a decade ago, the words "migrant Mother" were engraved on her tombstone.[39]

By that time *Migrant Mother* was so widely reproduced that it was being copied in drawings, adapted and altered to suit the purposes of different groups. It has become "part of folklore so you can tinker with it," Paul Taylor told an audience at a symposium on photography at Wellesley College in 1977.

One element in Lange's story, as in the life of most artists, was the creative leap into the dark in relation to her work, although the encouragement and help of Taylor and her connection with Stryker's group gave her security during the years when she was relatively unknown.[40] Fortunately, she lived long enough to see her achievement recognized. *An American Exodus,* which had been remaindered a few months after its original publication, was reissued in a revised edition by the Yale University Press in 1960. When she was terminally ill with cancer five years later, she prepared a retrospective exhibit of her work for the Museum of Modern Art with the help of Willard Van Dyke, who had mounted the first exhibit of her street pictures at his Oakland gallery in 1934. She died in October 1965. During the eighteen years Paul Taylor survived her, he kept her memory green. Theirs had been "a great love affair," in the words of Clark Kerr, and Taylor never ceased to mourn her.[41] He had the satisfaction of seeing her recognized by the public and honored by her peers.[42]

Lange and Steinbeck healed the breach that followed his refusal to write an introduction for *An American Exodus.* When she realized she had only a short time to live, she sent him a photograph from her 1930s files. He wrote immediately. "Nothing was ever taken that so illustrated that time," he said, then saluted her gallantry: "There have been great ones in my time and I have been privileged to know some of them and surely you are among the giants." He told her, "We have lived in the greatest of all periods. If the question were asked, if you could choose out of all time, when would you elect to have lived. I would surely say—the Present. Of course we don't know how it comes out.

No one ever does. The story ends only in fiction and I have made sure it never ends in my fiction."[43]

In 1940, Pare Lorentz declared that Dorothea Lange's photographs and John Steinbeck's fiction had done more for the migrants than all the politicians in the country. He saw this as "proof that good art is good propaganda."[44] He may have been right on that point, but he got the larger situation turned around. It was the work of the artists—and the social scientists and reporters—that alerted the politicians in the first place to the problems of the migrants and of California farm workers in general. Although the response of elected officials in Washington and Sacramento more often than not came too late to be effective, one of the reforms that seemed utopian in the 1930s was implemented a generation later: the California Agricultural Relations Act, a modification of the proposals of Governor Culbert Olson and Senator Robert La Follette, was signed into law by Governor Jerry Brown in 1975 at the instigation of César Chavez of the United Farm Workers Union. As a panacea, it has failed, however. Under Brown's Republican successors, who appointed agribusiness advocates to the ARLA board, the measure that was labeled "the Magna Charta of California farm workers" has become an impediment, rather than an aid, in implementing elections won by the union.

Carey McWilliams has commented on the cyclical nature of the public's concern for the California farm labor situation: "It's been lost sight of and rediscovered time and time again in the history of the state."[45] In the 1960s and 1970s, Chavez and his union won the kind of widespread liberal endorsement that had been evident on a smaller scale in the 1930s. The tide turned with the political changes of the 1980s, although the UFW began a resurgence under Arturo Rodriguez, Chavez's son-in-law and successor, in 1996–1997.

At the height of their involvement in the 1930s farm labor controversies, Steinbeck and McWilliams were men possessed by anger. As time passed, they began to have sober second thoughts. In a later recollection of the events of the period, McWilliams toned down his characterization of California growers. Steinbeck acknowledged that he might have been too partisan.[46]

After the depression decade ended, Lange and Steinbeck moved on to other projects. It was the social historians Paul Taylor and Carey McWilliams who made their work in the 1930s the basis for their ongoing concern for farm la-

bor issues. After McWilliams became editor of the *Nation,* he published articles by other writers on farm labor organizing through the 1970s. Like Taylor, he never missed an opportunity to speak out on the subject. During his last illness, he tried to reach Taylor by telephone from his hospital bed in New York.

192

These veterans of the 1930s battles, Taylor and McWilliams, were as familiar with and as concerned about the subject as any two people in the country. Their documentary writing interpreting the events of the depression decade was significant as an outgrowth of our national democratic tradition of investigation, protest, exposé, and analysis. The chief impact of their writing was its (and their) connection with the events at the time it appeared. Nor surprisingly, the impact has lessened after sixty years.

It is the artists who have kept alive the nation's collective memory of the turmoil that engulfed Califorinia as well as the rest of the country at the time. Based on the West Coast, they created work that had more than regional significance. Lange's photographs have come to signify that era.[47] Not long ago one of Steinbeck's contemporaries, the playwright Arthur Miller, spoke of *The Grapes of Wrath* in claiming that "works of art change the consciousness of people and their estimate of who they are and what they stand for."[48]

In the final analysis, it was the artists who gave history a human face.

NOTES

1. Shadows in the Land of Sunshine

1. Malcolm Cowley, *The Dream of the Golden Mountains: Remembering the 1930s* (New York: Viking, 1980), ix–x.

2. Carey McWilliams, "A Man, a Place, and a Time," *American West,* May 1970.

3. The government film maker Pare Lorentz, who knew Steinbeck and Dorothea Lange, spoke of some artistic borrowing among the three of them. Pare Lorentz, *FDR's Moviemaker: Memoirs and Scripts* (Reno: University of Nevada Press, 1992), 122.

4. Edwin Markham, *California the Wonderful* (New York: Edwin Markham Press, 1923), 2, 160, 172.

5. Sidney H. Burchell, an Englishman, glorified the California farmer in *Jacob Peek, Orange Grower: A Tale of Southern California* (London: Gay and Hancock, 1915).

6. Henry George, *Progress and Poverty,* 50th anniversary ed. (New York: Robert Schalkenbach Foundation, 1951), 287, 146.

7. Josiah Royce, *California, from the Conquest of 1846 to Second Vigilance Committee in San Francisco: A Study of American Character,* 1948 ed. (New York: Alfred A. Knopf), 281ff.

8. Robert Cherny, "Patterns of Toleration and Discrimination in San Francisco: The Civil War to World War I," *California History* (summer 1994), 134.

9. John Ludeke, book review of *In the Floating Army: F. C. Mills on the Itinerant Life in California, 1914,* by Gregory R. Woirol (Urbana: University of Illinois Press, 1992), in *California History* (fall 1993), 289–90.

10. Monty Noam Penkower, *The Federal Writers Project: A Study in Government Patronage of the Arts* (Urbana: University of Illinois Press, 1977), 243.

11. Stuart Jamieson, *Labor Unionism in American Agriculture,* Bulletin No. 836 (Washington, D.C.: United States Bureau of Labor Statistics, 1945), 17.

12. John Steinbeck to Elizabeth Otis, spring 1938, *Steinbeck: A Life in Letters,* ed. Elaine Steinbeck and Robert Wallsten (New York: Viking Penguin, 1975), 162.

2. The Strikes, the Partisans, and the Press

1. Kevin Starr, *Endangered Dreams: The Great Depression in California* (New York: Oxford University Press, 1996), 28. The early CAWIU strikes are described by Cletus E. Daniel in *Bitter Harvest: A History of California Farmworkers, 1870–1941* (Ithaca: Cornell University Press, 1981), 110–27.

2. *U.S. Statutes at Large,* 73rd Cong., 1st Sess., XLVIII, 16 June 1933.

3. Jamieson, *Labor Unionism in American Agriculture,* 87, reported thirty-two agricultural strikes in California in 1933, twenty-five of them under CAWIU auspices. Twenty-one of these "resulted in partial increases in wages." A more recent study lists thirty-seven

strikes: Devra Weber, *Dark Sweat, White Gold: California Farm Workers, Cotton, and the New Deal* (Berkeley: University of California Press, 1994), 79.

4. The Socialist Party's Southern Tenant Farmers Union, started in Arkansas in 1934, protested the impact of the Triple-A program on sharecroppers. See H. L. Mitchell, *Mean Things Happening in This Land* (Montclair, N.J.: Allanheld, Osmun, 1979).

5. The daily life and the philosophy of the CAWIU organizers is described by Porter M. Chaffee in his unpublished "History of the Cannery and Agricultural Workers Industrial Union," 2 vols. (Oakland: Federal Writers Project, Works Progress Administration, 1938), 119, Bancroft Library, University of California, Berkeley [hereinafter cited as Bancroft Library], 119.

6. *Western Worker,* 9 Apr. 1934.

7. Statement of a labor leader in Bakersfield, 17 Nov. 1933, in notes for "A Documentary History of the Strike of the Cotton Pickers in California, 1933," by Paul S. Taylor and Clark Kerr, Paul Taylor Papers, Bancroft Library.

8. Pat Chambers, interview by author, Portola Valley, Calif., 6 Sept. 1974.

9. Ibid., 6 Sept. 1974, 3 Sept 1977.

10. Maurice Isserman, *Which Side Were You On? The American Communist Party During the Second World War* (Middletown, Conn.: Wesleyan University Press, 1982), 3, 205.

11. T. H. Watkins, *The Great Depression: America in the 1930s* (Boston: Little, Brown and Co., 1993), 82.

12. Lincoln Steffens's *Autobiography,* published by Harcourt, Brace, won a silver medal from the San Francisco Commonwealth Club and a gold medal from the New York *Evening Post* Association.

13. Steffens's *Autobiography* was regarded by contemporaries as "almost a textbook of revolution." Daniel Aaron, *Writers on the Left: Episodes in American Literary Communism* (New York: Harcourt, Brace & World, 1962), 127.

14. In 1925, the year after Steffens and Winter were married, he wrote to a niece, "Nowadays we do not regard love and marriage as necessarily permanent"; Nora Sayre, *Previous Convictions: A Journey Through the 1950s* (New Brunswick: Rutgers University Press, 1995), 21. Justin Kaplan, *Lincoln Steffens: A Biography* (New York: Simon & Schuster, Touchstone Edition, 1988), 276, discusses Steffens's thoughts on the age difference between him and Winter.

15. Kaplan, *Lincoln Steffens,* 294–96. Steffens discussed the divorce in a letter to Ella Winter's mother, 12 June 1929, *The Letters of Lincoln Steffens,* ed. with introductory notes by Ella Winter and Granville Hicks (New York: Harcourt, Brace & Co., 1938), II, 832–35; the same source [hereinafter cited as *Letters*] 836, contains a comment by writer Garet Garrett, who was spending time in Carmel: "Only Freud himself can get the guts of this damned Steffens affair."

16. Ella Winter, *Red Virtue: Human Relationships in the New Russia* (New York: Harcourt, Brace & Co., 1933).

17. Isserman, *Which Side Were You On?* 3; Watkins, *Great Depression,* 113.

18. Kaplan, *Lincoln Steffens,* 322.

19. Anne Loftis, "Celestial Gatherings," *Steinbeck Newsletter* (winter–spring 1995).

20. George West wrote a satire, "The Success Boys at Stanford," for the *American Mercury,* Aug. 1930.

21. Caroline Decker Gladstein, interview by author, San Francisco, 27 Feb. 1976.

22. *Western Worker,* 12 June 1933.

23. On one occasion when she was ordered back and forth between courthouses in San Jose and Palo Alto, Ella Winter pulled rank and told the judge, "I am Mrs. Lincoln Steffens and you are not going to send me out *one more time!"* Ella Winter, interview by Elaine Berman, London, 25 Apr. 1977.

24. Caroline Decker Gladstein, interviews by author, San Francisco, 27 Feb. 1977, Calistoga, 30 Aug. 1985.

25. Steffens to Winter, 19 Nov. 1932, *Letters,* II, 935, described his first meeting with Cagney in Los Angeles.

26. Marie de L. Welch, "Camp Corcoran," in Welch, *This Is Our Own* (New York: Macmillan, 1940), 57.

27. Greg Mitchell, *The Campaign of the Century: Upton Sinclair's Race for Governor of California and the Birth of Media Politics* (New York: Random House, 1992), 143. Ella Winter wrote about the CAWIU strikes in "California's Little Hitlers," *New Republic,* 27 Dec. 1933.

28. Ella Winter, *And Not to Yield: An Autobiography* (New York: Harcourt, Brace & World, 1963), 186ff.

29. Steffens to Winter, 29 Jan. 1933, *Letters,* II, 947.

30. Harry H. Stein, "To Be a Reporter: The Apprenticeship of Lincoln Steffens," paper for the conference of the American Historical Association, Pacific Coast Branch, Corvallis, Oregon, 13–16 Aug. 1992.

31. "Lincoln Steffens Speaking," *Pacific Weekly,* 12 Apr. 1935.

32. Michael Gold, "transition," No. 13 (summer 1928), quoted in Aaron, *Writers on the Left,* 116.

33. Chester Rowell column, *San Francisco Chronicle,* 27 March 1935.

34. Among the reporters hired by Older during his long editorial career were Sinclair Lewis, Kathleen Norris, Rose Wilder Lane, Maxwell Anderson, and two of Anderson's contemporaries at Stanford, Bruce Bliven and Robert L. Duffus, who became editors on the *New Republic* and the *New York Times* respectively.

35. Older wrote: "I was fifty years old when Steffens woke me up to the realities of life, and it was by his guidance that I finally dragged myself out of the 'make-believe' world that I had lived in all my life." Quoted in Evelyn Wells, *Fremont Older* (New York: D. Appleton-Century, 1936), 207.

36. Andrew Rolle, *California: A History* (New York: Thomas Y. Crowell, 1963), 525.

37. Fremont Older column, *San Francisco Call-Bulletin,* 18 June 1932.

38. Ibid., 10 Apr. 1933. In the same period Older quoted a statement by Will Durant: "I would rather have my tail back and hang from the limb of a tree than live in a civilization evolved from such a tyranny"; ibid., 29 March 1933.

39. C. E. S. Wood letter in the *Los Gatos Mail-News,* 8 May 1937.

40. Allan Griffin wrote with humorous affection about Steffens in the *Carmel Pine Cone,* 16 Feb. 1934. Ella Winter noted that the *Monterey Peninsula Herald* and the *Merced Sun-*

Star covered the CAWIU strikes with fairness: Winter, "Where Democracy Is a Red Plot," *New Republic*, 6 June 1934.

41. Paul C. Smith, *Personal File* (New York: Appleton-Century, 1964). The *San Francisco Chronicle* of 24 Sept. 1936 carried a report on the Salinas lettuce packers' strike that reflected Smith's influence.

42. Steffens to Sproul, 29 Sept. 1933, *Letters*, II, 962–63.

43. Jackson J. Benson, *The True Adventures of John Steinbeck, Writer* (New York: Viking Press, 1984), 294–96.

44. Daniel, *Bitter Harvest*, 165; James Gregory, *American Exodus: The Dust Bowl Migration and Okie Culture in California* (New York: Oxford University Press, 1989), 89.

45. *San Francisco Chronicle*, 6, 7 Oct. 1933.

46. Ibid., 11 Oct. 1933; *San Francisco News*, 11 Oct. 1933.

47. *Sacramento Bee*, 12 Oct. 1933.

48. *Modesto Bee*, 12 Oct. 1933. The *Bakersfield Californian* of 12 Oct. 1933 identified the photographer as Fred Smith of the NEA.

49. *San Francisco Examiner*, 12, 13 Oct. 1933.

50. Ibid., 14 Oct. 1933.

51. Copies of the Hagel-Mieth film are in the Labor Archives and Research Center at San Francisco State University and the Archives of Labor History and Urban Affairs, Wayne State University.

52. Richard Steven Street, "Salinas on Strike: News Photographers and the Salinas Lettuce Packers Strike of 1936: The First Photo-Essay on a Farm Labor Dispute," *History of Photography*, 12, no. 2 (Apr.–June 1988).

53. *Los Angeles Times*, 11 Oct. 1933.

54. *San Francisco Chronicle*, 13, 15 Oct. 1933.

55. *San Francisco Call-Bulletin*, 16 Oct. 1933.

56. *San Francisco Chronicle*, 13 Oct. 1933.

57. Paul S. Taylor and Clark Kerr, "Documentary History of the Strike of the Cotton Pickers in California, 1933," in Paul S. Taylor, *On the Ground in the Thirties* (Salt Lake City: Gibbs M. Smith, Peregrine Smith Books, 1983), 59.

58. *Los Angeles Times*, 16 Oct. 1933.

59. *San Francisco Chronicle*, 12 Oct. 1933.

3. Arbitration and Analysis

1. Reichart's statement is quoted in Weber, *Dark Sweat, White Gold*, 103.

2. Steffens to Ella Winter, 19 Oct. 1933, *Letters*, II, 964–65. On 15 July 1933, Steffens wrote to Roosevelt about the CAWIU strikes; ibid., 961–62. In October he, Winter, and Noel Sullivan wrote to the president asking him to discourage the cotton growers from bringing schoolchildren into the fields as scabs; *San Francisco News*, 25 Oct. 1933.

3. *San Francisco Call-Bulletin*, 12 Oct. 1933.

4. Starr, *Endangered Dreams*, 76–77.

5. *San Francisco Call-Bulletin*, 18 Oct. 1933.

6. *San Francisco Chronicle*, 20 Oct. 1933.

7. Ibid., 19 Oct. 1933.

8. "Hearings Held on the Cotton Strike in San Joaquin Valley by the Fact-Finding Committee Appointed by James Rolph, Governor of the State of California" [hereinafter cited as Cotton Strike Hearings], *Violations of Free Speech and Rights on Labor,* U.S. Senate, 76th Cong., Washington, D.C., 1940, Part 54, Exhibit 8763, p. 19924. The hearings were held at the Civic Auditorium in Visalia, 19, 20 Oct. 1933.

9. *San Francisco Chronicle,* 20 Oct. 1933.

10. Taylor and Kerr, "Documentary History," 103, quote Merritt as saying, "I didn't come here to be insulted by being asked questions by a dirty scum of a communist."

11. Paul Taylor, interview by author, Berkeley, 18 Apr. 1983.

12. Clark Kerr, interview by author, Berkeley, 22 Feb. 1982.

13. Cotton Strike Hearings, 19913.

14. Paul Taylor, interview by author, 18 Apr. 1983.

15. *San Francisco Call-Bulletin,* 12 Oct. 1933.

16. Anne Loftis, "The Man Who Preached Strike," *Pacific Historian,* 30, no. 2 (summer 1986). Hamett's work history is described in the interview with "Clay" in "A Modern Patriarch," in Division of Special Surveys, State Relief Administration, *Migratory Labor in California* (1936).

17. Paul S. Taylor, "Again the Covered Wagon," *Survey Graphic,* July 1935.

18. *Western Worker,* 15 June 1932.

19. In her recent study of farm workers in the California cotton industry during the New Deal, Devra Weber gives reminiscences of Mexican participants in the 1933 cotton pickers' strike: Weber, *Dark Sweat, White Gold,* 52ff.

20. Daniel, *Bitter Harvest,* 158–59.

21. *People, etc.* v. *Chambers et al.,* 3 Crim. 1533, Appellate Court, Sacramento, 1935, p. 4053.

22. Sam Darcy, interview by the author, Harvey Cedars, N.J., 26 Aug. 1982.

23. Daniel, *Bitter Harvest,* 185.

24. Pat Chambers, interview by author, 6 Sept. 1974.

25. Caroline Decker Gladstein, interview by author, 27 Feb. 1976.

26. Cotton Strike Hearings, 19925.

27. Hamett once stated his conviction that Roosevelt was encouraging farm workers to fight for their rights. *People, etc.* v. *Chambers et al.,* 4131.

28. Paul Taylor, interview by author, Berkeley, 27 Oct. 1983.

29. Jamieson, *Labor Unionism in American Agriculture,* 104.

30. Taylor and Kerr, "Documentary History," 118.

31. Paul Taylor, interview by author, 18 Apr. 1983.

32. Carleton H. Parker, *The Casual Laborer and Other Essays* (New York: Harcourt, Brace & Howe, 1920).

33. Clark Kerr, preface to Taylor, *On the Ground in the Thirties,* vii–viii.

34. Paul Taylor's article appeared in the *Hispanic-American Historical Review,* Nov. 1922.

35. Paul Taylor, "Making *Cantaros* at San Jose Tateposco," *American Anthropologist,* 35, no. 4 (1933); *Puro-Mexicano* (Austin: Texas Folklore Society, 1935). Paul S. Taylor, *Mexican Labor in the United States,* 3 vols. (Berkeley: University of California Press, 1928–1934); Paul

Taylor, *An American-Mexican Frontier: Nueces Co., Texas* (Chapel Hill: University of North Carolina Press, 1934).

36. Manuel Gamio, *Mexican Immigration to the United States: A Study of Human Migration and Adjustment* (Chicago: University of Chicago Press, 1930); *The Mexican Immigrant: His Life Story,* (Chicago: University of Chicago Press, 1931).

37. *Mexicans in California: Report of Gov. C. C. Young's Mexican Fact-Finding Committee,* Dept. of Industrial Relations, Dept. of Agriculture, Dept. of Social Welfare, San Francisco, Oct. 1930.

38. Paul Taylor, *On the Ground in the Thirties,* ix.

39. Clark Kerr, interview by author, Berkeley, 25 Oct. 1989.

40. Paul Taylor, interviews by author, Berkeley, Apr., May 1978. Taylor described an encounter with a colleague from the College of Agriculture in "On a Campus," an epilogue to *"Nonstatistical* Notes from the field," *Land Policy Review,* 5, no. 1 (1942), rpr. in Paul Taylor, *On the Ground in the Thirties,* 240.

41. Clark Kerr and Paul S. Taylor, "The Self-Help Cooperatives in California," *Essays in Social Economics* (Berkeley: University of California Press, 1935); Clark Kerr and Paul S. Taylor, "Whither Self-Help," *Survey Graphic,* July, 1934. Kerr's 900-page doctoral thesis, "Productive Enterprises for the Unemployed, 1931–38" was completed in 1939, published in expanded form in 1949.

42. Clark Kerr, interview by author, 22 Feb. 1982.

43. Caroline Decker Gladstein, interview by author, 27 Feb. 1976.

44. Paul Taylor, *On the Ground in the Thirties,* xi.

45. Dr. Al Tapson, interview by George Ewart, CAWIU Interviews, Regional Oral History Office, Bancroft Library. George Ewart's 1973 thesis, "The Role of the Communist Party in Organizing the Cannery and Agricultural Workers Industrial Union (1929–1934)" is in Paul S. Taylor Collection, Bancroft Library.

46. Clark Kerr, interview by author, 22 Feb. 1982.

47. Taylor and Kerr, "Documentary History," 35–37.

48. Starr, *Endangered Dreams,* 79.

49. Taylor and Kerr, "Documentary History," 80, 50.

50. Ibid., 70–71.

51. Ibid., 33.

52. Ibid., 82.

53. Paul S. Taylor, "Opportunities for Research in the Far West," *American Sociological Society,* Aug. 1935.

54. Chaffee, "History of the Cannery and Agricultural Workers Industrial Union." Biographical material on Chaffee is from Porter M. Chaffee, interview by author, 27 Apr. 1978, Santa Cruz, and Mrs. Deolan Chaffee, interview by author, June 1990, Ukiah.

55. Chaffee called his travel memoir "The Journal of a Hungry Man."

56. Porter Chaffee, interview by author, Santa Cruz, 9 March 1977.

57. Ibid.

58. Ibid.

59. Ibid.

60. Taylor, *On the Ground in the Thirties*, xi.

61. Clark Kerr, "Paul and Dorothea," in *Dorothea Lange: A Visual Life*, ed. Elizabeth Partridge (Washington, D.C.: Smithsonian Institution Press, 1994), 39–40.

62. *The Documentary History of the Strike of the Cotton Pickers in California, 1933*, appears as an Appendix, Exhibit 8764 of Part 54 of *Violations of Free Speech and Rights of Labor.*

199

4. "A Wildly Stirring Story": Steinbeck's Interpretation

1. Harry Meade Williams, interview by author, Carmel, 1 March 1984.

2. Jeffers issue, *Carmelite*, 12 Dec. 1928.

3. Jeffers remarked facetiously that Una became more "instinctually Tory" in the presence of Steffens. Carmel *Pine Cone*, 16 Feb. 1934.

4. Steffens described the debate in a letter to his sister, Laura Suggett, 29 Feb. 1928, *Letters*, II, 816–17.

5. Steffens told his friend Jo Davidson that there were many sympathizers "who would like [to] but dare not join" the John Reed Club; 3 June 1932, *Letters*, II, 923.

6. Caroline Decker Gladstein, interview by author, Aug. 30, 1985.

7. Arnold Rampersad, *The Life of Langston Hughes*, vol. 1, *I, Too, Sing America* (New York: Oxford University Press, 1986), 276–81.

8. The manuscript of the play, "Blood on the Cotton," alternatively called "Blood in the Fields," is in the Langston Hughes Papers in the Beinecke Library at Yale University.

9. Rosalind Sharpe Wall, interview by author, Guerneville, 30 Nov. 1983.

10. Martin Flavin, Jr., "Conversations with Lincoln Steffens," *Harvard Advocate*, June 1938.

11. Jackson J. Benson, *The True Adventures of John Steinbeck, Writer* (New York: Viking Press, 1984), 294, 296.

12. Information on Steinbeck's early years comes from part I of Benson's biography.

13. Olive Steinbeck's reaction to the Big Sur country is described by Rosalind Sharpe Wall, *When the Coast Was Wild and Lonely* (Pacific Grove, Calif.: Boxwood Press, 1987), 10.

14. John Steinbeck, "The Summer Before," *Monterey Life*, July 1987.

15. John Steinbeck, "America and Americans," *Saturday Evening Post*, 2 July 1966.

16. Steinbeck described the incident with the German neighbor in *East of Eden* (New York: Viking, 1952), 593.

17. Benson, *Steinbeck, Writer*, 27.

18. Susan F. Riggs, "Steinbeck at Stanford," *Stanford Magazine* (fall–winter 1976).

19. Carlton Sheffield, introduction to *Letters to Elizabeth: A Selection of Letters from John Steinbeck to Elizabeth Otis*, ed. Florian J. Shasky and Susan F. Riggs (San Francisco: Book Club of California, 1978).

20. John Steinbeck to Robert Bennett, quoted in Bennett, *The Wrath of John Steinbeck* (Los Angeles: Robertson Press, 1939).

21. John E. Steinback [*sic*], "fingers of Cloud," *Stanford Spectator*, Feb. 1924.

22. John Steinbeck, "Adventures in Arcademy: A Journey into the Ridiculous," *Stanford Spectator*, June 1924.

23. Steinbeck to Robert O. Ballou, 11 Feb. 1933, *A Life in Letters,* 69.

24. Jackson J. Benson, "Hemingway the Hunter and Steinbeck the Farmer," *Michigan Quarterly Review* (summer 1985), 447.

25. Steinbeck to Mavis McIntosh, Jan. 1933, *A Life in Letters,* 68.

26. Steinbeck to Amasa Miller, ibid., 39.

27. Steinbeck to Edith Wagner, 23 Nov. 1933, ibid., 89–90; Steinbeck to George Albee, 1934, ibid., 92.

28. Sunday Book Page, *San Francisco Chronicle,* 2 June 1935.

29. Steinbeck to Elizabeth Otis, June 13, 1935, John Steinbeck Collection (M263), Special Collections, Stanford University Libraries [hereinafter cited as Steinbeck Collection].

30. "Lincoln Steffens Speaking," *Pacific Weekly,* 31 May 1935.

31. Susan Gregory wrote *When We Belonged to Spain: Old California Tales,* ed. John D. Short, Jr. (Nevada City, Calif.: Harold Berliner, 1983).

32. John Steinbeck's foreword to the Modern Library edition of *Tortilla Flat* (New York: Random House, 1937).

33. Peter Lisca discussed Steinbeck's representation of *paisanos* in *The Wide World of John Steinbeck* (New Brunswick, Rutgers Press, 1958), 81–82. More recently, Sylvia J. Cook noted that Steinbeck's "earlier, largely unpolitical fiction [including *Tortilla Flat*] examined the stultifying effects of respectability, mediocrity, and stability on the human tendency to wildness and eccentricity." "Steinbeck, the People, and the Party," *Steinbeck's "The Grapes of Wrath": Essays in Criticism,* ed. Tetsumaro Hayashi, Steinbeck Essay Series, No. 3 (Muncie, Ind.: Ball State University, 1990), 29.

34. Benson, *Steinbeck, Writer,* 294.

35. Ella Winter, interview by Elaine Berman, London, 25 Apr. 1977.

36. Mrs. Carol Brown (formerly Carol Steinbeck), interview by Jackson J. Benson, 31 May 1974. Benson discovered the circumstances of Steinbeck's acquiring information on farm labor strikes described in Benson and Anne Loftis, "John Steinbeck and Farm Labor Unionization: The Background of *In Dubious Battle,*" *American Literature,* May 1980.

37. *People, etc. v. Chambers et al.,* 60, 80.

38. Pat Chambers, interview by author, Portola Valley, 3 Sept. 1977.

39. Ibid., 6 Sept. 1974.

40. John Steinbeck, "The Raid," *North American Review,* Oct. 1934.

41. "The Raid," as interpreted in the 1990 film by Mac and Ava Productions, was discussed by Christina Waters, "Steinbeck on Screen," *Monterey County Herald,* 29 June 1990.

42. Steinbeck to Carlton A. Sheffield, 21 June 1933, *A Life in Letters,* 75.

43. Steinbeck to Mavis McIntosh, 4 Feb. 1935, ibid., 105.

44. Daniel, *Bitter Harvest,* 321 n. 45.

45. Steinbeck, *In Dubious Battle* (New York: Viking Compass ed., 1963), 27–28.

46. Ibid., 103.

47. Ibid., 185.

48. Ibid., 108.

49. Ibid., 267.

50. Ibid., 128.

51. Ibid., 130, 132.

52. Ibid., 229.

53. Ibid., 230.

54. Ibid., 297.

55. Ibid., 313.

56. Steinbeck to George Albee, 15 Jan. 1935, *A Life in Letters,* 98.

57. Steinbeck to Mavis McIntosh, [Apr.] 1935, ibid., 107–108.

58. Steinbeck to Elizabeth Otis, spring 1935, ibid., 109.

59. Steinbeck to McIntosh and Otis, 21 Jan. 1936, quoted in Lisca, *Wide World of Steinbeck,* 114.

60. Steinbeck to Ben Abramson, early spring 1936, quoted ibid., 114.

61. Clark Kerr, interview by author, 22 Feb. 1982.

62. Caroline Decker Gladstein, interview by author, 26 Feb. 1976.

63. Pat Chambers, interview by author, 3 Sept. 1977.

64. Dorothy Healey and Maurice Isserman, *Dorothy Healey Remembers: A Life in the American Communist Party* (New York: Oxford University Press, 1990), 45.

65. Mary McCarthy, "Minority Report," *Nation,* 11 March 1936.

66. Margaret Marshall, "Writers in the Wilderness," *Nation,* 25 Nov. 1939.

67. John Chamberlain, *New York Times,* 28 Jan. 1936.

68. *New York Times Sunday Book Review,* 2 Feb. 1936.

69. "Lincoln Steffens Speaking," *Pacific Weekly,* 24 Feb. 1936.

70. Steinbeck to Mavis McIntosh, [Apr.] 1935, *A Life in Letters,* 107.

71. Ella Winter review of *In Dubious Battle,* by John Steinbeck, *Daily Worker,* 6 March 1936.

72. Steffens to Sam Darcy, 25 Feb. 1936, *Letters,* II, 1015.

5. The Conversion of Carey McWilliams

1. Biographical material on McWilliams comes from chaps. 1 and 2 of his autobiography, *The Education of Carey McWilliams,* 2 editions (New York: Simon & Schuster, 1978, 1979); from Greg Critser, "The Making of a Cultural Rebel: Carey McWilliams, 1924–1930," *Pacific Historical Review,* 1986.

2. McWilliams, *Education,* 41.

3. Ibid., 45.

4. Ibid., 44.

5. Frances Ring of *Westways* magazine described McWilliams in her introduction to his "Writers of the Western Shore" in *A Western Harvest: The Gatherings of an Editor* (Santa Barbara: John Daniel and Co., 1991), 68.

6. Carey McWilliams, "Miss Edna Millay: An Informal Appreciation," *Lyric West,* 4 (Oct. 1924).

7. Carey McWilliams, "Notes on H. L. Mencken," *Wooden Horse,* Feb. 1925. Mencken's reply is quoted in Critser, "Making of a Cultural Rebel," 237.

8. Carey McWilliams, "Ambrose Bierce," *American Mercury,* Feb. 1929; "The Mystery of Ambrose Bierce," ibid., March 1931; "Ambrose Bierce and His First Love," *Bookman,* June 1932; *Ambrose Bierce* (New York: A. and C. Boni, 1929).

9. McWilliams, *Education,* 64–65; Greg Critser, "The Political Rebellion of Carey McWilliams," *UCLA Historical Journal,* 4 (1983), 45.

10. McWilliams, *Education,* 46.

11. Carey McWilliams, "The Folklore of Earthquakes," *American Mercury,* June 1933; "Swell Letters in California," *American Mercury,* Sept. 1930.

12. McWilliams, "Writers of the Western Shore," 75.

13. Ibid., 75–76; Critser, "Making of a Cultural Rebel," 240–42.

14. Charles Erskine Scott Wood, *Heavenly Discourse* (New York: Vanguard Press, The New Masses, 1927). McWilliams described with tongue in cheek a visit to Wood and Field dressed in Roman costumes at their Los Gatos home, "The Cats," *Los Gatos Mail News,* 31 January 1937.

15. Hildegarde Flanner quoted by McWilliams, "Writers of the Western Shore," 83.

16. Neil Gordon, "Realization and Recognition: The Art and Life of John Fante," *Boston Review,* Oct.–Nov. 1993. This essay discusses Fante's later career and posthumous reputation.

17. Frank Spotnitz quoted ibid.

18. Ben Pleasants quoted ibid.

19. McWilliams, "Writers of the Western Shore," 81.

20. Ibid.

21. McWilliams, *Education,* 177.

22. Carey McWilliams, "Young Man in Love," *Overland and Out West,* Aug. 1929.

23. Carey McWilliams, "A Letter from Carmel," *Saturday Review of Literature,* 4 Jan. 1930.

24. McWilliams, *Education,* 63; "Writers of the Western Shore," 73–74.

25. Adamic's essay on Jeffers was published in 1929 in a Chapbook Series of the University of Washington Press, edited by Glenn Hughes: McWilliams's "Robinson Jeffers: An Antitoxin" appeared in *L. A. Saturday Night,* 3 Aug. 1929.

26. McWilliams, *The New Regionalism in American Literature* (Seattle: University of Washington Press, 1930).

27. Louis Adamic, *Grandsons: A Story of American Lives* (New York: Harper & Brothers, 1935; rpr. New York: AMS Press, 1982), 30–31.

28. Ibid., 30.

29. Louis Adamic, *Laughing in the Jungle* (New York: Harper & Brothers, 1932).

30. Arthur Whipple, a printer, published Carey McWilliams's "Louis Adamic and Shadow America," in 1935 in a limited edition; McWilliams, "Writers of the Western Shore," 74.

31. Louis Adamic, *Dynamite: The Story of Class Violence in America* (New York: Viking Press, 1931; rev. eds. 1934, 1960).

32. For a total list of Adamic writings, see Henry A. Christian, *Louis Adamic: A Checklist* (Ohio: Kent State University Press, 1971).

33. Carey McWilliams's books on ethnic groups in America include *Brothers Under the Skin,* 1943; *Prejudice: Japanese-Americans, A Symbol of Racial Intolerance,* 1944; *A Mask for Privilege: Anti-Semitism in America,* 1948; and *North from Mexico: The Spanish-Speaking People of the United States,* 1949.

34. Carey McWilliams, "Getting Rid of the Mexicans," *American Mercury,* March 1933. Watkins, *Great Depression,* 69.

35. McWilliams, "Exit the Filipino," *Nation,* 4 Sept. 1935.

36. McWilliams, "Writers of the Western Shore," 81–83.

37. McWilliams, *Education,* 49.

38. Carey McWilliams, "Upton Sinclair: Two Impressions," *L. A. Saturday Night,* 24 Dec. 1927.

39. Malcolm Cowley, interview by author, Sherman, Conn., 29 Jan. 1985.

40. McWilliams, *Education,* 50.

41. Upton Sinclair, "Poor Me and Pure Boston," *Nation,* 29 June 1927.

42. Edmund Wilson, *The American Jitters: A Year of the Slump* (New York: Charles Scribner's Sons, 1932), 247.

43. McWilliams, *Education,* 69.

44. Upton Sinclair, "The Strange Case of Carey McWilliams," *Pacific Weekly,* 24 Feb. 1936.

45. Carey McWilliams, "Upton Sinclair and his EPIC," *New Republic,* 22 Aug. 1934.

46. Carey McWilliams, "Sinclair Wanes," *New Republic,* 2 Nov. 1934.

47. McWilliams, "Strange Case of Upton Sinclair," *Pacific Weekly,* 3 Feb. 1936.

48. Anna Louise Strong, letter to editor, *Pacific Weekly,* 21 March 1936; Upton Sinclair rebuttal, ibid., 13 Apr. 1936.

49. Sinclair, "Strange Case of Carey McWilliams."

50. McWilliams, *Education,* 84, 85.

51. Carey McWilliams, "Farmers Get Tough," *American Mercury,* June 1934.

52. McWilliams, *Education,* 84–85. Harry Bridges's pragmatism appealed to Sam Darcy who supported the International Longshoremen's Association over the Communist Party's Marine Workers' Industrial Union as the best vehicle for organizing San Francisco's longshoremen. According to Bridges's biographer, Robert Cherny, who examined the papers of the CPUSA in Moscow, the activities of the San Francisco CP during the 1934 maritime and general strikes and the election of CP members and supporters, including Bridges, to local ILA offices following those strikes were crucial elements in the CP's decision to close down the TUUL and send CP members and supporters into AFL (and later CIO) unions. Cherny, Bay Area Labor History Workshop, San Francisco, Nov. 17, 1996.

53. Critser, "Political Rebellion of Carey McWilliams," 45.

6. Raids and Reaction

1. Lowell K. Dyson, "Mudsills of American Society," *Red Harvest: The Communist Party and American Farmers* (Lincoln: University of Nebraska Press, 1982), 89ff.; Clarke A. Chambers, *California Farm Organizations: A History of the Grange, the Farm Bureau, and the Associated Farmers, 1929–1941* (Berkeley: University of California Press, 1952), 39.

2. George West, "California Sees Red," *Current History,* Sept. 1934.

3. Dyson, "Mudsills," 90–91.

4. Paul S. Taylor and Clark Kerr, "Uprisings on the Farms," *Survey Graphic,* Jan. 1935, rpr. in Taylor, *On the Ground in the Thirties,* 159–68.

5. Clarke Chambers, *California Farm Organizations*, 39.

6. Taylor and Kerr, "Uprisings," 167.

7. For the CAWIU's view of Glassford, see Healey and Isserman, *Dorothy Healey Remembers*, 51.

8. Taylor and Kerr, "Uprisings," 167.

9. Ibid., 168.

10. Ibid.

11. Ibid., 168, 159.

12. Ella Winter, "Stevedores on Strike," *New Republic*, 13 June 1934.

13. Katherine Beebe Pinkham Harris, interview by author, Stanford, 17 March 1993.

14. Smith, *Personal File*, 155.

15. Katherine Beebe Pinkham Harris, interview by author, 17 March 1993.

16. *San Francisco Examiner*, 22 June 1934.

17. *San Francisco Chronicle*, 1 July 1934; Evelyn Seeley, "Journalistic Strikebreakers," *New Republic*, 1 Aug. 1934. The identity of the raiders was revealed in Charles Norris's novel *Flint* (New York: Doubleday, Doran & Co., 1944).

18. Katherine Beebe Pinkham Harris, interview by author, 17 March 1993.

19. Earl Burke, "Dailies Helped Break General Strike," *Editor and Publisher*, 28 July 1934.

20. "The Press as Strikebreaker," *New Republic*, 8 Aug. 1934.

21. Ella Winter, *And Not to Yield*, 203–204.

22. Malcolm Cowley, interview by author, 29 Jan. 1985.

23. Winter, "Stevedores on Strike"; Robert Cantwell, "San Francisco: Act One," *New Republic*, 25 July 1934; Cantwell, "War on the West Coast," *New Republic*, 1 Aug. 1934.

24. Irving Bernstein, *Turbulent Years: A History of the American Worker, 1933–1941* (Boston: Houghton Mifflin, 1970), 294.

25. Lorena Hickok to Aubrey W. Williams, 15 Aug. 1934, Hickok, *One Third of a Nation*, ed. Richard Lowitt and Maurine Beasley (Urbana: University of Illinois Press, 1981), 305–306.

26. Fremont Older column, *San Francisco Call-Bulletin*, 6 Nov. 1933.

27. Ibid., 27 Nov. 1933.

28. *San Francisco Examiner*, June 29, 1934.

29. The syllabus for Taylor's course, "'Vigilantes' and the Labor Movement" (Economics 205-A), is dated 6 Nov. 1934.

30. Paul S. Taylor and Norman Leon Gold, "San Francisco and the General Strike," *Survey Graphic*, Sept. 1934.

31. The *Pacific Rural Press* editorial of 4 Aug. 1934 was reprinted in the *Carmel Pine Cone* of 10 Aug. 1934 under the title, "Weather Forecast: A Warm Ella Winter." The *Pine Cone* of 16 Feb. 1934 published tributes to Steffens by his Carmel friends after his illness.

32. Richard Criley, interview by the author, Carmel Highlands, 12 June 1984.

33. Charles P. Larrowe, *Harry Bridges: The Rise and Fall of Radical Labor in the United States*, 2nd rev. ed. (New York: Lawrence Hill & Co., 1972), 199–200.

34. Ella Winter, *And Not to Yield*, 207–10; Steffens to Mrs. A. Winter, 24 Sept. 1934, *Letters*, II, 998.

35. Steffens to E. A. Filene, 5 Sept. 1934, ibid., 993.

36. Steffens to Louis Oneal, 27 July 1934, ibid., 990.

7. The Trial

1. Carey McWilliams, "Fascism in American Law," *American Mercury,* June 1934.

2. Carey McWilliams, "Leo Gallagher," *Nation,* 16 Oct. 1935.

3. Bruce Minton, "The Battle of Sacramento," *New Republic,* 20 Feb. 1935; Heywood Broun, "Curtain Call," *Nation,* 17 Apr. 1935.

4. Travers Clement, "Red-Baiters' Holiday," *Nation,* 13 March 1935.

5. Statement in syllabus for Paul Taylor's course "'Vigilantes' and the Labor Movement," 6 Nov. 1934.

6. Assembly Bill 419 was introduced in the legislature on 21 Jan. 1935 by a Democratic assemblyman, Franklin Glover, with 21 Democrat and 2 Republican cosponsors. Starr, *Endangered Dreams,* 169.

7. Robert Gordon Sproul statement in *California Journal of Development,* July 1934.

8. *San Francisco Chronicle,* 30 March 1935.

9. Chester H. Rowell, "Catalogue of the Reds!" ibid., 14 May 1934.

10. Chester H. Rowell in *San Francisco Chronicle,* 30 March 1935.

11. Ibid., 27 March 1935. The American League Against War and Fascism conducted its Hearst "trial" in San Francisco on 31 July 1935; *Pacific Weekly,* 29 July 1935.

12. *San Francisco News,* 14 March 1935.

13. John D. Barry, "Ways of the World," undated 1935 column in *San Francisco News,* John D. Barry Letters, Bancroft Library.

14. Norman Mini, "The California Dictatorship," *Nation,* 20 Feb. 1935.

15. Caroline Decker letter, *Nation,* 24 Apr. 1935.

16. "Resolution on the Manner of Organizing Strike Struggles in the Agricultural Field, as Drawn from the Experiences of the 1933 Strike Movement," *People, etc.* v. *Chambers et al.,* 722–26.

17. Ella Winter to Caroline Decker, 22 Jan. [1934]. Writing about a strike in Pescadero, Winter asks, "And is it spinach as the 'Examiner' says, or brussels sprouts? If it's spinach you ought to get up a Children's Crusade in favor of the strike"; ibid., 872.

18. Dyson, *Red Harvest,* 90–91. Jack Warnick wrote to Caroline Decker on 22 March 1934: "The d— bulletin is coming along very slowly. We have only multigraphed two pages and we've been staying up to all hours of the night to do that"; *People, etc.* v. *Chambers et al.,* 862; Caroline Decker wrote to Pat Chambers: "It makes me weak to think about the whole mess. I just haven't got the strength to move to Sacramento"; *People, etc.* v. *Chambers et al.,* 875.

19. Sam Darcy to Caroline Decker, 5 Dec. 1933: "The Party comrades write that unless a leading comrade from the San Joaquin strike goes to Imperial Valley, everything will slip from our hands"; *People, etc.* v. *Chambers et. al.,* 1117. Caroline Decker responded on 6 Dec. 1933: "The Comrades in the District refuse to understand . . . the situation of the C. & A. W. I. U. There are no squads of district representatives of the union in San Jose waiting to be sent into the field"; ibid., 1127–28.

20. Clarke Chambers, *California Farm Organizations*, 108; Clement, "Red-Baiters' Holiday."

21. *People, etc. v. Chambers et al.*, 3375.

22. Lillian Dunn, interview by author, Bakersfield, 10 June 1983.

23. The letter Chambers read was from Rabbi Irving Reichart, a Northern California representative of the Federal Emergency Relief Administration, to Governor James Rolfe, warning of impending violence.

24. Hamett's testimony is in sections beginning on pp. 3118, 3994, and 4043 of *People, etc. v. Chambers et al.*

25. Pat Chambers's statement was quoted in the *Western Worker*, 1 Apr. 1935.

26. A motion to withdraw AB419 from the Judiciary Committee for a vote on the floor was defeated 31 to 35. The Criminal Syndicalism Law was removed from the statutes in the 1950s. Daniel, *Bitter Harvest*, 126.

27. The *Associated Farmer*, 19 June 1937, noted that the AF paid $13,750.59 to help secure the conviction of the CAWIU defendants. From May 1934 to Nov. 1939 the AF collected $184,231 and disbursed $175,002; Clarke Chambers, *California Farm Organizations*, 44.

28. Scharrenberg's statement appeared in the *New York Times*, 20 Jan. 1935.

29. Paul S. Taylor, "A Step Left," *Survey*, Nov. 1934.

30. Philip Bancroft, "The Farmer and the Communists," *Daily Commercial News* (San Francisco) 29, 30 Apr. 1935.

31. Benson and Loftis, "Steinbeck and Farm Labor Unionization," 220–21.

32. Pat Chambers talked to a younger generation of organizers at the La Paz headquarters of César Chavez's United Farm Workers in Keene, California, in the 1970s around the time that Ernesto Galarza, leader of an intermediate union, the National Farm Labor Union, AFL, described to UFW volunteers the situation in the 1930s and legacy of Decker and Chambers: "Their struggle brought to the attention of the country the fact that rural California was a place where there was no free speech. There were no civil liberties in rural California and the main victims were the Okies, the Mexicans, and the Blacks. . . . Those were the days when the question was, 'Can I as an organizer go into Fresno and come out alive?' I told Pat, 'If you hadn't been in the Imperial Valley ten years before I was, I wouldn't have been there at all.'" Speech at UFW boycott office, San Jose, 7 May 1974.

8. Literary Repercussions

1. Bernstein, *Turbulent Years*, 170.

2. Welch's poem "The Harvest" also appeared in the *New Republic* (27 Dec. 1933):
 Now among good harvests
 The human harvest fails
 The grain and fruit lie on the ground
 The men are stored in jails.

3. Charles A. Ware, "The Many Memories of W. K. Bassett," *Sunday Star-Bulletin and Advertiser*, Honolulu, 28 Apr. 1968.

4. *Pacific Weekly*, 24 May 1935.

5. McWilliams's articles appeared ibid. on, respectively, 11 Jan. 1936, 2 Sept. 1935, 20 July 1936, 24 Aug. 1936, and 10 Aug. 1935.

6. *Pacific Weekly,* 13 Apr. 1936.

7. Ibid., 6 Apr. 1936.

8. Steffens to Robert Cantwell, 15 June 1936, *Letters,* II, 1021.

9. Steffens to Dr. P. Gerson, 18 June 1936, Gerson Collection, Huntington Library, San Marino, Calif.

10. Ella Winter, "L. S.," *New Masses,* 8 Sept. 1936.

11. Steffens to Fremont Older, 20 Oct. 1934, *Letters,* II, 999.

12. The *San Francisco News* announced the death on 4 March 1935 of "the fighting California editor of the Call-Bulletin."

13. Wells, *Fremont Older,* 369, 384.

14. Steffens to Frederic C. Howe, 11 March 1936, *Letters,* II, 1016.

15. Steffens to Howe, 8 July 1936, ibid., 1023.

16. Steffens wrote his last column for the *Pacific Weekly* of 7 Aug. 1936.

17. Steffens to Pete Steffens, 21 July 1936, *Letters,* II, 1027.

18. The plaque installed by Sigma Delta Chi on 12 June 1967 reads: "Here in 'The Getaway' the greatest of the journalists known as 'muckrakers' passed the last years of a full and vibrant life."

19. *Monterey Peninsula Herald,* 10 Aug. 1936.

20. *San Francisco Chronicle,* 11 Aug. 1936.

21. Ella Winter to Sara Bard field, 30 Oct. 1936, Box 220, Charles Erskine Scott Wood Collection, Huntington Library.

22. Steinbeck to Elizabeth Otis, early Nov. 1939, Steinbeck Collection.

23. Winter to Field, 30 Oct. 1936, Box 220, Wood Collection.

24. Donated by his widow and younger son, Carey McWilliams's correspondence on the 1936 Western Writers Congress is in the Bancroft Library.

25. Henry Chester Tracy to Carey McWilliams, 14 Sept., 1 Oct. 1936, McWilliams correspondence on Western Writers Congress, Bancroft Library.

26. Humphrey Cobb to Barbara Chevalier, 15 Sept. 1936, Western Writers Congress correspondence, Bancroft Library.

27. *San Francisco Chronicle,* 16 Nov. 1936.

28. Janet Lewis, interview by author, Portola Valley, Dec. 1983.

29. *San Francisco Chronicle,* 14, 15 Nov. 1936.

30. Irving R. Cohen, "A Gathering of Literary Lions," *California Living Magazine (San Francisco Sunday Examiner and Chronicle),* 24 May 1981.

31. A few years later Ella Winter and Donald Ogden Stewart were married. They lived in Hollywood until he was "blacklisted" in the 1950s, then moved to England, where they kept open house for Americans similarly exiled as a result of congressional investigations. Sayre, *Previous Convictions,* 304ff.

32. Bernstein, *Turbulent Years,* 811–12 n. 8.

33. Haakon Chevalier, *For Us the Living* (New York: Knopf, 1949).

34. Arnold R. Armstrong [pseudonym], *Parched Earth* (New York: Macmillan, 1934).

35. Richard Allan Davison, *Charles G. Norris* (Boston: Twayne Publishers, 1983).

36. Davison, ibid. 125–26, quotes reviews of *Flint* by John Cort in *Commonweal,* 1 Apr. 1944, and by Jennings Rice in the *New York Herald-Tribune Book Review,* 4 Jan. 1944.

37. Ibid., 123.

38. Ibid., 27.

39. Norris, *Flint,* 99–100.

40. Charles G. Norris to Joseph Henry Jackson, 1939, quoted in Richard Allen Davison, "Charles G. Norris and John Steinbeck: Two More Tributes to the *Grapes of Wrath,*" in *Steinbeck's "Grapes of Wrath,"* ed. Hayashi, 33.

41. Adamic, *Grandsons,* 264.

42. Ibid., 214, 266.

43. Adamic, *My America, 1928–1938,* 330.

44. Ibid., 331.

45. John Steinbeck, *Working Days: The Journals of "The Grapes of Wrath," 1938–1941,* ed. Robert DeMott (New York: Viking, 1989), 164.

46. Adamic's heedless quality got him into trouble. In the 1940s when he was promoting multiculturalism in *Common Ground* and won the support of Eleanor Roosevelt, the First Lady invited Adamic and his wife to the White House, where Winston Churchill was also a guest. Adamic wrote of this meeting in a book that was critical of the prime minister. The fallout from this episode contributed to a downward spiral in his career. According to Carey McWilliams, a contributing factor in Adamic's depression was a charge by the California Un-American Activities Committee that he was "pro-Communist." He committed suicide in 1951. McWilliams, *Education,* 178.

9. Following the Forgotten Americans

1. William Stott, *Documentary Expression and Thirties America* (Chicago: University of Chicago Press, 1986), 252.

2. Adamic, *My America,* xiii.

3. Sherwood Anderson, *Puzzled America* (New York: Charles Scribner's Sons, 1935), 40–41.

4. Vicki Goldberg, *Margaret Bourke-White: A Biography* (Reading, Mass.: Addison-Wesley, 1987), 233–34.

5. John Kazarian, "The Starvation Army," *Nation,* 26 Apr. 1933.

6. Lorena Hickok, "The Unsung Heroes of the Depression," introduction to Hickok, *One-Third of a Nation: Lorena Hickok Reports on the Great Depression,* ed. Richard Lowitt and Maurine Beasley (Urbana: University of Illinois Press, 1981), x.

7. William T. Cross and Dorothy Embry Cross, *Newcomers and Nomads* (Stanford: Stanford University Press, 1937), 10, 13, 25.

8. McWilliams, *Education,* 69.

9. Watkins, *Great Depression,* 35. In a September 1935 Commonwealth Club talk Paul Taylor quoted Walter Davenport's comment: "All this migration of the unemployed" is "a part of [our] reward for all the milk-and-honey ballyhoo [we] had been broadcasting for years."

10. Samuel C. Blythe, "Camps for Homeless Men," *Saturday Evening Post,* 27 May 1933.

11. Cross and Cross, *Newcomers and Nomads,* 30; Blythe, "Camps for Homeless Men," 41–43.

12. Belli's report was incorporated into the Cross study.

13. Melvin Belli, interview by author, San Francisco, 14 Apr. 1990.

14. Cross and Cross, *Newcomers and Nomads,* 37, 34.

15. Ibid., 34.

16. Paul Taylor, interview by author, Berkeley, 8 Jan. 1982.

17. Paul Taylor, "Preliminary Report on Drouth Situation of North Dakota, based upon field reconnaissance of the north west quarter of the State, June 11–15, 1934," reprinted in Taylor, *On the Ground in the Thirties,* 169–73.

18. The prairie land use proposals of two New Jersey scholars are described by Anne Matthews in "The Poppers and the Plains," *New York Times Magazine,* 24 June 1990.

19. Hickok, *One-Third of a Nation,* 65.

20. Taylor, "Again the Covered Wagon," *Survey Graphic,* July, 1935.

21. Paul Taylor, interview by author, Berkeley, 13 Jan. 1982.

22. Cross and Cross, *Newcomers and Nomads,* 19.

23. Dorothea Lange, interview by Suzanne Riess, 1968, in "Dorothea Lange: The Making of a Documentary Photographer" (typescript of an oral history conducted by Riess), 175, Regional Oral History Office, Bancroft Library.

10. Paul Taylor Finds a Photographer

1. "Making of a Documentary Photographer," 144, Regional Oral History Office, Bancroft Library. For a close, personal look at how Dorothea Lange thought, I am grateful for the use of this oral history done by Suzanne Riess, 1960, 1961.

2. Ibid., 26, 16.

3. Biographical information on Lange also comes from Milton Meltzer, *Dorothea Lange: A Photographer's Life* (New York: Farrar, Straus, Giroux, 1978).

4. "Making of a Documentary Photographer," 23.

5. Ibid., 27.

6. Ibid., 28.

7. Ibid., 90.

8. Ibid., 97, 101.

9. Ibid., 97.

10. Ibid., 133–39.

11. Ibid., 147, 120.

12. Ibid., 149. Edward Weston's work with Group f.64 gave him an excuse to turn down the request of radical friends in Carmel that he photograph strikes, something he was reluctant to do for fear that he or his equipment would be harmed: Recollections of Charis Wilson at program "Group f. 64: 1932 Origin/1992 Inspirations," Oakland Museum, 24 Oct. 1992.

13. "Making of a Documentary Photographer," 149.

14. Ibid., 149–50.

15. The painting is in the Oakland Museum. Maynard Dixon was relatively conservative politically. He dissuaded Lange from accepting invitations from Communist groups; "Making of a Documentary Photographer," 151–52.

16. Ibid., 145.

17. Richard Steven Street, "Paul S. Taylor and the Origins of Documentary Photography in California, 1927–1934," *History of Photography,* 7, no. 4 (1983).

18. Nine of Taylor's photographs illustrate the historical essay on California farm workers by Taylor and Anne Loftis for *In the Fields,* a book of photographs by Ken Light, Roger Minick, and Reesa Tansey (Oakland: Harvest Press, 1982).

19. Paul Taylor, interview by author, Berkeley, 30 Jan. 1984.

20. Paul Taylor, "Mexicans North of the Rio Grande," *Survey Graphic,* May 1931. The text of the piece is reprinted in Taylor, *On the Ground in the Thirties,* with photographs by Dorothea Lange, 1–16.

21. Taylor is quoted in Beaumont and Nancy Newhall, *Masters of Photography* (New York: George Braziller, 1958), 140.

22. Paul Taylor's notes to "Making of a Documentary Photographer," 167.

23. Ibid., 165.

24. Willard Van Dyke, "The Photographs of Dorothea Lange: A Critical Analysis," *Camera Craft,* October 1934.

25. "Making of a Documentary Photographer," 166.

26. Street, "Taylor and the Origins of Documentary Photography."

27. Taylor's notes to "Making of a Documentary Photographer."

28. "Making of a Documentary Photographer," 177–79.

29. Ibid., 155.

30. Ibid., 160–61.

31. Report (7 March 1935) by Harvey R. Coverley on investigation of housing conditions for agricultural workers on Coachella Valley from 27 Feb. to 3 March 1935, Folder 2, Irving R. Wood Papers, Bancroft Library.

32. Taylor, "Again the Covered Wagon."

33. Paul S. Taylor, "The Migrants and California's Future: The Trek to California and the Trek in California," Commonwealth Club address, 13 Sept. 1935. It seems possible that the reference to the survey of migrants ending on 15 October was added when the address was printed in U.S. Congress, Senate, Subcommittee on Migratory Labor of the Committee on Labor and Public Welfare, *Farmworkers in Rural America, 1971–1972: Hearings,* 92nd Cong., 1st and 2nd sess., 3926–34.

34. The border blockade, reminiscent of the one proposed in 1931, was recommended by the Los Angeles police chief, James Davis, and supported by the *Los Angeles Times,* the Chamber of Commerce, the county sheriff's department, and the Department of Charities. It was implemented on 3 Feb. 1936 to protests by the *Los Angeles Evening News,* the American Civil Liberties Union, and individuals, including Lincoln Steffens. After the state attorney general ruled the blockade illegal, it was lifted in early April.

35. "Dorothea Lange: Field Notes and Photographs, 1935–1940," comp. Zoe Brown, Oakland Museum, 1979, II, 2, 9, 13, 18.

36. Ibid., 27, 29, 44, 48.

37. Paul S. Taylor, "Application for Funds for Rural Rehabilitation Camps for Migratory Laborers in California" (17 Apr. 1935), Box 2, Irving Wood Papers.

38. California Assembly Bill No. 2459 was defeated in the state senate in June 1935. Senator Culbert Olson, who was elected governor three years later, had tacked on an amendment to exclude also "financial racketeers, stock and bond jobbers, industrial monopolists, watered stock manufacturers . . . despoilers of the savings of the poor . . . defrauders of widows and orphans . . . millionaire wartime profiteers and promoters of war."

39. Taylor, "Again the Covered Wagon."

40. Taylor, Commonwealth Club Address, 13 Sept. 1935.

41. Paul S. Taylor, "Migrant Mother: 1936," *American West*, May 1970.

42. Laurence Hewes, interview by author, Nashville, 20 Apr. 1982.

43. There was some hostile reporting in the press on the Taylor-Lange marriage.

44. Russell Lee interview in William Howorth, "The Okies—Beyond the Dust Bowl," *National Geographic*, Apr. 1984.

45. Arthur Rothstein, interview by author, New Rochelle, N.Y., 24 Apr. 1982.

46. Marion Post Wolcott, interview by author, Santa Barbara, 18 May 1988; *Marion Post Wolcott: FSA Photographs*, introduction by Sally Stein (Carmel, Calif.: Friends of Photography, 1983), 46.

47. Roy M. Stryker and others, interviews, autumn 1952, Photography Collection, Oakland Museum.

48. Arthur Raper, *A Preface to Peasantry* (Chapel Hill: University of North Carolina Press, 1936); "Making of a Documentary Photographer," 174.

49. Rondal Partridge, quoted in Meltzer, *Dorothea Lange*, 167.

50. "Lange: Field Notes and Photographs," comp. Brown, II, 375, 379.

51. Pare Lorentz, "Dorothea Lange: Camera with a Purpose," text originally published in *U.S. Camera* (1941), reprinted in *America*, ed. T. J. Maloney, pictures judged by Edward Steichen (New York: Duell Sloan and Pearce, n.d.), I, 93–98.

52. Paul Taylor quoted in Dorothea Lange and Margaretta K. Mitchell, *To a Cabin* (San Francisco: Grossman, 1973).

53. Taylor's migrant quotations come from "Again the Covered Wagon" and his 13 Sept. 1935 Commonwealth Club address.

54. Stott wrote that "the quotations all show one kind of people, the wronged and strong—indomitable casualties of natural and economic systems beyond their control. The effect of so many quotes saying the same thing is sentimental; surely the migrants were not *all* so tough and competent. Lange's finest photographs are of people, and these, like the quotations, show a tendency toward the sentimental. Every one of her portraits has character; nearly all are handsome. Yet—such is her greatness—few are simple. Again and again, her people have an emotional complexity, an ambiguity, that breaks their stereotype and makes us look again." *Documentary Expression and Thirties America*, 228–29.

55. Lorentz, "Lange: Camera with a Purpose."

56. Lange quoted by Daniel Dixon, "D. L.," *Modern Photography*, Dec. 1952, 66–77, 138–41.

57. Stott, *Documentary Expression and Thirties America*, 61.

58. Margaret Bourke-White, "Dust Changes America," *Nation*, 22 May 1935.

59. Marion Post (Wolcott) photographed a man crouching on the ground digging with a stick. He is backed by an assertive-looking wife and daughters. "Migrant Family from Missouri, Belle Glade, Florida, 1939, 'We ain't never lived like hogs before, but we sure does now'": Cover photo, *Marion Post Wolcott: FSA Photographer*.

60. David Elliott, "Farming Life's Pained Beauty," *Chicago Daily News*, 27 Jan. 1977.

61. Arthur Rothstein, interview by author, 24 Aug. 1982.

62. Taylor, "Migrant Mother: 1936."

63. The son of the "migrant mother" said that the rest of the family was getting the radiator of their car fixed preparatory to moving on. Geoffrey Dunn, "Photographic License," *Metro* (San Jose), 19–25 Jan. 1995.

64. *San Francisco News*, 15 Feb. 1936.

65. Ibid., 11 March 1936.

11. The Road to *The Grapes of Wrath*

1. Greg Critser has described Herbert Klein's background and the itinerary of the spring 1935 trip in "Political Rebellion of Carey McWilliams," 35–37.

2. *Pacific Weekly*, 30 March, 6, 13 Apr. 1936.

3. Herbert Klein and Carey McWilliams, "Cold Terror in California," *Nation*, 24 July 1935.

4. Critser, "Political Rebellion of Carey McWilliams," 47.

5. *Pacific Weekly*, 13 Apr. 1936.

6. Weber, *Dark Sweat, White Gold*, 115, 116, 190, 217, 218.

7. *Pacific Weekly*, 6 Apr. 1936.

8. Charles Wollenberg, introduction to the 1988 reprint of John Steinbeck's "The Harvest Gypsies" in *On the Road to "The Grapes of Wrath"* (Berkeley: Heyday Books), xiii.

9. Folder RR-CF-25.8, Box 22, Record Group 96, National Archives, San Francisco (located in San Bruno).

10. J. H. Faclin to H. E. Drobish from J. H. Faclin, 30 Apr. 1935, D. Nickel to Drobish, 21 March 1935, both Folder RF-CF-25-200, Box 19, Record Group 96, National Archives, San Francisco.

11. *Brentwood News*, 18 Oct. 1935.

12. Eric H. Thomsen to Jonathan Garst, "Preliminary Report on Arvin Migratory Labor Camp," 3 Aug. 1936, Folder RF-CF-16-918, p. 9, Box 22, Record Group 96, National Archives, San Francisco.

13. *San Francisco News*, 20 Feb. 1936. Many years later Paul Taylor said, "I don't think the camps did much to increase the conflict." He made the argument that they would calm labor strife. "Employers didn't always believe me. . . . I remember one grower wanted me to agree that there should be no more than fifteen families in each camp." Interview by author, 8 Jan. 1982.

14. *San Francisco News*, 5 Oct. 1936.

15. Biographical information on Eric H. Thomsen and copies of the Thomsen-Steinbeck

correspondence were provided by his daughter-in-law, Alice B. Thomsen of Houston, Texas. See also Alice Barnard Thomsen, "Eric H. Thomsen and John Steinbeck," *Steinbeck Newsletter* (summer 1990).

16. The Arvin camp opened on 13 Dec. 1935.

17. In *The Grapes of Wrath* Steinbeck called the federal camp Weedpatch; in the movie version of the novel it was called Wheatpatch.

18. For other impressions of the Hoovervilles, see interview with Juliet Thorner, M.D., 18 Feb. 1981, no. 202, and interview with William Rintoul, 8 June 1981, no. 208, Oral History Series, California Odyssey Project, California State University, Bakersfield. In the summer of 1934, Lorena Hickok wrote about a so-called Hoover City, "a jungle of tents, cardboard houses, built out of cartons, no sanitation whatsoever." It was about ten miles from the ranch of Allan Hoover, the son of the former president, which had thirty model adobe houses for workers. Hickok to Eleanor Roosevelt, 15 Aug. 1934, *One Third of a Nation: Lorena Hickok Reports on the Great Depression,* ed. Richard Lowitt and Maurine Beasley (Urbana: University of Illinois Press, 1981).

19. Eric H. Thomsen to Erik and Alice Thomsen, 1 March 1940.

20. Collins's work before he joined the RA/FSA was mentioned in an article in the *Bakersfield Californian,* 15 Feb. 1937, quoted by Jackson J. Benson in "'To Tom, Who Lived It': John Steinbeck and the Man from Weedpatch," *Journal of Modern Literature,* Apr. 1976, 184.

21. This manuscript was given to Jackson Benson by Collins's youngest daughter and is reprinted at the end of his article. See Benson, "'To Tom, Who Lived It,'" 211–13.

22. Report dated 6 Apr. 1936, Ser. 2, Folder RF-CF-25-620, Box 20, Record Group 96, National Archives, San Francisco.

23. "Camp Manager's Weekly Report: Arvin Migratory Labor Camp" for weeks ending 18 Apr., 10 Oct., 24 Oct. 1936, Record Group 96, ibid.

24. Stein thought that the RA's democratization program had the effect of denigrating the indigenous culture of the dust bowl migrants as expressed in their folkways, superstitions, and the fundamentalist religion in which they found emotional release. Walter Stein, *California and the Dust Bowl Migration* (Westport, Conn.: Greenwood Press, 1973), 171–78, passim.

25. Sherman Easton (sometimes spelled Eastom) to Eric Thomsen, 26 Dec. 1936, Folder RC-CF-25-935, Box 24, Record Group 96, National Archives, San Francisco.

26. "Camp Manager's Weekly Report: Arvin" for weeks ending 12 Dec., 26 Dec. 1936, Record Group 96, ibid.

27. Ibid. for weeks ending 4 Jan., 11 Jan., 1 Feb., 8 Feb., 29 Feb., 21 March, 2 May, 23 May, 6 June, 20 June, 11 July, 8 Aug., 22 Aug., 29 Aug., 16 Oct., 24 Oct. 1936; Thomas Collins to Eric H. Thomsen, 25 Nov. 1936, Folder RF-CF-183, Box 19, Record Group 96, National Archives, San Francisco.

28. Frederick Soule to Thomas Collins, 27 June 1936, in Folder RF-CF-25-935, Box 24, Record Group 96, National Archives, San Francisco.

29. Benson, "'To Tom, Who Lived It,'" 187.

30. "Camp Manager's Weekly Report: Arvin," week ending 14 March 1936, Record Group 96, National Archives, San Francisco.

31. "Camp Manager's Weekly Report: Marysville Migratory Labor Camp," week of 14 Sept. 1935, Irving Wood Papers, Bancroft Library.

32. "Camp-Manager's Weekly Report: Arvin," week ending 10 Oct. 1936, Record Group 96, National Archives, San Francisco. The camp central committee wrote Steinbeck a letter of appreciation, reproduced in Collins's report for week ending 24 Oct. 1936; Steinbeck's letter appeared in the *San Francisco News*, 20 Oct. 1936.

33. Steinbeck's *Nation* article appeared on 12 Sept. 1936.

34. Ella Winter, "They Tell Me," *Pacific Weekly,* 12 Oct. 1936, compared "The Harvest Gypsies" with Ernest Hemingway's account of the drowning of some U.S. veterans in Florida. Hemingway's article, "Who Murdered the Vets? (A First-Hand Report on the Florida Hurricane"), appeared in the *New Masses,* 17 Sept. 1935.

35. *San Francisco News,* 13, 9 Oct. 1936.

36. Paul S. Taylor, "The Migrants and California's Future," Sept. 1935 Commonwealth Club address.

37. 1988 Wollenberg edition of Steinbeck, "Harvest Gypsies," 23.

38. Paul S. Taylor and Tom Vasey, "Historical Background of California Farm Labor," *Rural Sociology,* 1, no. 3 (1936), 283.

39. 1988 Wollenberg edition of Steinbeck, "Harvest Gypsies," 61.

40. James Gregory, *American Exodus,* 15. Only 36 percent of the migrants were from farms; 50 percent were from cities; the remainder were from small towns.

41. 1988 Wollenberg edition of Steinbeck, "Harvest Gypsies," 22, 58.

42. Paul Taylor, interview by author, 8 Jan. 1982.

43. Gerald Haslam, "The Okies: Forty Years Later," *Nation,* 15 March 1975.

44. 1988 Wollenberg edition of Steinbeck, "Harvest Gypsies," 56, 57.

45. Carey McWilliams, *Factories in the Field* (Boston: Little, Brown, 1939), 306. He reviewed the subsequent labor history of the migrants in his introduction to the 1971 edition of the book.

46. There was an increase of 52,554 whites and 1,729 blacks in the population of Kern County in the 1930s. See Fifteenth and Sixteenth U.S. Censuses. The California Odyssey oral history series includes interviews with two black migrants.

47. Tom Collins to Eric H. Thomsen, 12 Oct. 1936, Folder RF-CF-26-550-02, Box 19, Record Group 96, National Archives, San Francisco.

48. See Fifteenth and Sixteenth U.S. Censuses.

49. Paul S. Taylor to Jonathan Garst, 22 May 1937, quoted with permission.

50. Fred Ross, interview by author, Alameda, California, 22 March 1982.

51. Jackson Benson, Steinbeck's 1984 biographer, writes: "According to Carol, John made no conscious effort to do any research for his book along the way. Still, it would seem he deliberately chose the route, and he must have gathered some impressions." *Steinbeck, Writer,* 360.

52. James Gregory, *American Exodus,* 17, writes that the migrants "came from particular areas, chiefly the Oklahoma–north Texas cotton belt."

53. Dorothea Lange and Paul S. Taylor, *An American Exodus: A Record of Human Erosion* (New York: Reynal & Hitchcock, 1939), 63.

54. Richard Hammer and Calixtro Romias, "An American Odyssey: *The Grapes of Wrath* Revisited," *Stockton Record*, 16 Nov. 1986.

55. Paul Taylor's article, "Power Farming and Labor Displacement in the Cotton Belt, 1937," appeared in the March–Apr. 1938 issue of the *Monthly Labor Review*. The *Dallas Morning News* of 3 Apr. 1938 quoted Taylor in a story headlined: "Tractors Blamed for Farmer Trek to West Coast."

56. Carol Schloss, *In Visible Light: Photography and the American Writer, 1810–1940* (New York: Oxford University Press, 1987), 213.

57. Benson, "'To Tom, Who Lived It,'" 184.

58. Ibid., 185.

59. John Steinbeck to Pare Lorentz, 6 March [1938], quoted in Lorentz, *FDR's Moviemaker*, 122.

60. Benson, "'To Tom, Who Lived It,'" 186.

61. Steinbeck, *Working Days*, ed. DeMott, 12.

62. Ibid., xxiii.

63. Ibid., 97.

12. Voices from the Battlements

1. Michael Gold, writing in the *Liberator* in Apr. 1922, pilloried the *Saturday Evening Post*, "whose manufacture involved the exploitation of hundreds of lumberjacks standing 'knee-high in icy water to send the logs down for pulp,' kept 'hundreds of office-girls round shouldered at typewriters,' and 'hundreds of pale, nervous authors who plough their brains for this magazine.' It poured out 'spiritual opium' for the masses and corrupted readers and writers alike. 'Oh! the filthy lackey rag, so fat, shiny, gorged with advertisements, putrid with prosperity like the bulky, diamonded duenna of a bawdy house.'" Quoted in Aaron, *Writers on the Left*, 24.

2. Garet Garrett, "Labor at the Golden Gate," *Saturday Evening Post*, 18 March 1939; Frank J. Taylor, "Labor Moves on Hawaii," ibid., 18 June 1947, and "Roughneck Boss of the Sailors' Union," ibid., 18 Apr. 1953. The ILWU was the direct descendant of Bridges's ILA.

3. Profile of Frank J. Taylor by Ben Hibbs, *Country Gentleman*, January 1941.

4. Taylor's article "The Busy Unemployed," *New Republic*, 15 Jan. 1940, appeared in the *Reader's Digest* of February 1940 as "From Unemployed to Self-Employed"; "Blue Ribbon Citizen: The Townswoman," *Survey Graphic*, March 1940, came out in the same month in the *Digest* as "Santa Barbara's Pearl"; Taylor's *Christian Century* article of 18 Jan. 1939 was condensed in the February 1939 *Digest*.

5. Hibbs profile of Frank Taylor.

6. Frank J. Taylor, "Hot Lettuce," *Collier's*, 26 Sept. 1936.

7. Steinbeck wrote to George Albee in an undated letter from Los Gatos in 1936: "Any reference to labor except as dirty dogs is not printed by the big press out here." *A Life in Letters*, 132.

8. Vivian Raineri, *The Red Angel: The Life and Times of Elaine Black Yoneda, 1906–1988* (New York: International Publishers, 1991), 136.

9. Frank J. Taylor, "Green Gold and Tear Gas," *California: Magazine of Pacific Business,* November 1936.

10. Frank J. Taylor, "The World's Greatest Empire," *Fortnight,* 8 Jan. 1951.

11. Frank J. Taylor, "The Right to Harvest," *Country Gentleman,* October 1937.

12. Frank J. Taylor, "Green Gold and Tear Gas."

13. Frank J. Taylor, "Right to Harvest."

14. John Steinbeck to Elizabeth Otis, Nov. 1939, Steinbeck Collection.

15. Frank J. Taylor, "Right to Harvest."

16. Testimony of Dr. John B. Canning, Dec. 1939 Hearings Before a Subcommittee of the Committee on Education and Labor, U.S. Senate, 76th Cong., 2nd Sess., pursuant to S. Res. 266 (74th Cong. "to investigate violations of the right of free speech and assembly and the right of labor to organize and bargain collectively," U.S. Printing Office, Washington, D.C., 1940), 18351–52.

17. Ibid., 17987.

18. The Balfour-Guthrie Ranch in Contra Costa County spent $551.41 on tear gas equipment. Ibid., 18024ff.

19. Frank J. Taylor, "The Merritt System," *Reader's Digest,* February 1939.

20. "Camp Manager's Weekly Report, Arvin," week ending 8 Feb. 1936, Record Group 96, National Archives, San Francisco.

21. Ibid., 11 Jan. 1936.

22. Ibid., 24 Oct. 1936.

23. Weber, *Dark Sweat, White Gold,* 44.

24. Frank J. Taylor, "Labor on Wheels," *Country Gentleman,* July 1938.

25. Weber, *Dark Sweat, White Gold,* 39–42.

26. "Camp Manager's Weekly Report: Arvin," week ending 8 Feb. 1936.

27. Ibid., 22–29 Aug. 1936.

28. "Mr. Thomsen Has His Say," *Bulletin No. 45,* Associated Farmers of California, Inc., Eric H. Thomsen Papers.

29. Eric H. Thomsen to Prof. Julian Hartt, Berea College, Kentucky, 20 Feb. 1941, Eric H. Thomsen Papers.

30. Frank Taylor later commended a local relief program by a Madera County health official, Dr. Lee A. Stone, who "mobilized all the trucks and cars he could find, moved eight hundred refugees thirty miles through blinding rain to shelters and raised funds for railroad tickets to send them home"; "California's 'Grapes of Wrath,'" *Forum,* November 1939.

31. Steinbeck to Otis, February 1938, *A Life in Letters,* 158.

32. Horace Bristol, "Faces of 'The Grapes of Wrath': A Life photographer's travels with John Steinbeck through the Central Valley, winter 1938," *This World* in *San Francisco Chronicle,* 25 Oct. 1987.

33. Steinbeck to Otis, 7 March 1938, *A Life in Letters,* 161.

34. The editors of *Fortune,* "I Wonder Where We Can Go Now," *Fortune,* Apr. 1939.

35. Horace Bristol, "Faces of 'The Grapes of Wrath,'" *Life,* 5 June 1939.

36. *Publishers' Weekly,* 13 Apr. 1940.

37. At a 7 Dec. 1939 meeting in New York City, Eleanor Roosevelt said she "knew from

experience that the picture of the living conditions of these workers at least is partially true." *New York Times,* 8 Dec. 1939.

38. John E. Pickett, "Termites Steinbeck and McWilliams," *Pacific Rural Press,* 29 July 1939.

39. Frank Condon, "The Grapes of Raps," *Collier's,* 27 Jan. 1940.

40. The Kern County Library ban, imposed in August 1939, was not lifted until 1941, but *The Grapes of Wrath* sold out in Bakersfield bookstores; Interview No. 204 with Catherine Sullivan, 27 Feb. 1981, California Odyssey Project. Two copies of the novel, grease-stained from constant handling, continued to circulate at the Arvin camp; Fred Ross, interview by author, 22 March 1982.

41. Quoted in *New York Times,* 19 Aug. 1939. Another Fresno County librarian, Doris Gates, defied the threats of a group that tried to stop her from writing *Blue Willow,* her prize-winning book about a migrant child; see *Steinbeck Quarterly,* autumn 1993.

42. Frank J. Taylor, "California's 'Grapes of Wrath,'" *Reader's Digest,* November 1939.

43. Frank J. Taylor, "The Story Behind 'The Many Californians': An American Travelogue," *Reader's Digest,* January 1952.

44. Frank Taylor's *Reader's Digest* article "Promised Land" was adapted from "The Northwest: Our Promised Land," *American Mercury,* February 1940.

45. *New York Times,* 19 Aug. 1939.

46. Starr, *Endangered Dreams,* 260.

47. Gregory, *American Exodus,* 14, 23, 24; Starr, *Endangered Dreams,* 260.

48. A handbill: "800 PEA PICKERS WANTED, SANTA MARIA, CALIFORNIA," which was distributed by Arizona labor contractors, is reproduced in Malcolm Brown and Orin Cassmore, *Migratory Cotton Pickers in Arizona* (Washington, D.C.: U.S. Government Printing Office, 1939). Kevin Starr has a different take on the handbill issue: *Endangered Dreams,* 259–60.

49. "Camp Manager's Weekly Report: Arvin," 11 Jan. 1936.

50. Dorothea Lange and Paul Taylor reproduced a section of a want-ad page of the *Daily Oklahoman* of 31 Oct. 1937 with an ad placed by a Farm Labor Service in Phoenix, Ariz., requesting "several thousand" cotton pickers. *An American Exodus,* 54.

51. Brown and Cassmore, "Migratory Cotton Pickers in Arizona," xix.

52. Steinbeck insisted on keeping the word *shit-heels* in the novel. Steinbeck to Pascal Covici, 13 Jan. 1939, quoted in Benson, *Steinbeck, Writer,* 390.

53. Garet Garrett, "Whose Law and Order?" *Saturday Evening Post,* 25 March 1939.

54. Ben Hibbs, "Footloose Army," *Country Gentleman,* February 1940.

13. "Something Must Be Done, and Done Soon!"

1. *Factories in the Field* was reprinted in July, August, and twice in September 1939, and again in April 1940.

2. Carey McWilliams, *Ill Fares the Land* (Boston: Little, Brown, 1942), 43.

3. McWilliams, *Factories in the Field,* 2. McWilliams also noted that the book was independent of the Oakland Federal Writers Project work on California migrant labor; *Ill Fares the Land,* 43.

4. McWilliams, *Factories in the Field*, 318, 319.

5. *Factories in the Field* was serialized in *People's World* in eleven installments between 27 Dec. 1938 and 3 Feb. 1939; *Progressive Weekly*, a Sunday supplement of *People's World* reprinted excerpts of Steinbeck's *Their Blood Is Strong* in the issues of 29 Apr. and 6 May 1939.

6. Steinbeck to Elizabeth Otis, 30 July 1939, Steinbeck Collection (M263).

7. McWilliams, *Factories in the Field*, 324; Stein, *California and the Dust Bowl Migration*, 174.

8. Paul S. Taylor, Commonwealth Club address, 13 Sept. 1935.

9. Ibid., 15 Apr. 1938.

10. McWilliams, *Ill Fares the Land*, 45.

11. Steinbeck to Elizabeth Otis, 27 March 27, Steinbeck Collection (M263).

12. Explaining her move to the Simon J. Lubin Society, Helen Hosmer said, "There was no way we were going to be able to tell the whole truth in a government agency—not in this state, not the way it was then." Interview by author, Summerland, Calif., 24 Feb. 1986.

13. Helen Hosmer, interview by author, Summerland, Calif., 24 Feb. 1986. Warren French reprinted "Their Blood Is Strong" in *A Companion to "The Grapes of Wrath"* (New York: Viking, 1963).

14. McWilliams, *Ill Fares the Land*, 42.

15. *Porterville Reporter*, 5 Dec. 1939.

16. *Stockton Record*, 12 Dec. 1939; McWilliams, *Education*, 77, and *Ill Fares the Land*, 44.

17. McWilliams, *Ill Fares the Land*, 43.

18. Ibid., 43–44.

19. Ibid.

20. Ruth Comfort Mitchell, *Of Human Kindness* (New York: D. Appleton-Century, 1940).

21. *Pacific Rural Press*, 16 Dec. 1939.

22. Joan B. Barriga, "Lark on a Barbed-Wire Fence: Ruth Comfort Mitchell's *Of Human Kindness*," *Steinbeck Newsletter* (summer 1989).

23. *Los Angeles Times*, 22 Apr. 1940.

24. Carey McWilliams, "Glory, Glory, California," *New Republic*, 22 July 1940.

25. David King Dunaway, *Huxley in Hollywood* (New York: Harper & Row, 1989), 56.

26. Aldous Huxley, *After Many a Summer Dies the Swan*, Avon ed. (New York: Harper & Bros., 1939), 18, 36, 80.

27. John Steinbeck, "Stars Point to Shafter," *People's World*, 24 Dec. 1938.

28. Starr, *Endangered Dreams*, 256.

29. An unnamed executive secretary of the Associated Farmers responded in the *Nation* of 23 Oct. 1936 to Steinbeck's 12 Sept. article.

30. Steinbeck to Elizabeth Otis, 4, 11 March 1939, Steinbeck Collection (M263).

31. When he traveled with the photographer Horace Bristol, Steinbeck asked him to sign a hotel register under a false name. Horace Bristol, "Faces of 'The Grapes of Wrath,'" *This World* in *San Francisco Chronicle*, 25 Oct. 1987.

32. Steinbeck to Elizabeth Otis, 11 March 1939, Steinbeck Collection (M263).

33. Ibid., 13 Nov. 1939.

34. There was constant warfare between the Dies and the La Follette Committees, one instance of which was reported in the *New York Times* of 24 Aug. 1938.

35. Steinbeck to Carlton A. Sheffield, 23 June 1939, *A Life in Letters,* 187.

36. Natalie Robins, *Alien Ink: The FBI's War on Freedom of Expression* (New York: William Morrow, 1992), 96.

37. Ella Winter, interview by Elaine Berman, 25 Apr. 1977. Speaking of "the party line left," Steinbeck wrote, "I never went over to them—they shifted to me and then away." Letter to Elizabeth Otis, 5 Oct. 1940. Steinbeck Collection (M263).

38. Herbert Mitgang, "Annals of Government: Policing America's Writers," *New Yorker,* 5 Oct. 1987.

39. Ella Winter article, *New Masses,* 20 Feb. 1940.

40. Investigation of Western Writers Congress, Hearings Before a Special Committee on Un-American Activities, House of Representatives, 75th Cong., 3rd Sess. 25 Oct. 1938, vol. 3, p. 1996.

41. James Cagney testimony, 30 Aug. 1940, San Francisco, Hearings Before a Special Committee on Un-American Activities, House of Representatives, 76th Cong., 3rd Sess., 1484.

42. Paul Taylor was criticized for material he presented to his classes at Berkeley. Taylor to Robert Gordon Sproul, 7 Apr. 1941, responding to criticism for his quoting from La Follette Committee testimony on information supplied by the Industrial Association of San Francisco. Paul S. Taylor papers, Bancroft Library, University of California, Berkeley.

43. McWilliams, *Education,* 79. McWilliams wrote about the situation in California in "What's Being Done About the Joads?" *New Republic,* 20 Sept. 1939, and "The Joads On Strike," *Nation,* 4 Nov. 1939.

44. "Vital Statistics on the Darryl F. Zanuck Production for Twentieth-Century Fox of John Steinbeck's 'The Grapes of Wrath,'" Theater Arts Library, University of California, Los Angeles.

45. Doris Bowdon Johnson (Rosasharn in the film, widow of screenwriter Nunnally Johnson), interview by author, Beverly Hills, 12 June 1987.

46. Steinbeck asked the permission of the director of the FSA's Region IX to recruit government camp residents as extras in the film. Laurence Hewes, interview by the author, 20 Apr. 1982.

47. Steinbeck to Pascal Covici, 16 Jan. 1939, *A Life in Letters,* 178.

48. The Steppenwolf production opened in Chicago in Sept. 1988 and in New York on 22 March 1990. It was shown on PBS American Playhouse and won a Tony Award.

49. Steinbeck to Elizabeth Otis, 15 Dec. 1939, Steinbeck Collection (M263).

50. Steinbeck to Mrs. Franklin D. Roosevelt, 24 Apr. 1940, *A Life in Letters,* 202.

51. FDR was quoted in the *New York Times,* 27 Aug. 1939.

52. Paul Taylor, interview by author, 13 Jan. 1982; Helen Gahagan Douglas, *A Full Life* (New York: Doubleday & Co., 1982), 146.

53. Ibid., 154.

54. Laurence Hewes, interview by author, 20 Apr. 1982. See also Hewes's autobiography, *Boxcar in the Sand* (New York: Knopf, 1957).

55. McWilliams, *Ill Fares the Land,* 47.

56. Section 2615 of the California Welfare Institutions Code, passed by the legislature in May 1933, began to be invoked in late 1939 by county attorneys general. The Supreme Court decision on the Edwards case, argued by the ACLU, was handed down in Oct. 1941. Stein, *California and the Dust Bowl Migration*, 130ff.

57. Hearings were held on 17, 19, and 21 Nov. 1941 on HR 5510, the Employment Agency Act of 1941.

58. Jerold S. Auerbach, *Labor and Liberty: The La Follette Committee and the New Deal* (Indianapolis: Bobbs-Merrill, 1966), 184.

59. Auerbach, *Labor and Liberty,* 180.

60. Taylor received a letter dated 14 Dec. 1939 from William Allen White, the famous editor of the *Emporia (Kans.) Gazette,* congratulating him for his testimony before the La Follette Committee.

61. Carey McWilliams, interview on La Follette Civil Liberties Committee, 28 Feb. 1964, Columbia Oral History Project, 4–5. Auerbach, *Labor and Liberty,* 181, writes that "La Follette's reluctance notwithstanding, his committee went to California 'pencil in hand, taking notes on a social revolution'" (quoting Arthur Eggleston, *Nation,* 27 Jan. 1940).

62. Steinbeck to Carlton A. Sheffield, 23 June 1939, *A Life in Letters,* 187.

63. Nelson A. Pichardo, "The Power Elite and Elite Driven Countermovements: The Associated Farmers of California During the 1930s," *Sociological Forum,* 1, no. 1 (1995), citing various issues of *Business Week* from 1937 and 1938.

64. James Price, an Oklahoman active in the National Farm Labor Union strike on the DiGiorgio Ranch in 1949, asked the young congressman Richard Nixon, "Why is it that the farming industry, the Associated Farmers, if they have got the privilege to have an organization, why is it that the farm workers, the guy that does the old heavy-heavy, why doesn't he have the privilege to have an organization?" *Investigation of Labor-Management Relations,* House of Representatives, Special Investigating Committee No. 1 of the Committee on Education and Labor, Bakersfield, Calif., 13 Nov. 1949, 697.

65. Ernesto Galarza talk at UFW boycott office, San Jose, 7 May 1974, Regional Oral History Office, Bancroft Library.

66. Auerbach, *Labor and Liberty,* 191.

67. Paul Taylor quoted Harry H. Fowler, who had been counsel to the TVA before he joined La Follette's staff.

14. Aftermath

1. James Agee and Walker Evans, *Let Us Now Praise Famous Men* (Boston: Houghton Mifflin, 1941). *An American Exodus* sold for $2.75.

2. David P. Peeler, *Hope Among Us Yet: Social Criticism and Social Solace* (Athens: University of Georgia Press, 1987), 91.

3. Paul Taylor, interview by author, 8 Jan. 1982.

4. Steinbeck refers to his rejection of Lange's request and her reaction in letters to Elizabeth Otis, 20, 30 July 1939, Steinbeck Collection (M263).

5. Steinbeck to Elizabeth Otis, 10 May 1940, ibid.

6. Woody Guthrie said about his song "Tom Joad": "I wrote this song because the people back in Oklahoma haven't got two bucks to buy the book, or even thirty-five cents to see the movie, but the song will get back to them and tell them what Preacher Casy said." Bernstein, *Turbulent Years*, 812n8.

7. Pare Lorentz, *FDR's Moviemaker*, 43; Lorentz, "Dorothea Lange: Camera With a Purpose," *U.S. Camera*, 1941, pp. 93–98.

8. Eleanor Roosevelt, "My Day," *San Francisco News*, 10 Apr. 1940.

9. *New Republic*, 12 Feb. 1940.

10. Sherwood Anderson, *Home Town* (New York: Alliance Book Corp., 1940). Thirty-three of Lange's photographs appeared in *Land of the Free* by Archibald MacLeish (New York: Harcourt, Brace, 1938). Other FSA photographers contributed from one to ten pictures apiece.

11. Paul S. Taylor, "Nonstatistical Notes from the Field," *Land Policy Review*, Jan. 1942, is reprinted in Taylor, *On the Ground in the Thirties*, 233–40. The essay answered a question that had been raised by a reporter a year earlier. The drought was over. Wheat was growing in the Dust Bowl. Where were the people who had left? *New York Times*, 27 Aug. 1939.

12. Many years later, when Clark Kerr was president of the University of California, he got the Regents to approve an honorary degree for his former teacher. Kerr recently wrote of Taylor: "He was, when I first met him, among the least noticed of professors in the social sciences at Berkeley; now he is among the most remembered in a broader world." Kerr, "Paul and Dorothea," 39.

13. Hamett formed Employees Security Alliance to protest a drop in the rates for picking cotton. The organization of small farmers, laborers, and their sympathizers had Communist roots. Hamett stated his views in *Migratory Labor in California*, 1936, p. 139.

14. Robert S. McElvaine, *The Great Depression: America, 1929–1941* (New York: Times Books, 1984), 338.

15. In December 1938 UCAPAWA had only fifteen locals in California. Jamieson, op. cit., 173.

16. Gregory, op cit., 163–64.

17. Joe Klein, *Woody Guthrie: A Life* (New York: Knopf, 1980), 133.

18. Interview with Fred Ross, 22 March 1982. In the camp newspaper, the *Tow Sack Tatler* of 11 Nov. 1939, Woody Guthrie wrote: "Go tell the Ass Farmers and the vigilantes I said go take a long, tall, flying suck at a sunflower. Tell 'em I said go ahead and pay you guys that $1.25."

19. Hewes, *Boxcar in the Sand*.

20. Ibid.; Douglas, op. cit., 145–46.

21. Hewes, *Boxcar in the Sand*, 127.

22. Ibid., 128.

23. Bobby Glen Russell interview, 3 Feb. 1981, 107 Oral History Series, p. 6, California Odyssey Project, California State University–Bakersfield.

24. Interview with Laurence Hewes, 20 Apr. 1982.

25. Carole Schloss, op. cit., 226–29.

26. Collins, "Bringing in the Sheaves," *Journal of Modern Literature,* Apr. 1976.

27. Memoir of Mary Sears, FSA Agricultural Workers Health and Medical Association nurse, Bancroft Library.

28. Interviews with Fred Ross by author, Alameda, Calif., 22 March 1982, and Milen Dempster, Mill Valley, 5 May 1982.

29. Jackson Benson uncovered information about Collins's life after he left the FSA. *Journal of Modern Literature,* Apr. 1976.

30. Harvey Swados, ed., introductory note in *The American Writer and the Great Depression* (New York: Bobbs-Merrill, 1966), 118.

31. Russell Lee to Roy Stryker, 13 May, 21 June, 1939, Stryker Papers, Archives of American Art; Peeler, *Hope Among Us Yet,* 92.

32. John Fischer, "The Promised Land," *San Jose Mercury-News,* 9 Apr. 1989.

33. Studs Terkel, "We Still See Their Faces," *San Francisco Review of Books,* spring 1989.

34. Gregory, op. cit., xiv.

35. The four-part series "An American Odyssey: *The Grapes of Wrath* Revisited" appeared in the *Stockton Record* on 16, 17, 19, 20 Nov. 1986.

36. Dislike of *The Grapes of Wrath* was a frequent, though not universal, opinion among some of the more than 200 individuals (former migrants and the local citizens who came in contact with them) who were interviewed through the California Odyssey Project at California State University–Bakersfield in 1981–82.

37. Dan Morgan, *Rising in the West: The True Story of an "Okie" Family from the Great Depression Through the Reagan Years* (New York: Knopf, 1992).

38. *San Francisco Chronicle,* 21 Aug., 18 Sept. 1983.

39. Geoffrey Dunn, "Photographic License," *Metro San Jose,* 19–25 Feb. 1995.

40. Lange's early career as a documentary photographer was dramatized by Elizabeth Roden, whose one-act play opened at the Tale Spinners Theatre in San Francisco on 9 November 1989.

41. Kerr describes Taylor, late in his life, weeping when Kerr quoted what he (Taylor) had said of Lange: "It was a wonderful thing to see her, always. Just to come into the room where she was." Quotation from Malca Chall, *Taylor, California Social Scientist* (Berkeley: Regional Oral History Office, Bancroft Library, University of California, Berkeley, 1973); Kerr, "Paul and Dorothea," 42.

42. Ansel Adams wrote in 1978: "I think Dorothea Lange bridged the space between photo-documentation and photo-poetry to an extraordinary degree. There are few such examples." *Perspectives,* San Francisco Center for Visual Studies, 1978, p. 8. A Lange show of forty-three photographs opened in New York on 3 March 1994. It was described in the *New Yorker* of 7 March 1994 (p. 22) as "the first substantial exhibition of her photography in New York since the 1966 Museum of Modern Art retrospective secured Lange's place in the pantheon."

43. The letter, presented by Terese Hayman of the Oakland Museum, is reprinted in the *Steinbeck Newsletter,* San Jose State University, summer 1989.

44. Pare Lorentz quoted in Stott, *Documentary Expression and Thirties America,* 24.

45. McWilliams interview, 28 Feb. 1964, pp. 16-17, Columbia Oral History Project.

46. In an interview for the Voice of America, 11 Feb. 1952, Steinbeck said of his attitude at the time he wrote *The Grapes of Wrath:* "I was filled with certain anger . . . at people who were doing injustices to other people, or so I thought. I realize now that everyone was caught in the same trap." VOA, Motion Picture Sound and Video Branch, National Archives, Washington, D.C. In his 28 Feb. 1964 Columbia Oral History Project interview on the La Follette hearings, McWilliams described California growers as "individually decent men" who "had had their own way so long they were a badly spoiled group of employers."

47. According to Drew Johnson of the Oakland Museum of California, Lange "is finally taking her place in the front rank of twentieth-century photographers," *Museum Bulletin,* 1994.

48. *New York Times,* 30 Nov. 1996.

Aaron, Daniel. *Writers on the Left: Episodes in American Literary Communism.* New York: Harcourt, Brace & World, 1962.

Adamic, Louis. *Dynamite: The Story of Class Violence in America.* New York: Viking Press, 1931.

———. *Laughing in the Jungle.* New York: Harper & Brothers, 1932.

———. *Grandsons: A Story of American Lives.* New York: Harper & Brothers, 1935. Rpr. New York: AMS Press, 1982.

———. *My America, 1928–1938.* New York: Harper & Brothers, 1938.

Agee, James, and Walker Evans. *Let Us Now Praise Famous Men.* Boston: Houghton Mifflin, 1941.

Anderson, Sherwood. *Puzzled America.* New York: Charles Scribner's Sons, 1935.

———. *Home Town.* New York: Alliance Book Corp., 1940.

Armstrong, Arnold R. [pseud.]. *Parched Earth.* New York: Macmillan, 1934.

Bennett, Robert. *The Wrath of John Steinbeck.* Los Angeles: Robertson Press, 1939.

Benson, Jackson J. "'To Tom, Who Lived It': John Steinbeck and the Man from Weedpatch." *Journal of Modern Literature,* Apr. 1976, 184.

———. *The True Adventures of John Steinbeck, Writer.* New York: Viking Press, 1984.

Bernstein, Irving. *Turbulent Years: A History of the American Worker, 1933–1941.* Boston: Houghton Mifflin, 1970.

Burchell, Sidney H. *Jacob Peek, Orange Grower: A Tale of Southern California.* London: Gay and Hancock, 1915.

Chambers, Clarke. *California Farm Organizations: A History of the Grange, the Farm Bureau, and the Associated Farmers, 1929–1941.* Berkeley: University of California Press, 1952.

Collins, Tom. "Bringing in the Sheaves." *Journal of Modern Literature,* Apr. 1976.

Cowley, Malcolm. *The Dream of the Golden Mountains: Remembering the 1930s.* New York: Viking, 1980.

Critser, Greg. "The Political Rebellion of Carey McWilliams." *UCLA Historical Journal* 4 (1983).

———. "The Making of a Cultural Rebel: Carey McWilliams, 1924–1930." *Pacific Historical Review* (1986).

Cross, William T., and Dorothy Embry Cross. *Newcomers and Nomads.* Stanford: Stanford University Press, 1937.

Daniel, Cletus E. *Bitter Harvest: A History of California Farmworkers, 1870–1941.* Ithaca: Cornell University Press, 1981.

Davison, Richard Allan. *Charles G. Norris.* Boston: Twayne Publishers, 1983.

Dunaway, David King. *Huxley in Hollywood.* New York: Harper & Row, 1989.

Dyson, Lowell K. *Red Harvest: The Communist Party and American Farmers.* Lincoln: University of Nebraska Press, 1982.

Gamio, Manuel. *Mexican Immigration to the United States: A Study of Human Migration and Adjustment; The Mexican Immigrant: His Life Story.* Chicago: University of Chicago Press, 1930, 1931.

George, Henry. *Progress and Poverty.* 50th anniversary edition. New York: Robert Schalkenbach Foundation, 1951.

Goldberg, Vicki. *Margaret Bourke-White: A Biography.* Reading, Mass.: Addison-Wesley, 1987.

Gordon, Neil. "Realization and Recognition: The Art and Life of John Fante." *Boston Review,* Oct.–Nov. 1993.

Gregory, James. *American Exodus: The Dust Bowl Migration and Okie Culture in California.* New York: Oxford University Press, 1989.

Healey, Dorothy, and Maurice Isserman. *Dorothy Healey Remembers: A Life in the American Communist Party.* New York: Oxford University Press, 1990.

Hickok, Lorena. *One-Third of a Nation: Lorena Hickok Reports on the Great Depression.* Edited by Richard Lowitt and Maurine Beasley. Urbana: University of Illinois Press, 1981.

Huxley, Aldous. *After Many a Summer Dies the Swan.* New York: Harper & Bros., 1939.

Isserman, Maurice. *Which Side Were You On? The American Communist Party during the Second World War.* Middletown: Wesleyan University Press, 1982.

Jamieson, Stuart. *Labor Unionism in American Agriculture.* Bulletin No. 836. Washington, D.C.: United States Bureau of Labor Statistics, 45.

Kaplan, Justin. *Lincoln Steffens: A Biography.* New York: Simon & Schuster, Touchstone Edition, 1988.

Kerr, Clark. "Paul and Dorothea," in *Dorothea Lange: A Visual Life.* Edited by Elizabeth Partridge. Washington, D.C.: Smithsonian Institution Press, 1994, 39–40.

Kerr, Clark, and Paul S. Taylor. *Essays in Social Economics.* Berkeley: University of California Press, 1935.

Klein, Herbert, and Carey McWilliams. "Cold Terror in California." *Nation,* July 24, 1935.

Klein, Joe. *Woody Guthrie: A Life.* New York: Knopf, 1980.

Lange, Dorothea, and Paul S. Taylor. *An American Exodus: A Record of Human Erosion.* New York: Reynal & Hitchcock, 1939.

Larrowe, Charles P. *Harry Bridges: The Rise and Fall of Radical Labor in the United States.* New York: Lawrence Hill & Co., 1972.

Lisca, Peter. *The Wide World of John Steinbeck.* New Brunswick: Rutgers Press, 1958.

Loftis, Anne. "The Man Who Preached Strike." *Pacific Historian* 30, no. 2 (1986).

———. "Celestial Gatherings." *Steinbeck Newsletter* (winter–spring 1995).

Lorentz, Pare. *FDR's Moviemaker: Memoirs & Scripts.* Reno: University of Nevada Press, 1992.

Markham, Edwin. *California the Wonderful.* New York: Edwin Markham Press, 1923.

McElvaine, Robert S. *The Great Depression: America, 1929–1941.* New York: Times Books, 1984.

McWilliams, Carey. *Ambrose Bierce.* New York: A. and C. Boni, 1929, 1984.

———. *The New Regionalism in American Literature.* Seattle: University of Washington Press, 1930.

————. *The Education of Carey McWilliams.* New York: Simon & Schuster, 1978.

————. *Factories in the Field.* Boston: Little, Brown, 1939.

————. *Ill Fares the Land.* Boston: Little, Brown, 1942.

Meltzer, Milton. *Dorothea Lange: A Photographer's Life.* New York: Farrar, Straus and Giroux, 1978.

Mitchell, Greg. *The Campaign of the Century: Upton Sinclair's Race for Governor of California and the Birth of Media Politics.* New York: Random House, 1992.

Mitchell, Ruth Comfort. *Of Human Kindness.* New York: D. Appleton-Century, 1940.

Morgan, Dan. *Rising in the West: The True Story of an "Okie" Family from the Great Depression through the Reagan Years.* New York: Alfred A. Knopf, 1992.

Newhall, Beaumont, and Nancy Newhall. *Masters of Photography.* New York: George Braziller, Inc., 1958.

Norris, Charles. *Flint.* New York: Doubleday, Doran & Co., 1944.

Parker, Carleton H. *The Casual Laborer and Other Essays.* New York: Harcourt, Brace & Howe, 1920.

Peeler, David P. *Hope Among Us Yet: Social Criticism and Social Solace in Depression America.* Athens: University of Georgia Press, 1987.

Penkower, Monty Noam. *The Federal Writers Project: A Study in Government Patronage of the Arts.* Urbana: University of Illinois Press, 1977.

Rampersad, Arnold. *The Life of Langston Hughes.* Vol. 1, *I, Too, Sing America.* New York: Oxford University Press, 1986.

Ring, Frances. *A Western Harvest: The Gatherings of an Editor.* Santa Barbara: John Daniel and Co., 1991.

Robins, Natalie. *Alien Ink: The FBI's War on Freedom of Expression.* New York: William Morrow, 1992.

Rolle, Andrew. *California: A History.* New York: Thomas Y. Crowell, 1963.

Royce, Josiah. *California, from the Conquest of 1846 to Second Vigilance Committee in San Francisco: A Study of American Character.* New York: Alfred A. Knopf, 1948.

Sayre, Nora. *Previous Convictions: A Journey Through the 1950s.* New Brunswick: Rutgers University Press, 1995.

Schloss, Carol. *In Visible Light: Photography and the American Writer, 1810–1940.* New York: Oxford University Press, 1987.

Shasky, Florian J., and Susan F. Riggs, eds. *Letters to Elizabeth: A Selection of Letters from John Steinbeck to Elizabeth Otis.* San Francisco: Book Club of California, 1978.

Smith, Paul C. *Personal File.* New York: Appleton-Century, 1964.

Starr, Kevin. *Endangered Dreams: The Great Depression in California.* New York: Oxford University Press, 1996.

Stein, Walter. *California and the Dust Bowl Migration.* Westport, Conn.: Greenwood Press, 1973.

Steinbeck, Elaine, and Robert Wallsten, eds. "Various Excerpts by John Steinbeck." From *Steinbeck: A Life in Letters.* Copyright 1952 by John Steinbeck, © 1969 by The Estate of John Steinbeck, © 1975 by Elaine A. Steinbeck and Robert Wallsten. Used by permission of Viking Penguin, a division of Penguin Books USA Inc.

Steinbeck, John. "The Raid." *North American Review* (October 1934).

————. *Tortilla Flat*. New York: Random House, 1937.

————. *In Dubious Battle*. New York: Viking Compass, 1963.

————. *Working Days: The Journals of "The Grapes of Wrath," 1938–1941*. Edited by Robert DeMott. New York: Viking, 1989.

Stott, William. *Documentary Expression and Thirties America*. Chicago: University of Chicago Press, 1986.

Street, Richard Steven. "Paul S. Taylor and the Origins of Documentary Photography in California, 1927–1934." *History of Photography*, 7, no. 4 (1983).

————. "Salinas on Strike: News Photographers and the Salinas Lettuce Packers Strike of 1936: The First Photo-Essay on a Farm Labor Dispute." *History of Photography*, 12, no. 2 (1988).

Taylor, Frank J. "Hot Lettuce." *Collier's*, 26 September 1936.

————. "Green Gold and Tear Gas." *California: Magazine of Pacific Business*, November 1936.

————. "The Right to Harvest." *Country Gentleman*, October 1937.

————. "Labor on Wheels." *Country Gentleman*, July 1938.

————. "The Merritt System." *Reader's Digest*, February 1939.

————. "California's 'Grapes of Wrath.'" *Reader's Digest*, November 1939.

————. "The World's Greatest Empire." *Fortnight*, 8 January 1951.

————. "The Story Behind 'The Many Californians': An American Travelogue." *Reader's Digest*, January 1952.

Taylor, Paul S. *Mexican Labor in the United States*. 3 vols. Berkeley: University of California Press, 1928–1934.

————. *An American-Mexican Frontier, Nueces Co., Texas*. Chapel Hill: University of North Carolina Press, 1934.

————. "A Step Left." *Survey*, November 1934.

————. "Again the Covered Wagon." *Survey Graphic*, July 1935.

————. "Power Farming and Labor Displacement in the Cotton Belt, 1937." *Monthly Labor Review*, April 1938.

————. "Migrant Mother: 1936." *American West*, May 1970.

Taylor, Paul S., and Norman Leon Gold. "San Francisco and the General Strike." *Survey Graphic*, September 1934.

Taylor, Paul S., and Clark Kerr. "Uprisings on the Farms." *Survey*, November 1934.

————. *On the Ground in the Thirties*. Salt Lake City: Gibbs M. Smith, Peregrine Smith Books, 1983.

Terkel, Studs. "We Still See Their Faces." *San Francisco Review of Books* (spring 1989).

Van Dyke, Willard. "The Photographs of Dorothea Lange: A Critical Analysis." *Camera Craft* (1934).

Watkins, T. H. *The Great Depression: America and the 1930s*. Boston: Little, Brown and Co., 1993.

Weber, Devra. *Dark Sweat, White Gold: California Farm Workers, Cotton, and the New Deal*. Berkeley: University of California Press, 1994.

Welch, Marie de L. *This Is Our Own*. New York: Macmillan, 1940.

Wells, Evelyn. *Fremont Older*. New York: D. Appleton-Century, 1936.

228

West, George. "California Sees Red." *Current History* (1934).

Wilson, Edmund. *The American Jitters: A Year of the Slump.* New York: Charles Scribner's Sons, 1932.

Winter, Ella. *Red Virtue: Human Relationships in the New Russia.* New York: Harcourt, Brace & Co., 1933.

———. "California's Little Hitlers," *New Republic,* 27 December 1933.

———. "Where Democracy Is a Red Plot." *New Republic,* 6 June 1934.

———. "Stevedores on Strike." *New Republic,* 13 June 1934.

———. "L. S." *New Masses,* 8 Sept. 1936.

———. *And Not to Yield: An Autobiography.* New York: Harcourt, Brace & World, 1963.

Wood, Charles Erskine Scott. *Heavenly Discourse.* New York: Vanguard Press, New Masses, 1927.

INDEX

232

233

236